COMFORT AND JUDGEMENT

Comfort and Judgement

Nineteenth Century Advice Manuals and the Scripting of Australian Identity

Gene Bawden

MONASH University Publishing

Comfort and Judgement: Nineteenth Century Advice Manuals and the Scripting of Australian Identity

Monash University Publishing
Matheson Library Annexe
40 Exhibition Walk
Monash University
Clayton, Victoria 3800, Australia
www.publishing.monash.edu

Monash University Publishing brings to the world publications which advance the best traditions of humane and enlightened thought.

Monash University Publishing titles pass through a rigorous process of independent peer review.

ISBN: 9781925835489 (paperback)
ISBN: 9781925835496 (pdf)
ISBN: 9781925835502 (epub)

www.publishing.monash.edu/books/cj-9781925835489.html

Series: Art History

Series Editor: Luke Morgan

Design: Les Thomas

Cover image: J. Brooks Thornley, photographer, *The End of the Book* (1896), gelatin silver photograph, 16.0 x 11.0 cm. State Library of Victoria.

A catalogue record for this book is available from the National Library of Australia.

Printed in Australia by SOS Print + Media Group (Aust) Pty Ltd.

CONTENTS

ABOUT THE AUTHOR

GENE BAWDEN has over twenty-five years' experience as a communication designer and design academic. He currently leads the Department of Design at Monash University, where he is a passionate advocate of teaching, design thinking and practice-based research. His research interests combine notions of gendered spatial practices with his communication design expertise, to reveal new ways of imagining interiors that are shared and equitable.

LIST OF FIGURES

Introduction

Chapter 1

Chapter 2

Chapter 3

LIST OF FIGURES

Conclusion

ACKNOWLEDGMENTS

There have been many who have supported me through *Comfort and Judgement*. My friend and colleague Dr Julie Roberts provided initial enthusiastic support for the topic and encouraged my first steps in a long journey through the pages of ageing and fragile Australian advice manuals. Dr Bronwyn Stocks and Dr Karen Burns were equally supportive. The insightful reviews of Dr Georgina Downey and Dr Denise Whitehouse were pivotal to shaping the final manuscript. However, my greatest thanks go to the editor of the series in which this book appears, Dr Luke Morgan. With his generous guidance and critical assessment I was able to complete the research, and most importantly bring it together in this book. For this I am eternally grateful.

My thanks also go to the State Library of Victoria for permitting me hands-on access to the incredibly rare and fragile W.H. Rocke's *Remarks on Furniture and the Interior Decoration of Houses*. As a key text within the study, completion of the project would not have been possible without it. To Richard Overall and Stephen Herron, thank you for access to the exceptional collection at the Matheson Rare Books Collection at Monash University. It is through the Matheson collection that I was able to secure access to the other key texts: Harriet Wicken's *The Australian Home* and Wilhelmina Rawson's *The Australian Enquiry Book*. Without access to rare book collections and the generous and enthusiastic support of the librarians who preside over them, I would not have been able to complete this project.

I extend my gratitude to the British Council for the Design Researcher Award that funded a pivotal research trip to London. My

thanks go especially to Professor Teal Triggs whose generous support of my application was key to its success. I am also grateful for her incredible 'connectedness' and her introductions to eminent English historians of interior design, especially Trevor Keeble, Penny Sparke and Jeremy Aynsley. Their response and feedback were invaluable in shaping the study.

Thank you also to my friends and colleagues at Monash University, Art Design and Architecture. To be a member of such a diverse, engaged and creative community is a daily joy.

Thank you to my three sons, Tom, Ben and Ollie, for their equal doses of patience and enthusiasm, however feigned. Dusty old books don't hold particular sway with teenagers, but they understood and respected their value to me. To my wife Janet for the last 26 years of encouragement and support, and her much appreciated role as impromptu copy editor, thank you.

And finally, to my mother Hazel who, amid the dust and heat of an isolated outback sheep property, created a domestic haven that connected me spiritually and physically forever to the comforts of home and the value of family. Thank you.

PREFACE

Comfort and Judgement closely examines Australia's often overlooked history of colonial interior design, in particular that which occurred between the 1870s and 1890s. The value of the Australian interior was, even in the nineteenth century, regularly trivialised or ignored in favour of an overwhelming alignment of national identity to the outdoors: the bush, the beach, and the outback. These iconic images were – and remain – undeniably fundamental to Australian identity. In comparison, the nineteenth-century domestic interior might appear as a pastiche of borrowed European references, complicit in aligning our aesthetic and moral values to a British precedent. Yet, for settler communities operating within the complex and troubled colonial experience, the interior was a daily solace; a retreat to familiarity, comfort and behaviours understood to be 'good'. The few nineteenth-century interiors that remain (or have been reimagined) in National Trust homes and historic buildings across Australia provide the possibility for tangible and even experiential studies of the Victorian interior. But this alone is an historical journey confined within the frame of a twenty-first century 'observer'. Our understanding of these interiors and their operation within their 'real' time can be assisted by texts: contemporaneous diaries, inventories, furniture catalogues, newspaper and magazine articles, and, most pertinent to this book, home advice manuals. These were the publications that proffered instruction on how colonial Australians were to create their 'nests' of comfort. While there are many of these manuals housed within Australian libraries and archives, there are three locally-authored texts that became of particular interest to this study: W.H. Rocke & Co.'s *Remarks on*

Furniture and the Interior Decoration of Houses (1874), Harriet Wicken's *The Australian Home: A Handbook of Domestic Economy* (1891) and Wilhelmina Rawson's *The Australian Enquiry Book of Household and General Information: A Practical Guide for the Cottage, Villa and Bush Home* (1894). *Comfort and Judgement* interrogates the writings of Rocke, Wicken and Rawson, and compares their domestic ideals with those of the many other authors who collectively created an exhaustive library of nineteenth-century lifestyle manuals. It reflects on the persuasive authority of nineteenth-century printed matter; the period's reliance on prescriptive behaviour as an operation of transnational middle-class identity; and the value of the domestic interior as an essential tool of colonial expansion.

Comfort and Judgement asserts that the Victorian interior – and the morality, taste and consumption it dictated – required mediation through advice literature in Australia as much as it did elsewhere. But advice manuals, like the ordinary rooms and the polite but commonplace behaviour they guided, can be far too easily dismissed on the grounds of their insignificant contribution to history and culture. Advice manuals are undoubtedly historical documents, but arguably bear no relation to historical accuracy. After all, they did not record actual events or experiences, but rather advised on how those events or experiences *should* have been performed, arranged and responded to. There is no guarantee that their readers performed the advice to any degree of accuracy, or even at all. As Rachel Rich suggests, 'if we assume that advice is often written in reaction *against* a prevailing tendency', then using advice manuals as 'evidence' of lived experience is problematic.[1]

However, Grace Lees-Maffei, a leading scholar in the field, champions their value:

Advice literature needs careful handling. It cannot be taken as direct evidence of past experience; it is not a record of what people actually did in their homes or of how they decorated or used their domestic interiors. But, to disregard advice literature as unreliable, and to prefer primary unpublished sources such as diaries and letters as having a closer relation to actual historical practice, is to miss out on its value... The normative ideals shared by members of a society prescribe desirable behaviours and consumption practices. Domestic advice literature is, therefore, a richly useful genre of constructed ideals offering insights into the social and material histories of the home.[2]

While Lees-Maffei's argument is largely in reference to English and American examples, it is – like advice manuals themselves – entirely transportable to the Australian context. Undoubtedly the publications of Rocke, Wicken and Rawson investigated in the following chapters replicated a familiar trope of middle-class home-centredness, influenced by a litany of pre-existing advisory texts and prevailing social attitudes. However, each author has framed their advice within a semi-autobiographical context. They provided advice determined through lived *Australian* experience, making each geographically relevant to their readers. Rocke, Wicken and Rawson advised on how to achieve the Victorian domestic ideal, but within the framework of colonial possibilities.

Nineteenth-century lifestyle advice appeared extensively in Australia, and in multiple forms: books, pamphlets, newspaper columns, journals and periodicals. Such prolific quantity suggests an eager colonial audience.[3] But what is it – beyond their popularity and perceived 'Australianness' – that makes the works of Rocke, Wicken and Rawson such significant exemplars of their literary genre?

Published in 1874, Rocke's *Remarks on Furniture and the Interior Decoration of Houses* is arguably Australia's first dedicated interior design

manual. Its advice pertains only to domestic ornamentation, furniture and their arrangements. Unlike other manuals of the period it does not stray from its singular ambition to better educate its readers on the qualities of a modern, aspirational interior and its value within both an economic and social context. There is no mention of recipes; no advice on wayward servants; no lengthy scripture on domestic morality; no guides to etiquette or social behaviour. There were many other publications, like *Mrs Beeton's Book of Household Management* (1861), that amply provided for those requirements.[4] Rocke's book was only concerned with the physical manifestation of the modern interior, and how best to furnish it in a manner befitting one's place within an emerging colonial middle-class.

Remarks on Furniture and the Interior Decoration of Houses provides evidence that in Australia, as in Britain, the prevailing tendency was to assume that mid-Victorian men usually possessed superior expertise in interior decoration, and not, as commonly thought, women.[5] While not internationally renowned like his English contemporaries – Henry Cole, Charles Eastlake, Augustus Pugin, John Ruskin, or Christopher Dresser – Rocke does provide a unique Anglo-Australian commentary on the popular topic of interior decoration in the Victorian period. As a retailer of elaborate furnishings and an employer of craftsmen, painters and artisans, Rocke could also provide the required chattels and talent for his customers to realise his book's advice. And, as an English migrant of standing and education within the blossoming middle-class citizenry of Melbourne, his advice could be trusted to be acted upon. As Emma Ferry argues, 'the notion of authorship is crucial: any advice worth buying should, after all, be given by someone of repute with acknowledged expertise'.[6] H. Mortimer Franklyn, a contemporary of Rocke, wrote of his store:

W.H. Rocke & Co. [have] the most extensive and elegant stock of first-class furniture, as well as carpets and general furnishings, that are to be found in the whole of Australia... As proving the position now held by W.H. Rocke & Co., we may state that recently they have had conferred upon them the appointment of first-class medalists, and holders of the diploma of the Grand Council of the Society of Arts, Letters, Science, and Industry, of Naples.[7]

Like his furniture, Rocke's *Remarks on Furniture and the Interior Decoration of Houses* is sumptuously produced, deploying multiple ornamental printing devices to elevate it beyond a mere retailer's marketing tool. Florid, multicoloured lithography and gold leaf adorn the cover while photographic prints of showroom interiors are hand-pasted within its pages. The book represents the highest levels of print production possible in Australia at the time. Advice publications did not normally command such lavish attention to detail. Instead, they were more utilitarian – hard cover for household resilience, and rarely ornamented in luxury finishes. Rocke's book, however, provided a clue to the opulence his interiors promised; and the rooms in which his book – and its readers – should reside.

Recognition of W.H. Rocke & Co. as a significant colonial furniture maker and decorator adds reflective value to his publication. An English review of Rocke's decorative displays at the 1880 Melbourne International Exhibition was required, somewhat reluctantly, to acknowledge the level of quality evident in the furniture he manufactured:

We have no hesitation in giving unstinted praise to the contents of Messrs Rocke's pavilion, the more so because this would bear favourable comparison with the manufacturers of the best houses in Great Britain... Such a collection of colonial art furniture

must go a long way to dispel the notion that anything really artistic must come from London or Paris. With such artificers and designers as this firm possesses, they can (unfortunately for us) dispense with their instructors. (*Cabinet Maker and Art Furniture*, London, May 2, 1881)[8]

Today the National Gallery of Victoria includes the W.H. Rocke & Co. 1880 Melbourne International Exhibition Cabinet to which the critic refers amid its collection of significant Australian furnishings.[9] Design historians and scholars have regularly acknowledged the Rocke company as a major player in Australia's furniture-making history. Tracey Avery and Andrew Montana have both referenced Rocke's furniture in their texts, using it as evidence of the exceptional quality of high-end Australian furnishings that easily surpassed much of the inferior product that was readily exported to Australia throughout the nineteenth century.[10]

However, no in-depth analysis of *Remarks on Furniture and the Interior Decoration of Houses* has yet been undertaken. To date the book has been predominantly used to support arguments surrounding a broader discussion of Australia's colonial material culture.[11] Similarly, reference to Harriet Wicken's *The Australian Home* and Wilhelmina Rawson's *Australian Enquiry Book* is infrequent.[12] As prolific authors of early Australian recipe books it not surprising that most reference to – and analysis of – Wicken and Rawson examines their culinary contributions to colonial development.[13] Food, like furnishings, made an important contribution to the sense of a shared and familiar Anglocentric identity. As Blake Singley suggests, 'food was a central element in the articulation of many colonial societies and became a lens through which to observe the operation of colonialism'.[14] Although food consumption, table setting and dining etiquette were important to

Victorian interior practice, they are not topics covered in this book. It is the women's focus on the late Victorian interior, and its considerable shift in moral and material manifestations from those of Rocke, that draws them into direct comparison with him. Rocke's were interiors reflective of an economic prosperity brought about by gold, agriculture and mercantile growth between the 1860s and 1880s. Wicken and Rawson's advice was not. Theirs was borne of more austere economic circumstance; a result of a major economic depression, and their own particular situations as middle-class women of limited means.

Harriett Wicken authored her advice from a position keenly shared by many Australians in the late nineteenth century: as a participant in an emerging middle-class suburban majority. As a migrant of the preferred kind – English, female, middle class and aspirational – Wicken provided a guiding exemplar for women; as key contributors to urban harmony through domestic order and economy. As a recent migrant she embodied trustworthy English authority; and, as a published author before her arrival, she understood the currency of advice literature 'back home' in Britain. She represented a new era of 'Lady Expert'[15] that understood a changing social landscape in which middle-class women were required to operate; with less domestic help but ever-persistent moral standards. Domesticity became less genteel, and increasingly framed within the science of hygiene and the language of economics. As Rachel Rich further explains, 'writers in this new mode addressed their female readers as efficient managers of homes to be run along the same lines as any other economic enterprise'.[16] Home was at the locus of order and control; economically, socially and morally. If it was managed correctly its effects were believed to permeate well beyond the domestic milieu and into society as a whole. Sarah Leavitt argues that domestic advice literature, like that of Wicken:

allowed for women themselves to be in control of a collective, female, moral destiny. They contributed to a national dialogue about character and its importance to their vision of society. Though the advice was not always followed, it gave white, middle-class women a common vocabulary and a place to begin their own journeys with home (and moral) improvement.[17]

Wilhelmina Rawson's *The Australian Enquiry Book* dispensed advice for a very different female readership to that of Wicken. Her advice had little relevance to women in cities or towns. It was, instead, written with reference to her own position as a squatter's wife within the isolation of the Australian bush, and was advice she deemed pertinent to other wives of similar circumstance. There were no literary precedents in this space, or high street shops from which to procure the materials required to construct the home spaces that delineated middle-class identity. She instead recorded her own methods to overcome these shortfalls, by documenting autobiographical projects in furniture making, decorating, home management and entertaining. No other publication of its type presents such unique resolutions to the considerable domestic challenges faced by Australia's outback women. While she continued to perpetuate what Rich identifies as a 'dominant ideology' – order, economy, gender identity and morality, all bound together within the ties of interiorised domesticity – Rawson does so within the constraints of an isolated and lonely frontier experience. The bush, described by the Australian author Rick Morton as a 'vast complex of fear',[18] was not a space conducive to nineteenth century gender-coded acts of middle-class gentility. Yet Rawson successfully navigated a feminine identity that honoured the 'dominant ideology', by reimagining what behaviours, actions and materials defined it. Via Rawson's advice, outback women could retain their feminine middle-class

membership, while simultaneously denying any prevailing weak or fragile stereotype. If they desired a decorative interior within which to nurture their families, outback women would have to build it themselves from the limited resources of the bush. She encouraged a self-sufficiency that did not (and could not) rely on the input of husbands, tradespeople or the comfort of an ample bank account. Husbands were frequently absent or otherwise preoccupied; and no access to trades or stores limited any capacity to spend money even if it was available. The abundant 'nest' of bounty that so defined the nineteenth-century interior was to be carved from the detritus of colonial expansion and the bush itself. Only Rawson who truly confronted the Australian wilderness could advise with authority and the advantage of knowing its possibilities and limitations.

Comfort and Judgement gathers these three significant authors[19] – Rocke, Wicken and Rawson – into a framework of nineteenth-century domestic practice in order to expose the home interior as a potent signifier of class, gender and identity in Australia's immense and complex colonial space. Each author is the subject of their own chapter. Their texts are analysed as guides to interiorised codes of practice, operationalised by furniture and the abundance of nineteenth-century materiality. Each has a unique perspective on the interior, shaped by personal experience, geography and their situation within Australia's colonial social hierarchy. On some points they agree, on others they stand opposed; but none dispute the importance of the domestic interior as a site of familial comfort and peer judgement. *Comfort and Judgement* examines the primary evidence provided by *Remarks on Furniture and the Interior Decoration of Houses*, *The Australian Home* and *The Australian Enquiry Book* within the context of the enormous body of existing scholarship pertaining to domestic interiors in order to build a new

understanding of the origins of Australia's enduring commitment to home-centredness and the comforts of domestic dwelling.

Comfort and Judgement: A Personal Journey

My journey to this book is the culmination of a long-held fascination with the history and currency of Australia's domestic interior. Having been born in a remote, desert-bound Queensland town, I have felt its power as a solace; a retreat from the extremities of the Australian environment. The interior provided a zone in which we were kept safe, but so too were our traditions, behaviours and belief systems. As I sifted through the pages of Australia's advice manuals I was struck by the continuum of the interior and its purpose: as a refuge to induce both comfort and confidence.

From the works of Rocke and Wicken it is possible to trace the gentle but pervasive influence of interior design on a modern, city-centric Australia; forever in pursuit of spatial experiences that abound with individual taste, yet falling within a familiar pattern of material belonging. They guided the 'correct' choice of interior elements from the bewildering array of many, and advised on their position and purpose. Today we turn to any number of media for the same guidance: books, magazines, television and the internet.

The works of Wilhelmina Rawson, however, offer something far more unique. Then as now, it is difficult to align her advice to a contemporary, urban population. Hers was home advice that could only materialise with dogged determination and the ingenuity known only to those forced to conjure solutions from the 'nothing' of their circumstances. 'Nothing' was for Rawson a 'mysterious source'[20] from which she was able to fabricate imaginaries of interior bliss, that aligned her interiors – in look if not in material or monetary value – to those of

her city equivalents. The absence of familiar domestic items would not rob her, or those she advised, from the joys of interior appreciation. Her advice stirs my own distant memories of remarkable bush women who, like her, made comfortable family homes in locations entirely hostile to the middle-class ideal of a virtuous haven.

While memory is often the enemy of historical accuracy, I can vividly recall the energy my parents and their peers would expend upon their remote interiors. Bedrooms, dining rooms, hallways and even verandahs were carefully composed reflections of self. But one room in particular brought to the fore the potent union of domestic materiality and cultural alignment. It was a room I knew throughout my childhood that was both the most decorative and most useless of all: 'the good room'; interchangeably known as 'the front room', 'the best room' or 'parlour' in other western interior traditions. These were prescriptive caverns of formal furniture suites, patterned carpet, velvet drapes, china cabinets, occasional tables, and collections of ornaments all awkwardly coalescing in spaces impregnated with the acrid waft of furniture polish. But above their aesthetic compliance hovered the rooms' universally understood rules of exclusion. These were rooms for demonstrable show, not ones of welcome, warmth or comfort. In my journey through the colonial advice literature of Australia, I would frequently come across reference to the 'good room' – albeit in its former manifestation as the 'drawing room' – expensively dressed to perfection, then soundly abandoned and off limits to family, and only ever briefly occupied by privileged visitors. In the intriguingly named *Men and How to Manage Them: A Book for Australian Wives and Mothers* (1885) – anonymously authored under the pseudonym 'An Old Housekeeper' – reference is made to the room as one of waste as much as exclusion:

His wife says, 'it's a luxurious little nest' and her bosom friend says 'it's quite a boudoir'. He says nothing, but I expect he thinks a lot... They now have three children, not one of whom has yet set foot inside 'the luxurious little nest', in which to tell the truth, the mother has latterly spent but little of her time. Bye-and-bye, despite all pains, moths will get into the carpet, and the dry rot into that suite of furniture... for all practical purposes the £250 might just as well have been thrown away.[21]

An English contemporary to the Australian 'Housekeeper', Jane Ellen Panton, viewed the unpeopled drawing room with pitiful sadness. In *From Kitchen to Garret* (1887) Panton lamented, 'I am quite convinced that rooms resent neglect just as human beings do, and that they become morose and sulky-looking if they are kept closed, or only opened when strangers are expected'.[22]

Our room struggled under additional levels of abandonment. Situated 300 kilometres from the nearest rural township on an isolated sheep property in the far western Queensland deserts made it difficult to perform its singular duty as a showpiece of respectability. The room was intended as a public demonstration of worth to a select panel of judgemental peers who subscribed to the same language of domesticity, and understood the behaviour it dictated. Yet visitors to it were incredibly rare. With no audience to judge it, approve of it, or enjoy its array of riches, the room was all but pointless.

Its isolation would render it an irrelevant indulgence, but its compliance to rules of behaviour deemed it essential. The room was both the material and moral link for my family to a nation of middle-class aspirants, and, importantly, the space that demarcated Anglocentric civilisation from the barbarity of the bush. All the semiotics bound up in the dull, bourgeois compliance of property and possessions were felt even more intensely in the bush, and not just in our home but the

many dispersed and disconnected houses across the outback. The room and its assemblage of banal materiality stood at the threshold between civility and dereliction.

Popular, commonly understood interiors, like the good rooms of my childhood, were a reassuring and tangible bond that connected an expansive body of like-minded people. They both wrote and revealed the shared tastes of a dispersed middle-class community intent on procuring the commodities of a popular aesthetic economy. The elements of the interior – chairs, lights, wall coverings, pictures and ornaments – were reflective of the mutable shifts in aesthetic novelty, that popular – indeed 'fashionable' – interiors were required to demonstrate and put to work. The myriad of familiar interior accoutrements created a sense of connection – in taste, values and belief systems – and a line of demarcation from those who did not possess, could not afford, or did not understand such 'fashionable' novelties.

Jukka Gronow argues that 'fashionable' consumer goods are understood and adopted in reference to what has gone before. A mutation in form – such that it is 'new' but not entirely unfamiliar – ensures a product's capacity to fall easily into 'the customary patterns of consumption'.[23] Our good room was simply an evolution of a customary pattern; a mutation of the Victorian drawing room that continued to showcase an abundance of familiar 'things' that also performed their duty as signals of middle-class virtue and belonging. These things – chairs, cabinets, wall coverings, carpets, and ornaments – had simply been reimagined in 'modern' form. Although most mid-twentieth century homeowners would deride Victorian taste as fussy and old fashioned, the Victorians reigned in the arena of reimagination, and created the precedent for abundant consumer choice. The union of advanced industrial manufacture, increased consumer spending, and

cut-throat retail competition provided the impetus to reimagine a mass of domestic chattels that would spill onto the late nineteenth century homemaker market.

Even the most basic objects of utility, like cutlery, expanded dramatically in the Victorian period. To the knife, fork and spoon would be added fish knife, teaspoon, asparagus tongs, oyster knives, lobster fork, marrow spoon, soup spoon, butter knife, parfait spoon, sugar nips and fruit knife. Each was a variation of a familiar form, but possessed its own individual purpose and rules of use.[24] According to Colin Bisset, the Victorians boasted in excess of 200 individual items of cutlery. '[The] introduction of a variety of implements to help distinguish the serving and eating of everything from oysters to elaborate puddings, [made] negotiating a dinner a nightmare for those lacking knowledge of table etiquette'.[25] Thus consumption, as represented through the 'fashionable' designed object, became a system of social distinction. The ever-expanding canteen of cutlery and the good behaviour it dictated (or poor breeding it exposed) was just one of the numerous interior objects used to demarcate status. This defining characteristic of the Victorian interior is explored throughout each of the following chapters with particular reference to how advice manuals helped to negotiate the growing complexity within private-as-public displays of middle-class belonging.

In no other room were these complexities more potently evident than in the Victorian 'good' room: the drawing room. The drawing room was the one in which the moral and material delineation between the 'haves' and 'have-nots' of social competencies was revealed. Despite its popularity in the nineteenth century it was, even then, a highly contested space. The drawing room, the 'luxurious little nest', was a prolific manifestation of middle-class identity across the globe. The

room – painstakingly detailed in the lengthy inventory below by the aforementioned 'Old Housekeeper' under the provocative heading 'How not to furnish a room' – was one familiar to all her readers in 1885:

Take the following room, which I have no doubt you can match among your friends. It is fifteen feet by twelve, and indeed if you could measure right into the centre of the little bay window at one end it would be sixteen feet six inches long; but as the fireplace, which faces this window, takes off twenty inches, the result is that the fifteen feet of length are encroached upon by a handsome bright fender, with an *ormalu* bar, which supports a set of fire irons to match. A large snow-white sheepskin rug lies in front of this arrangement, and it measures seven feet by two feet six, it has a very splendid appearance. Indeed it fills up all the space between the fender and the valuable *loo* table, with a diameter of nearly four feet one way and nearly five feet the other, which occupies the central position. One recess beside the chimney is occupied by a chiffonier – or cabinet, as it is called – and a very nice one too in the latest combination of black and gold and silvered glass. The corresponding recess on the other side is filled with a bookcase, which has another cabinet below it. On one side of the room there is a second window, and in there is a jardinière. In the bay window there is a small occasional-table with something very splendid under glass upon it, which I never dare approach for fear of knocking it over. The carpet is a capital Brussels, for which my friend gave nine-and-sixpence a yard, and she has a suite of furniture, of course, all very delightful and pretty – six chairs, lady's easy chair, gentleman's easy chair, and lounge, which last convenience faces the side window, behind the door in the opposite side of the room. Between the bay window and the side window there is a very good piano; over the fireplace there is the inevitable over-mantel, which is intended to remind you that Queen Anne is dead. There are some pretty nick-nacks on the over-mantel, there are a couple of good vases on the chiffonier, there are two pairs of long handsome curtains at each window, carefully festooned and each pair showing at least a foot of exquis-ite border upon the carpet. There are fairly chosen pictures on

the wall, good books in the bookcase, flowers in the vases, pretty albums and presentation volumes on the centre-table and there are various graceful odds and ends of feminine work about the place. Your first thought as you looked through the window at it would be, 'what a pretty little room!' and your second would be, 'How horribly unfit for a human being to live in!'[26]

Despite the author's clear dislike of the space it is, nonetheless, an exemplar of the rooms that occupied the homes of the aspiring middle-class across Australia and abroad. The reproach of the 'Old Housekeeper' was, however, entirely defied by the popularity of the room. It thrived throughout Britain and its colonial dominions as both a personal and public celebration of empire and a sign of both a contribution to it, and enjoying the spoils of it. Within their dark, heavily draped rooms, people could compose an entire narrative of self that transcended actual geography to locate them in the same physical and metaphoric space of English belonging. In her pragmatic dismissal of the drawing room the 'Old Housekeeper' failed to acknowledge the complex semiotics entangled in the clutter of ornament, textiles and furnishings. These objects signalled a family's moral worth; made visible in the material curation of a single room. Bemoaning the inability of a Victorian family to comfortably occupy the room neglects to accept that this was not the room's guiding purpose. Like its latter, twentieth-century manifestations, the drawing room was for reviewing and making a judgement of; not of spatial useability, but of familial compliance to the acknowledged principles of interior decorum and civil, middle-class behaviour. In Australia's colonial settler communities this was of paramount importance. Isolation from – and ignorance of – the bourgeois semiotics of material culture could lead a family dangerously away from systems of behaviour seen as befitting a good,

Christian, white community in the midst of conquering new frontiers in the name of country, queen and empire. Hence, the introductory chapter of this book begins in the Australian-Victorian drawing room and locates it as an essential space of discovery, not only of divisive decorative schemes – for some beautiful, for others vulgar – but as a spatial scripting of social belonging defined by well-rehearsed behaviours. The room introduces the elements and metaphors of Victorian interior space, through which the advice of Rocke, Wicken and Rawson can be imagined to materialise.

INTRODUCTION

Comfort and Judgement in the Drawing Room

In the mid-1880s the Australian artist, Emma (Minnie) Boyd, created a number of paintings of Victorian middle-class interiors. *Corner of a Drawing Room* (1887) (Figure 1) is one of them. At only 40 cm × 30 cm, it is not a stately painting, but it is a meticulously detailed and skilled rendering of a nineteenth-century interior. An *Argus* newspaper critic declared it was 'carefully drawn and well composed, full of painstaking detail, nicely worked out'.[27] But, beyond this minimal acknowledgment, it failed to capture the enthusiasm of the Australian public. Their popular pictorial heritage was far better represented through the large, rural-based works of her male contemporaries; the likes of Frederick McCubbin, Tom Roberts and Arthur Streeton. Of Streeton's *June Evening at Box Hill* (1887) the same *Argus* critic declared it a painting of 'force and value'.[28] Perhaps, as a nation, Australians were underwhelmed by Boyd's depiction of a dull, safe, compliant and un-peopled interior. Even now its prolonged absence from the walls of the National Gallery of Victoria implies a cultural and public nonchalance towards it.[29] Within the nation's white mythology the country's progress was not built on the polite repartee and genteel acts of the formal drawing room, but on the heroic endeavours of brave explorers and the labours of the working class. Even the national anthem celebrates 'toil' twice. 'Toil' is the metaphor for industry and selfless nation-building; not the needlepoint and other worsted work of middle-class women cocooned within the comforts of the suburban drawing room.

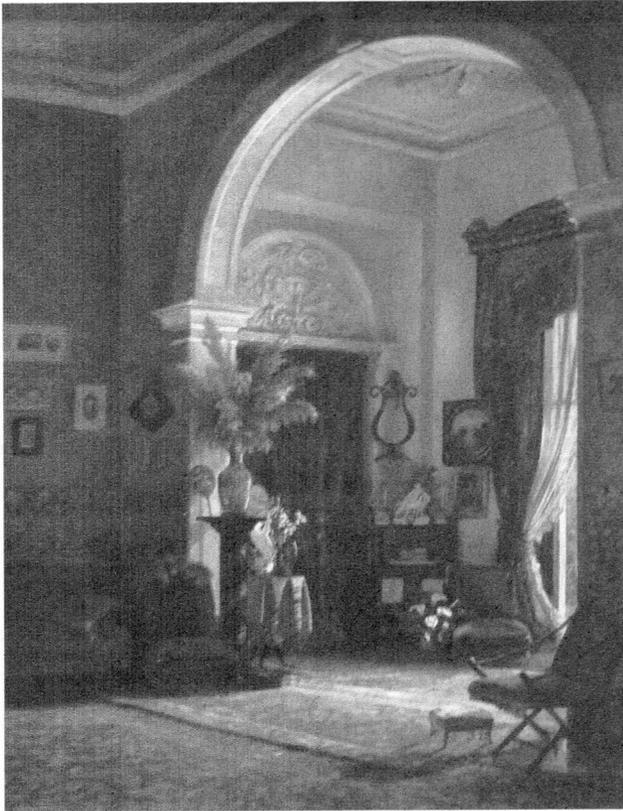

FIGURE 1. Emma Minnie Boyd, *Corner of a Drawing-room* (1887),
National Gallery of Victoria.

Although Boyd's painting is the antithesis of the nationalistic
bush machismo of McCubbin, Roberts and Streeton, and largely
uncelebrated beyond its inclusion among the digital collection of
the National Gallery of Victoria, *Corner of a Drawing Room* speaks
clearly of white Australia's long devotion to home-centredness and
the comforts of European dwelling. While Australians pinned their
nineteenth-century pictorial identity firmly to the frontier myths of
the conquering squatter, the lawless bushranger and the penniless

swagman, Boyd's paintings of bourgeois suburban interiors provide clues to an alternative and potentially more powerful belonging: as members of the vast transnational middle-class who subscribed to the same complex systems of codified nineteenth-century habitation.

For nineteenth-century Australians, the abundantly decorated drawing room provided what Gaston Bachelard identified as 'the proofs or illusions of stability'.[30] In a country whose settlements were new, raw, isolated and subject to an ever-present threat of dissolution, stability was a desperately sought commodity, and for many Anglo-Australians bound up in the familiar spatial patterns of domestic interiors. What could not be tamed in the Australian exterior could be usurped or weakened via a material display of control on the inside. Outside Australian space was vast, undefined, unforgiving and often brutal. The interior with its familiar, comforting and carefully delineated rooms, be they constructed of stone, slabs or even canvas, permitted overt control and a site of small but daily personal victories: parental nurture, cleanliness, neatness, even prettiness. Small and domestic as they were, these triumphs were indicative of the capacity for colonial Australians to conquer their unfamiliar space before it conquered them. As Mary Douglas posits, 'the persons who devote vigilance to the maintenance of the home apparently believe that they personally have a lot to lose if it were to collapse'.[31] To surrender to 'collapse' in the Australian colonial context was not uncommon and, for those it impacted, heartbreaking and demoralising. In Henry Lawson's short story 'The Drover's Wife' (1892), the plight of a once comfortable squatter's family, their income devastated by drought, articulates the distressing levels of base existence a colonial family could descend to when set upon by 'collapse' (see also Chapter 3).[32]

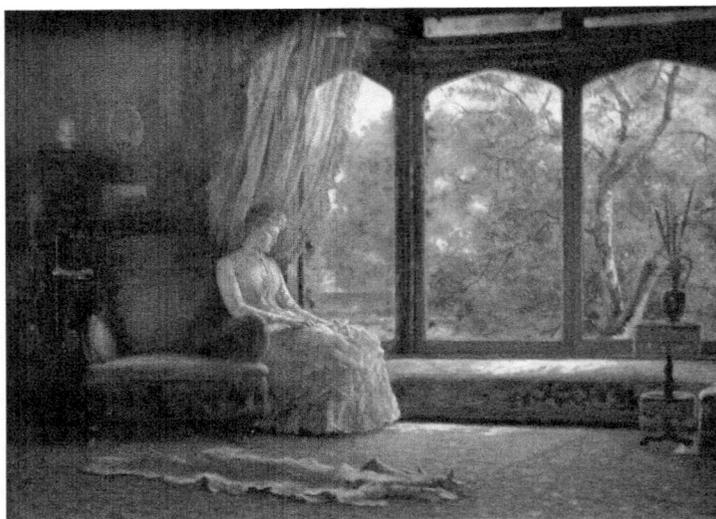

FIGURE 2. Emma Minnie Boyd, *The Window Seat* (1887), National Gallery of Victoria.

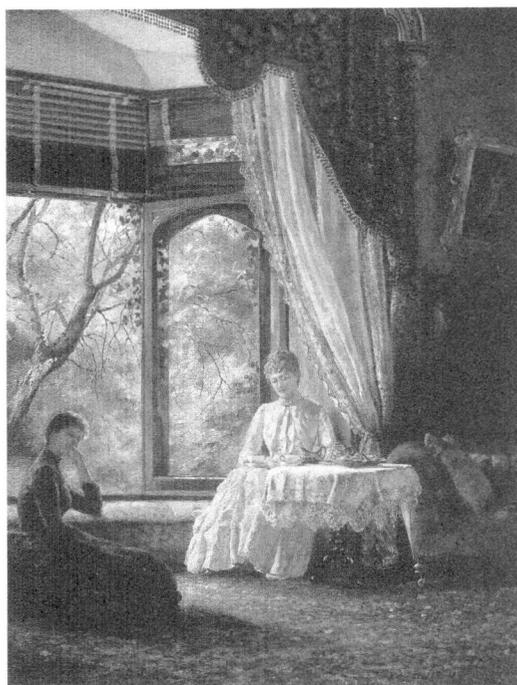

FIGURE 3. Emma Minnie Boyd, *Afternoon Tea* (1888), Bendigo Art Gallery.

FIGURE 4. Nancy Adair Sabine Pasley, *Interior with a Couple Playing Cards* (1887), The Geffrye Museum of the Home.

As an image the Boyd painting – and another two, *The Window Seat* (1887) (FIGURE 2) and *Afternoon Tea at Glenfern* (1888) (FIGURE 3) – provides evidence of Australia's material alignment to a prescriptive English interior. If we compare her paintings to that of her English contemporary Nancy Adair Sabine Pasley (1865–1903) (FIGURE 4), we can safely assume the couple in Pasley's painting would have been equally at ease playing cards in the drawing room of *Glenfern*. In *Interior with a Couple Playing Cards* (1887), all the accoutrements and comforts of the modern English interior have been captured with the same care and attention as those in Boyd's painting. The furniture, ornaments, paintings, drapes and carpet are almost interchangeable. Each item is part of a network of material belonging that binds one resident to the other. These objects are the words, punctuation, exclamations, pauses and inflections of a common language; a language of 'things'. In his book *The Language of Things*, Deyan Sudjic claims that 'objects are the

way in which we measure out the passing of our lives. They are what we use to define ourselves, to signal who we are and who we are not.'[33] For those who dwelt in the rooms of Pasley and Boyd, these objects signalled a community that, despite their vast distance apart, remained spiritually bound through the consumption of decorative objects. The potted parlour-palm and the fern in the fire-grate of Pasley's image transposes to the large vase of pampas grass in Boyd's. While physically different, the grass, fern and palm are symbolic. They are the souvenirs of empire shared among the homes of the middle class as a sign of the vast geographic extent of the powerful empire to which they all belonged. The home interior – its objects and actions – represented the consolidation of a global English middle-class identity.

Images of the Victorian interior are key to decoding the aspirations of colonial Australians. The Boyd paintings provide the clear visual evidence of a nineteenth-century culture reliant on the imported semiotics of the English home, articulated through the objects and styles of the English interior. As Linda Young explains, 'the imperial agenda of supplying goods to the colonies shaped the domestic material culture of Australian life since 1788 especially in furniture, textiles, ceramics, glass and cutlery'.[34] English notions of class, gendered behaviour, taste and civility could, it was believed, be simply imposed on Australian space via the familiar objects of material dwelling. The semiotics of interior possessions could be interpreted in similar ways by their geographically dispersed users, therefore recreating equivalent actions and attitudes across the colonial experience.[35] Providing the appropriate set would provide the cues for the acting out of appropriate behaviour. The sociologist Erving Goffman claimed the roles enacted by people, as participants of a bonded community, required first and foremost a familiar set for those actions to be clearly framed and understood.

In 1969 he wrote, 'Firstly there is the "setting", involving furniture, decor, physical layout, and other background items which supply the scenery and stage props for the spate of human action played out before, within or upon it'.[36]

Boyd's drawing room is Goffman's performative space. It provided the appropriately furnished set – a background story – within which to act out a broader narrative of respectable colonial belonging.

Dramaturgical metaphors have long been employed in the analysis of interior dwelling. Walter Benjamin, in his poetic appreciation and criticism of the bourgeois home, declared, 'the phantasmagorias of the interior… for the private man represents the universe. In the interior he brings together the far away and the long ago. His living room is a box in the theatre of the world.'[37] In the context of the Australian interior Benjamin's analysis confirms the room as a carefully reimagined memory of a distant, but ever-influential motherland. But his metaphor of the theatre box suggests a passive observance of interiority rather than an active role within it. These were places to dwell, self-consumed in a display of acquisition and worth. He also wrote:

> To live in these interiors was to have woven a dense fabric about oneself, to have secluded oneself within a spider's web, in whose toils world events hang loosely suspended like so many insect bodies sucked dry. From this cavern one does not like to stir.[38]

In *The Window Seat*, we see evidence of Benjamin's claim. Boyd's sister-in-law Lucy sits inert in the corner of the room. Her elegant but restrictive dress appears almost as an extension of the lace curtain behind her; the 'web' of Benjamin's bourgeois domesticity. None of the anxieties of the exterior world appear to have any impact on her. Lucy is objectified as one of the beautiful chattels within the room, her stillness equivalent to the breathless objects that surround her.

The isolation of the space is palpable, and the quiet inactivity of it endured because it was expected and scripted to be so. But objects and furnishings alone cannot script behaviour and their mere presence cannot signify any real comprehension of taste and etiquette. It is far easier to inelegantly slump in a chair than it is to sit, like Lucy, with perfect deportment. Lucy is an exemplar of her class: well educated in the ways of elegantly inhabiting space. Her skills were most likely gleaned from the social position she was born to; a world of servants, governesses and female peer role models. But not all Australians were born to this status. Australia was a site of rapid social mobility. As explained by Tracey Avery, 'owing to the anonymity of new emigrants, higher wages and greater home ownership, social mobility could be rapid in the Australian colonies'.[39] For free settlers the reinvention of class could even occur on the voyage out.[40] A subservient lower status or an unfortunate past could simply be abandoned on board, with no-one in the colonies being any the wiser. Charles Dickens's famous character Mr Micawber does this.[41] He leaves London for Australia a social and financial failure only to become manager of the Port Middlebay Bank and a successful government magistrate. Newfound wealth from farming, mining or mercantile success could also provide the necessary funds to acquire the objects of middle-class dwelling. But these alone were not enough. A comprehension of the behaviour and taste these objects inferred had to be secured – or reaffirmed – from elsewhere. It is here that the advice manuals of the nineteenth century played their most significant role.

Remarks on Furniture and the Interior Decoration of Houses, a small, beautifully printed and carefully worded composition on the interior design of Australian houses, published by the Melbourne furniture

retailer William Henry Rocke in 1874, helped to illuminate my investigation of Boyd's drawing room paintings. As my study progressed, and additional Australian-authored advice manuals were discovered, it became clear that the language of Australian home, as represented through these manuals, was a rich and thus far untapped resource in the retelling of domestic Australian dwelling. The texts are largely without pictures (the Rocke book contains only two sepia photographs), but each conjures imaginaries of domestic space that both reiterate and challenge the visual decoding of Boyd's rooms.

This study interrogates three nineteenth-century Australian documents as significant to the scripting of interior dwelling; the aforementioned *Remarks on Furniture and the Interior Decoration of Houses* (1874), Harriet Frances Wicken's *The Australian Home* (1891) and Wilhelmina Rawson's *The Australian Enquiry Book of Household and General Information: A Practical Guide for the Cottage, Villa and Bush Home* (1894).

If Boyd's paintings provide a visual testimony to English compliance, these three documents are its literary confirmation. They clearly encouraged and promoted imported notions of class, gendered behaviour, moral probity, material culture and 'civilised' dwelling. However, all, in varying degrees, adapted their English prejudice to the nuances of their specific Australian situation. The three authors differed in opinion, audience and language, but concurred on the fervent belief in the familiar Victorian canon of 'home': a comforting haven, a bastion of virtue and a showpiece of class belonging, all carefully articulated in the one room to which all three pay varying degrees of homage – the drawing room.

Rocke, above all, proclaimed the national priority of the drawing room:

> It is… an excellent outcome of our national feeling that the
> most bigoted utilitarian has never laid his profane hand on the
> British drawing-room. That one room in every house suggests
> ideas of poetry and beauty, as well as comfort and decency, is a
> vast national blessing.[42]

'The drawing room', Wicken declared, 'by universal consent, is sup-
posed to be the prettiest and nicest room in the house'.[43] Rawson, in her
far smaller, four-roomed bush cottage, devoted one room to a 'sitting
room, or rather drawing room I suppose'.[44] As we progress down the
strata of Australia's middle-class from Rocke's wealthy colonial elite,
to Rawson's bush-bound bourgeoisie via Wicken's ordinary suburban
middle-class, the drawing room remains a consistent if progressively
less esteemed site of domestic triumph. All, however, believed in its
preservation and its importance to both affluent and ordinary middle-
class identity. And thus, as a segue into the advice of Rocke, Wicken
and Rawson, this study begins in the drawing rooms of Emma Boyd.
Within them, issues pertaining to class, identity, gender and taste can
be reviewed and evaluated, thus establishing the cultural framework
within which Rocke, Wicken and Rawson were required to operate
and influence. Within their books they could, as Boyd did within her
rooms, insist upon, conform to, and skilfully adapt a middle-class
identity dictated by English cultural authority.

Reading the Drawing Room: The Interior and Australian Identity

Unlike the rural iconography of her contemporaries, Boyd's interior
images were an exercise in sameness that was difficult to align to
Australia's burgeoning nationalism. 'Every nation', argues Tony Fry,
'believes in a need to claim the uniqueness of its culture as proof of its

identity'.[45] The Australian landscape and those who laboured within it provided a powerful – if somewhat parochial – pictorial identity that clearly met the needs of 'uniqueness'. Boyd's image of middle-class 'anywhere' did not. Nothing of her interior speaks of 'Australianness' short of the unruly gum tree visible through the window in both *Afternoon Tea* and *The Window Seat*. The window serves as a clear demarcation between 'outside' Australian space and 'inside' English comfort. A familiar memory of English dwelling shields the home's inhabitants from the heat, flies and other 'unique' qualities of the Australian exterior. In *The Window Seat*, a kangaroo rug graces the floor, but, although distinctly Australian, this is no more exotic than (or perhaps as exotic as) the abundant fur lying at the foot of the fireplace in Pasley's painting. In some ways Boyd's rug is an atrocity. The great national emblem of the muscular and upright kangaroo lies as a deflated husk on the floor; its dignity and value as an independent and idiosyncratic symbol reduced to an ornamental parlour souvenir.

Compositionally Boyd's images hover in corners. For Bachelard the corner is a potent domestic metaphor. The corner is 'that most sordid of havens… [that]… ensures us of one of the things we prize most highly – immobility'.[46] In one sense immobility in the drawing room was indicative of middle-class leisure irrespective of geography; the evidence that one had the time, the servants and income to do 'nothing'. However, in regard to Boyd's Australian room, Bachelard's observation of 'immobility' can be interpreted as 'permanency'.

Boyd's space captures a solid, physical presence. Hers is not a temporary colonial dwelling made of flimsy makeshift materials that could be uprooted and moved with relative ease. This drawing room resides in a house firmly grounded in a sound and familiar architectural framework. An ornamental frieze above the door, the thickly sculpted

leaves of the ceiling rose and the grand arch speak directly to permanency and solid, resilient immovability. This room, its 'corners' and the grand house they reside within were a sign of a fledgling culture that had conquered its environment and was determined to stay and dwell amidst its victory.

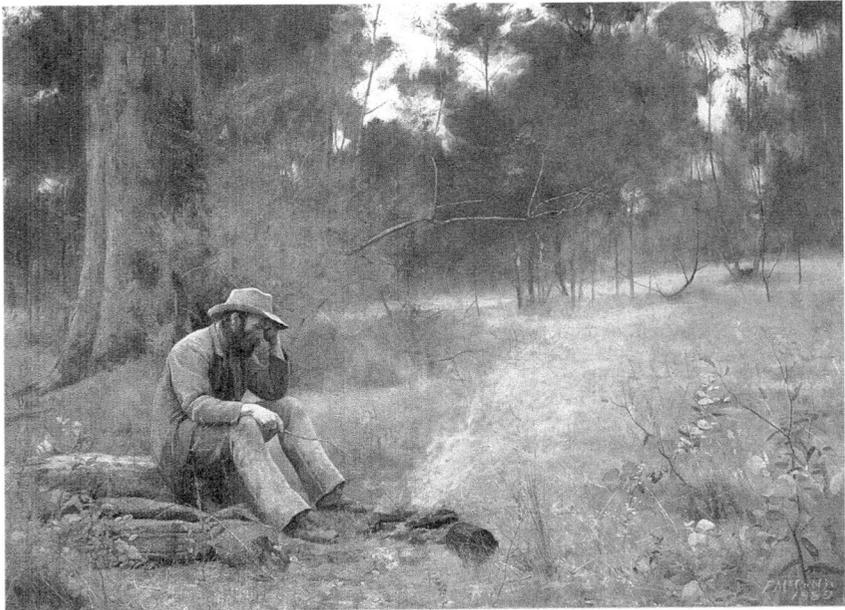

FIGURE 5. Frederick McCubbin, *Down on His Luck* (1889),
Art Gallery of Western Australia.

There are no corners in McCubbin's *Down on His Luck* (1889) (FIGURE 5). His penniless swagman sits downcast at a temporary campsite surrounded by a majestic but unruly and possibly dangerous bush. There is no hope of permanency, no 'immobility', no prospect of comfort; only homelessness, vagrancy and transience. Yet, this image captured the nation's affection. It is an image of proud, albeit provincial, independence that possibly could only read as 'honourable'

in Australia. A *Table Talk* review of the painting in 1889 declared, 'The face tells of hardships keen and blighting in their influence, but there is a nonchalant and slightly cynical expression, which proclaims the absence of all self-pity… McCubbin's picture is thoroughly Australian in spirit'.[47]

Cynicism, albeit proclaimed 'slight', may seem an odd imposition upon the national character. But cynicism is independence, the right to mistrust and even ignore imposed protocols of behaviour. McCubbin's character is strong, determined and hopeful despite the total absence of all the signs of civilised politeness that demarcated the 'haves' from the 'have-nots' of the nineteenth century. Despite the fact that most middle-class urban dwellers would have found the presence of an actual vagrant in their midst threatening, this painting is a symbol of freedom: an Australian 'spirit' perceivably liberated from the meaningless codes of etiquette and other complicated but trivial practices of interior dwelling. Boyd's rooms are not. They are rarefied, cloistered spaces, subservient to English domestic values and the weak, effeminate opposite of the hard, rural colonial experience.

When McCubbin completed *Down on His Luck*, it was publicly exhibited at the Victorian Artists' Society Exhibition of 1889.[48] At the same exhibition Boyd exhibited another of her small domestic interiors, *The Letter* (1889) (FIGURE 6), in which she depicts her sister at the Boyd's Fulton Street house.[49] In scale alone *The Letter* would have been dwarfed by McCubbin's painting, but even more so by its glorified rural Australian iconography. Her pretty interior of middle-class city privilege could not compete with the bush motifs upon which the national psyche was determined to align its identity. For artists like McCubbin the bush frontier was the site of egalitarian individualism,

where even a penniless swagman could be heroised. But, despite the popular conceptions of Australian identity constructed around the outback and bush life, they were also challenged by the fact that Australia was fast becoming one of the most urbanised nations in the world.[50] By 1891 two-thirds of the population would live in urban domains.[51] And so emerged one of the contradictions of Australian identity. In reality if not in its pictorial mythology, the country was growing increasingly distant from the root of its bush legends. While Boyd's interiors are undoubtedly those of a privileged class, they do represent a far more enduring and accurate telling of Anglo-Australian identity.

Figure 6. Emma Minnie Boyd, *The Letter* (1889), Art Gallery of South Australia.

The works of Rocke and Wicken, like Boyd's painting, demonstrate their commitment to the preservation of Anglicised identity, bound within the construct and practices of urban dwelling, not the idiosyncrasies of the Australian bush. Wicken simply ignored the bush entirely. Rocke conceded that Australia's wealthy citizens – his clientele – were to be found in the country as much as the city, but they were bonded to their urban counterparts by way of grand houses and the behaviour that they implied. Their rural location was irrelevant; their comprehension of (and capacity to afford) civilised dwelling was vital. It is only Rawson who wrote specifically for the rural minority. Hers was an idiosyncratic, autobiographical approach; a hybrid identity that fully embraced her remote Australian location without once reducing her claim to Anglocentric middle-class membership.

Reading the Drawing Room: The Conundrum of Australian Class

Australia's first white imposition as a penal colony, and later as a haven of betterment for working-class migrants, has initiated frequent debate around the construction of Australian class belonging. The absence of a ruling aristocracy did not eliminate the comprehension of an English class system. Although physically absent, the aristocracy was symbolically maintained via a conduit of lower-order knights employed as governors, and within every city and town the plump, dour image of Queen Victoria reigned in some publicly accessible space as either a statue or sepia photograph. There was, in the mid-1850s, a movement headed by the explorer, journalist and politician William Charles Wentworth to establish a colonial aristocracy in Australia. He campaigned for a hereditary nobility, selected initially from the country's wealthy landowners, to form a colonial House of Lords. But

the premise of Australian egalitarianism had, by the mid-nineteenth century, established a firm foothold. His suggestion was ridiculed as a 'bunyip aristocracy' and 'far too severe a strain on the democratic temper of the colony'.[52]

Australia's earliest homespun advice manual was, however, devoted to the imposition of an English class system, but, unlike later publications, it was intended to instruct an underclass of servants, not assist an emerging society of middle-class aspirants. While the latter would eventually need to know the idiosyncrasies of Victorian decorum, the former needed to first know how to serve them. Eliza Darling, wife of the Governor of New South Wales, wrote *Simple Rules for the Guidance of People in Humble Life* in 1837 and had it distributed to orphans in her Sydney-based Female School of Industry. A class-structured nation was, according to Darling, part of God's scheme for an ordered society, and it 'is the Great God Himself who appoints to all persons their stations and their duties'.[53] A class system of command and obedience was indelibly bound within the construct of nineteenth-century English Christendom, and, as such, Darling intended it for Australia as well.

In 1864, Edward Abbott would pen Australia's first local cookbook. The title alone alludes to the existence of an established class structure: *The English and Australian Cookery Book: Cookery for the Many, as Well as the 'Upper Ten Thousand'*. The 'upper ten' is a term borrowed from the American poet Nathanial Parker who used it in 1852 to describe the wealthy elite of New York. Very quickly it gained a more global familiarity to describe the upper circles of any city. But, despite the presence of classism in the colonies, a national character built upon ideals of egalitarianism (like a swagman being recognised of equal worth to all other Australians), would prompt a reassessment of middle-class Australian identity. Linda Young asserts:

Much historiographical energy was dedicated to explaining that the British middle-class changed when it arrived in Australia, or indeed, during the voyage out, into something different, characteristically egalitarian, and therefore not middle-class. In so far as recognition was acknowledged at all, the bourgeoisie tends to be have been presented as small, pathetic or ludicrous. Much of this dismissive tone arises from the powerful local tradition of labour history, focusing on working-class struggle as the defining dynamic of Australian history.[54]

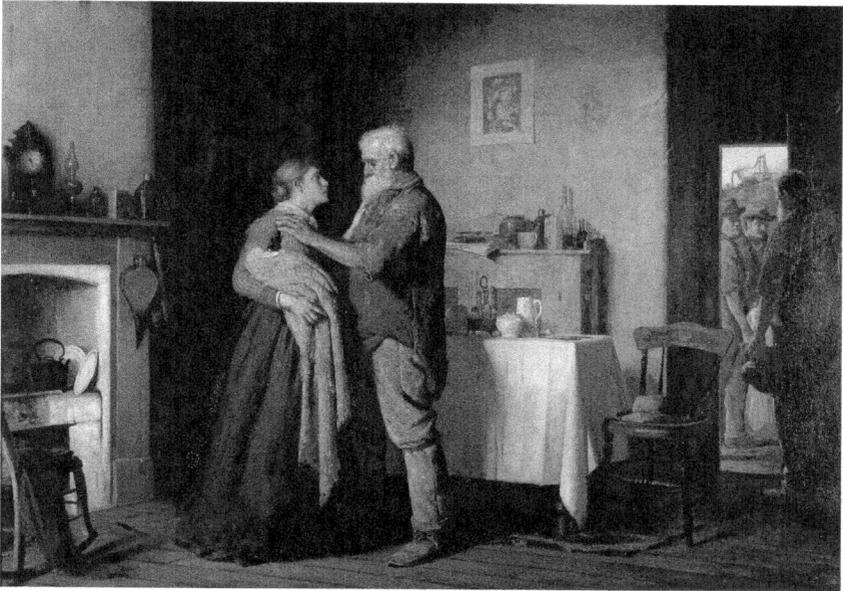

FIGURE 7. John Longstaff, *Breaking the News* (1887), Art Gallery of Western Australia.

The contradictions in Australia's relationship to class are clearly evident if we compare Boyd's *The Letter* with *Breaking the News* (1887) (FIGURE 7), by another of her contemporaries, John Longstaff. Both paintings deal with the delivery of news, with a young woman centred as its receiver. In Boyd's painting, the young woman is her sister Ethel, in receipt of a love letter at the doors of Boyd's St Kilda drawing room.

Her tailored white dress and elegant poise define her class, and her interior, flush with the modernity of a lighter English aestheticism, leaves us with no uncertainty of it. Longstaff's female protagonist is a poor miner's wife in receipt of news of her husband's death. His pallbearers are waiting at the entrance to the cottage while the news is broken by a kind and sympathetic elder. The grief-stricken woman is dressed in brown, carries a baby and stands amid the entirety of her home, a room that serves a multitude of functions: kitchen, sitting room and bedroom. However, it is not a hovel, but well-tended, clean and neat. A white tablecloth and carefully arranged cruet and china are testimony to her domestic pride despite the impositions of poverty and labour. *Breaking the News* appealed immediately to the Victorian taste for sympathy and sentimental narrative. More importantly, it illustrated Australia's pride in its stoic worker. Boyd's painting did not. *The Letter* was, however, an accurate and truthful depiction of her family's existence, while Longstaff's was not. His is a piece of fiction, entirely composed in comfort on the ground floor of the old Melbourne Gallery in Swanston Street, not in the gritty goldfields of Central Victoria.[55] But, by comparing the two, we pit ennobled righteous worker against privileged, protected middle-class female; an entirely unfair match in the emerging construct of Australia's egalitarian class mythology.

Despite the 'honourable worker' mantra as a prevailing constituent of the national character, class elevation was a guiding principle for many locally born and migrant Australians. Access to 'egalitarianism' also meant equal opportunities to better oneself financially and socially. Emma Boyd's own family history is a case in point. She was at once a member of the new world elite, a part of the Melbourne establishment, and at the same time granddaughter of a convict. In

many ways Boyd's paintings are a more convincing representation of Australian egalitarianism than the glorified fictions of McCubbin and Longstaff. They are the material evidence that even the descendants of a lawless convict can prosper in Australia and take their place amid the great and the good. Her respected situation amid Melbourne's polite society owes a great deal to her mother's marriage to William Arthur Callendar a'Beckett, son of Sir William a'Beckett, first Chief Justice of Melbourne's Supreme Court; but equally to her convict grandfather's substantial fortune amassed from breweries, speculative land investments and public houses. A marriage between a judge's son and a convict's daughter, even a rich one, would surely have been the ruination of a family name in England. But not so in the small, hybridised social circles of Australia in which its residents could acquire wealth and property far above what their status would permit them in England.

Advice manuals, like those of all three authors who feature in this study, were an essential part of navigating an increasingly complex landscape of middle-class belonging. Thorstein Veblen, as a participant in nineteenth century middle-class activity, observed:

> Under the requirement of conspicuous consumption of goods, the apparatus of living has grown so elaborate and cumbrous, in the way of dwellings, furniture, bric-a-brac, wardrobe and meals, that the consumers of these things cannot make way with them in the required manner without help.[56]

Advice manuals would provide some service towards 'helping' the middle class, but not nearly as much as the underclass of servants who performed the numerous tasks required of the increasingly complex and object-rich house. They were, he states, 'a concession of physical comfort to the moral need of pecuniary decency'.[57] Within Boyd's drawing room and the rooms that Rocke and Wicken furnished,

servants were essential. Neither author make special note of them; they are simply assumed to exist as part of the requisite chattels of middle-class membership. Even for Rawson in her four-roomed isolated bush home, servants were integral to the maintenance of lifestyle and middle-class identity.

For servants themselves the rooms of their employees represented unachievable luxury and were looked upon as spaces of dread: endless dusting, fear of breakages, sites of admonishment. Their status as an unwelcome but tolerated service to the drawing room did not permit them the capacity to comprehend the intended meaning embedded in the space. As Elizabeth Langland explains, 'a working girl would not be sufficiently conversant with the semiotics of middle-class life'.[58] This was the preserve of visiting peers, for they alone understood the material value and moral virtues of the room as a comparative site to their own aspirational domesticity.

Reading the Drawing Room: Taste and Judgement

'Taste', states Penny Sparke, 'is that highly personal and yet collectively negotiated aesthetic discrimination'.[59] In the context of nineteenth-century habitation it was also a visible marker of middle-class belonging and a civilising achievement. McCubbin's swagman is obviously not middle class. He owns nothing. Ownership of things was the badge of membership to the middle class through which an assessment of 'taste' could be made. Longstaff's interior possessions are well-kept but commonplace objects of daily use with no significant aesthetic that alludes to their owner's taste. Again this is not a middle-class home as its interior is furnished on the premise of necessity not choice. Boyd's drawing rooms, however, are brimming with extraneous objects, 'liberated from the drudgery of usefulness' but *chosen* as signifiers of taste.[60]

Taste was to possess the luxury of choice and the capable judgement to ensure it was right. The drawing room, and its profusion of objects carefully selected for their aesthetic narrative rather than their practical application, was the site where taste and middle-class belonging coalesce, but not in an entirely comfortable union. To fail in the arena of 'taste' was to expose oneself as an imposter to the status of middle class; those who the nineteenth-century journalist Richard Twopeny would term the parvenu:[61]

> Without education and taste, the parvenu has small means of enjoying herself except by making a display which costs her even more anxiety and trouble than it does money… She has no tastes except those she does not dare to gratify and becomes a slave to the very wealth whose badge she loves to flaunt.[62]

Twopeny's 1883 *Observation of Life in Australia* identifies the core of the nineteenth-century's popular comprehension of taste: its coupling of 'education' with 'women'. English author and critic, Charles Eastlake elaborates:

> The faculty to distinguish good from bad design in the familiar objects of domestic life is a faculty which most educated people – and women especially – conceive they possess… While a young lady is devoting at school, or under a governess, so many hours a day to music, so many to languages, and so many to general science, she is all this time forming a sense of the beautiful, which we call taste – that this sense once developed will enable her unassisted by special study or experience, not only to appreciate the charms of nature in every aspect, but to form a correct estimate of the merits of art-manufacture.[63]

Eastlake goes on to dispute this belief: 'It is a lamentable fact that this very quality (of taste) is commonly deficient, not only in the generally ignorant, but also among the most educated classes in this

country'.[64] For Eastlake the assumption that good breeding inferred good taste was a piece of fiction that could only be remedied by an alternative education. For both the English and Australian middle-class this education could be sought through the profusion of advice manuals that included Eastlake's own *Hints on Household Taste* (1869). These publications covered the multiplicity of issues regarding taste in both objects and behaviour. How one arranged a room could be read alongside the etiquette of visiting rituals. Rocke, Wicken and Rawson repeatedly refer to or imply 'taste' through the metaphor of 'beauty', but none define it outright. They did disagree with Eastlake and assumed, through the benefit of class, that 'taste' existed already. 'Most women', claims Rawson, 'have sufficient taste to make pretty things'.[65] The task of Rocke, Wicken and Rawson was to tap into an already present understanding of taste, then reaffirm, redirect or refine it. 'Taste', Rocke states (quoting Thomas Carlyle), 'is something more than connoisseurship. It is a guiding principle instinct with truth and nobleness'.[66] By simply obeying their guiding principles of decoration and furnishing, all levels of middle-class Australians could be taught to be 'tasteful' and then be confidently judged as 'true' and 'noble'.

'Beryl', a journalist for *The Illustrated Sydney News* in 1890, proclaimed the importance of the drawing room and all that it communicated:

> … the drawing room is the most important room in the house… [it is]… the neutral ground where callers can penetrate without further approach to intimacy, and from that standpoint gather their impressions of what lies beyond – of what are the tastes, intellectual pursuits and characteristics of the occupiers of the house.[67]

Boyd's drawing rooms capture the self-reflective, class-conscious display of Victorian taste upon which judgement would be cast. From

the carpet to the curtains, the ornaments to the pictures, the family's 'taste', intellectual pursuits and characteristics were laid bare. They were on show in order to be assessed: open to ridicule, dismissal, admiration or envy. 'In the context of nineteenth-century domestic culture… to have taste was to have the ability to judge', explains Trevor Keeble.[68]

And judge they did. One attendee to a Boyd evening party, Fanny Barbour, wrote in her diary:

> Their room is laden with things but all the things are interesting because they all seem to have a story of their own. When you first go in the effect strikes you as being heavy and cumbersome… but after a while you feel you could wander about and study the different things with an interest. The walls are covered with pictures, plaques and all sorts of curios.[69]

Celeste Olalquiaga, like Sudjic, describes these objects – 'pictures, plaques and all sorts of curios' – as a material language, but a secret one that could only be decoded by those who understood and participated in the conventions of Victorian taste and judgement:

> The Victorian interior is an isolated space where the most cherished furnishings are meticulously arranged, side by side and on top of one another, creating an intimate dialogue between things which only those versed in these secrets can decipher.[70]

The opinion of those who could decipher the meaning of 'things', like Fanny Barbour, was a vital consideration to the construction of the room. This space was as much for them as it was the family itself. The middle-class home, especially the drawing room, was a contradictory public and private sphere. It was one in which visitors could assess the worth of the inhabitants via a profusion of furniture, knick-knacks, pictures, novelties, souvenirs, textiles, colour and pattern. The room was a crucial site of peer judgement, and simultaneously provided a

family with a theoretical safe haven into which they could retreat from public scrutiny and pursue a private life defined as modern, virtuous, tasteful, and individual. The Victorians identified closely with their belongings as a means to narrate a complex duality of social like-mindedness and distinctive personality. As explained by Deborah Cohen, 'a new confidence that possessions could communicate their owner's individuality made for a giddy period of acquisitive experimentation'.[71] Boyd's drawing room acquisitions defined its inhabitants as belonging to a shared middle-class identity, with sufficient individuality for the composite to be 'read' as personal, characterful and unique.

Reading the Drawing Room: A Gendered Space

> The more reputable, 'presentable' portion of middle-class household paraphernalia are, on the one hand, items of conspicuous consumption, and on the other hand, apparatus for putting in evidence the vicarious leisure rendered by the housewife.[72]

The Boyd drawing room elicits many of the attributes of Victorian feminine accomplishment that Veblen alludes to as 'evidence of vicarious leisure'. The arrangement of flowers, the embroidered antimacassars, and the sentimental display of keepsakes and curios on the corner whatnot, infer this was the home of a family whose matriarch was permitted the leisurely pursuit of decorating and home craft. Her obvious abilities could be read as proof of her domestic competence and the strength of her marriage. A well-managed and decorative home bode well for her husband, as one who could afford to reward a wife with leisurely diversions and material indulgences. Inside the drawing room, indeed inside the entire middle-class home, women were expected to reign supreme in a peculiar and contradictory frame of operation. To appear affluent they were required to be seen to be

gently idle, like Lucy Boyd, but simultaneously run the house with ruthless precision. Everything from the management of servants to the arrangements of ornaments, the participation in visiting rituals and the cultural education of children, all had to be managed from a perceived state of motionless grace. The interior had to be preserved as the still, quiet retreat from the outside world, a respite from the male arena of 'work', whether the agricultural management of the land or the white-collar employments of the city. Neither city nor bush was the place to nurture womanly virtues. Domestic interiors were. As Sabine Willis argues, 'a man's world was seen as a place of materialism without morality; a woman's purity derived from her seclusion in the sanctuary of the home'.[73]

Rocke, Wicken and Rawson would all contribute to the gendering of Australian domestic space. Rocke provided a male perspective. He, like his English equivalents, was a purveyor of the expensive goods women bought, and as such instrumental in influencing female taste from a male perspective. His was a grand, ostentatious approach that subscribed to all the excessive ornamentation of the Victorian era; a spectacle of big furniture, within big houses built by men with big money. Wicken would assert that the lower suburban domestic realm was the preserve of the middle-class woman. She celebrated home as a place of genuine womanly work, rather than one that hid domestic duties and home management beneath a fiction of inactivity. For Rawson, her particular acumen for fashioning a middle-class presence from the 'nothing' of the bush relied heavily on her adjusting and challenging the scripted behavioural protocols of Victorian womanhood. Her drawing room had no attending angel, but a woman whose skills in carpentry, upholstery and building was the match of any man. Linda Young notes: 'Middle-class compliance was not driven by money…

more critically, acceptance by peers required fluent participation in a core of beliefs and rituals'.[74]

In Boyd's drawing rooms we can see far more than a slavish compliance to English convention and the excesses of Victorian dwelling. They are valuable sites of belonging shared between a vast and geographically dispersed community, united in a modern economy of decorative consumption. Within them she preserves the complexities of colonial domesticity and offers a potential source of Australia's home-centred psyche. Her 'pretty' and 'meticulously detailed' representations of a suburban middle-class home are what Prime Minister John Howard a century later would consider 'a noble aspiration' and 'the heart of the Australian experience'.[75]

Equally the advice manuals of Rocke, Wicken and Rawson offer revealing insights into Australian identity, bound up in the same system of decorative semiotics and its careful delineation of class. How they differ from Boyd is that they orchestrated rather than just revealed the operational systems of middle-class interior culture. It was through their advice that an understanding of the 'core beliefs and rituals' of middle-class belonging could be gleaned. Through them, Australia's hybridised colonial middle-class could acquire the requisite knowledge to emulate rooms familiar to an empire-wide community of like-minded citizens. Into these they could confidently invite, without embarrassment or apology, others who subscribed to the same system of middle-class dwelling. Perhaps, somewhere, in the corner of one of Emma Boyd's drawing rooms, hidden beneath the plethora of objects and bibelots, lay the manuals that helped shape these rooms and the many others that quietly emerged from the Australian landscape as a potent but largely unacknowledged sign of colonial English hegemony.

MASCULINITY AND MAGNIFICENCE

W.H. Rocke & Co. and *Remarks on Furniture and the Interior Decoration of Houses*

In 1852, a mere 17 years from when John Batman and John Pascoe Fawkner begrudgingly agreed to a shared settlement on the banks of the Yarra River, father and son – George and William Henry Rocke – arrived in Melbourne from Wrexham in Northern Wales. By the time of their arrival Melbourne had already been declared a city by decree of Queen Victoria in 1847, and anointed capital of the newly established colony of Victoria in 1851. Robert Hoddle's famous grid of wide gracious boulevards and slender service lanes had been graded into the earth north of the Yarra along which were beginning to sprout the initial signs of a grand Victorian metropolis. The Victorian gold rush was well into its second year, drawing thousands of 'eminently adventurous and enterprising' residents into the colony.[76] Melbourne was awash with people, hope, money, ambition and the anxious civic vanity that comes with purposeful and successful settlement. If ever there was a city prepared to nurture a fledgling commercial enterprise

intent on providing its residents with the means to indulge their desire for aspirational materiality, Melbourne was it.

By 1854 George and William had established W.H. Rocke & Co. at 18 Lonsdale Street and immediately set about positioning themselves as the purveyors of choice for those seeking the best in decorative finery. Melbourne was, at this time, still quite a rudimentary settlement yet the Rockes were confident enough to believe their future lay in the exclusivity of fashionable novelties for the colonial drawing room. Their speculation was, as H. Mortimer Franklyn observed in *A Glance at Australia in 1880, or Food from the South*, well rewarded:

> Owing to the crude state of society in Melbourne at this early period of its history, the furniture used was of a very primitive and common kind, having no pretense whatever to grace or symmetry of form... As people began to settle on the lands, a greater demand for furniture began to spring up; and Messrs. W.H. Rocke and Co. were equal to the occasion.[77]

The 'crude society' of Melbourne in the 1850s would not hinder the Rockes in their pursuit of excellence in the furniture and decoration trade. This would mean pitting their skills against the acknowledged modern masters of mid-nineteenth century style and ornamentation: the English and the French. The Great Exhibition in London in 1851 would initiate a series of elaborate trade exhibitions, the scale and expense of which would position them among the most significant events of the nineteenth century. Walter Benjamin would describe them as 'places of pilgrimage to the commodity fetish' and in doing so acknowledge the nineteenth-century bourgeois obsession with the ownership of 'things', those surplus to need but valued for their positional status.[78] Alongside industrial machinery, enormous bales of wool and other commercial commodities, the exhibitions tempted their

audiences with a covetable array of personal domestic consumables: china, glass, fabrics, carpets, lighting, wallpapers and furnishings. The Rockes would exhibit internationally for the first time at the 1855 Paris Exhibition where their display was notably 'fitted up and furnished in a costly manner'.[79] This was to be the first of many exhibitions in which this young and ambitious enterprise would participate, securing awards and praise from critics and judges, and establishing their reputation as the premier provider of luxury goods in Melbourne. Franklyn assured his readers of the quality of the Rocke establishment's inventory, and its trustworthiness as an authority on taste, through reference to their awards:

> W.H. Rocke & Co. [have] the most extensive and elegant stock of first-class furniture, as well as carpets and general furnishings, that are to be found in the whole of Australia… As proving the position now held by W.H. Rocke & Co., we may state that recently they have had conferred upon them the appointment of first-class medalists, and holders of the diploma of the Grand Council of the Society of Arts, Letters, Science, and Industry, of Naples.[80]

W.H. Rocke & Co. clearly understood the nuances of modern retail practice and its reliance on publicity and reputation as much as stock and real estate.

Undoubtedly the store's most significant exhibition display was at the Melbourne International Exhibition of 1880–81. Its sumptuously furnished and decorated apartments were the rival of any European equivalent. Despite their set-like artifice within the Exhibition Buildings, the 'rooms' (FIGURES 1.1–1.2) displayed a comprehension of the highest levels of elite European dwelling: ornamental, luxurious, rich, confident and permanent. Via Rocke & Co., visitors to the exhibition were reassured that a southern geography did not deny

FIGURE 1.1. W.H. Rocke & Co., Exhibition Drawing-room (1880),
State Library of Victoria.

those wealthy enough the trappings of abundant materiality and the secure spaces in which to display it. They captured what Benjamin in the twentieth century would describe as 'the immemorial feeling of bourgeois security'.[81] These display suites were so luxurious – so bereft of any dispiriting meanness, melancholy or human tragedy – nothing bad could ever be imagined to happen within them. It was this 'security' that Rocke could offer his clientele; provided, of course, that they possessed the funds to afford it.

The Melbourne Exhibition was not only an event significant for Rocke, but also for the city at large. Within the expansive, purpose-built structure of the Exhibition Buildings in Carlton, Melbourne provided the visible proof of the strides it had made in its short 50-year history. It had risen from a 'crude' dishevelled settlement to a sophisticated and internationally competitive metropolis, capable of hosting, without fear of parochial embarrassment, the great nations of the

FIGURE 1.2. W.H. Rocke & Co., Exhibition Bed Chamber (1880),
State Library of Victoria.

nineteenth century. And, within such a city, a migrant aspirant like
Rocke could elevate himself with equivalent haste and admiration. In
1880, Franklyn would again praise the Rocke establishment and the
commercial heart of Melbourne:

> The latest changes in fashion, the freshest designs in furniture,
> are to be obtained in the greatest variety at Messrs. W.H. Rocke
> & Co., as well as glass, china, and so forth. There is nothing in
> Melbourne but the broader streets, the warmer atmosphere, the
> brighter sun, and the newness of the public and private buildings,
> to efface the impression that you are in an English city. Lines
> of omnibuses converge upon two centres of traffic adjacent to
> the railway station; carriages, with their liveried coachmen and
> footmen, are drawn up outside the principal drapers, jewellers
> and music-sellers.[82]

Rocke and his fellow traders were the visible evidence of a replica
English city that provided its burgeoning middle-class – complete

with their conspicuous liveried servants – the equivalent consumer opportunities as their English peers. The journalist and diarist Richard Twopeny, although generally more critical than Franklyn, would agree on the quality of Melbourne's retailers:

> The general run of shops are little better than in English towns of the same size, if we except those of some dozen drapers and ironmongers in Melbourne... which are exceptionally good. Of these it may be said that they would be creditable to London itself... Their shops are quite amongst the sights of Australia... Indeed Melbourne has decidedly the best set of shops, not only in outward appearance, but as to the variety and quality of the articles sold in them.[83]

The acknowledgment by both Franklin and Twopeny that Melbourne was a significant and thoroughly modern English-like city rests with their assertion that it was also one in which its residents could indulge their capacity for spending. The presence of W.H. Rocke & Co., and

FIGURE 1.3. Charles E. Winston, Wood engraving of the Rocke Showroom (1869), State Library of Victoria.

the other 'drapers, jewellers and music stores', demonstrated a sophisticated city well versed in the semiotics of a modern commodity-driven economy. Shopping had, by the mid-nineteenth century, evolved into an activity both pleasurable and critical to middle-class identity. To wander the galleried premises of W.H. Rocke & Co. was a leisurely act. It was not an activity essential to survival, but critical to establishing, maintaining and parading one's class status. As Andrew Montana explains, the Rocke store indulged 'the pretentions of the gold generation, the enfranchised squattocracy and the city merchants and professionals'.[84] The financial capacity that enabled the acquisition of ornamental domestic items clearly identified these Victorian consumers as belonging to a middle class, well above that of servant or poorly paid labourer. But the vast array of expensive furnishings and bibelots available through the Rocke store also permitted them the opportunity to position their wealth and rank in relation to each other, through what Veblen described as a 'selective process'.[85] Rocke's customers could selectively choose – or selectively eliminate – class affiliation via the price, exclusivity, quantity and quality of the goods they purchased. The upper middle class could certainly afford Rocke's high-end bounty. The lower orders, however, needed to affirm their identity as best they could through lesser quality goods or simply fewer of them.

In 1862 the elder Rocke, George, would return to Britain, but his now 26-year-old son, William, would remain to grow the business into one of the finest furniture emporiums in the colonies. W.H. Rocke & Co. opened its new showrooms at the far more salubrious address of 40–42 Collins Street in the same year. In 1863 William formed a partnership with the auctioneer Horatio Beauchamp and traded as Beauchamp & Rocke, with Beauchamp's auction rooms adjoining the

Rocke premises at number 38, next door to the imposing edifice of the Bank of Victoria (FIGURE 1.4). This establishment would be consumed by fire in 1866 but rebuilt on the same location in a grander, less provincial style (FIGURE 1.5). On January 4, 1869 *The Australian Illustrated News* published engravings of the new premises that:

> show the march of improvement in our colonial industries and the capabilities we possess of manufacturing articles for which only a few years ago we were entirely dependent upon the mother country... It reflects credit on this firm in having expended so large an amount of capital in aiding to develop this branch of colonial industry, and we trust they meet with merited success.[86]

Ten years later, Rocke had his premises extended further by the architect George Wharton (FIGURE 1.6). The height of his premises was keeping pace with the grand vertical streetscapes of modern Melbourne,

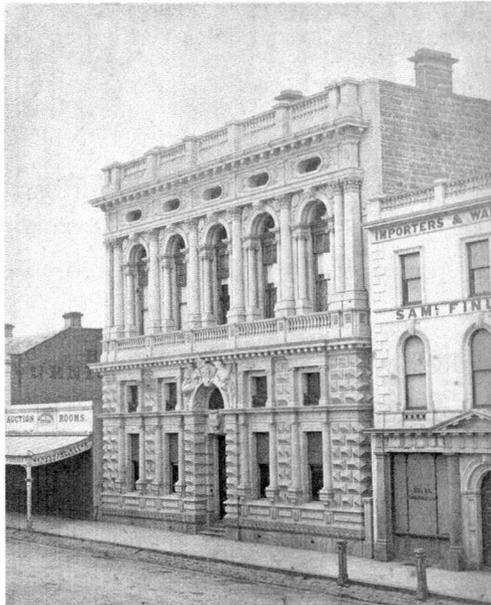

FIGURE 1.4. Bank of Victoria (c.1863), State Library of Victoria. Photographer unknown.

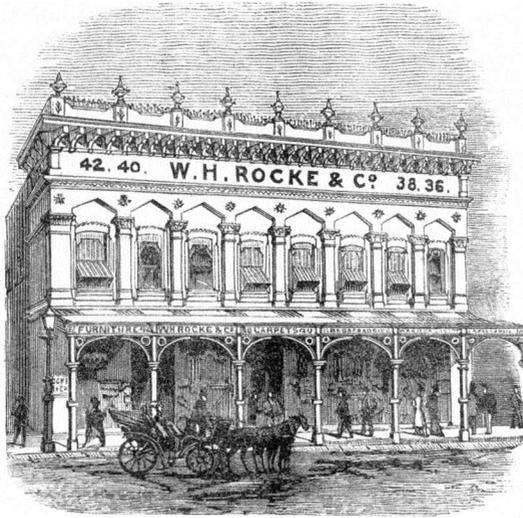

FIGURE 1.5. W.H. Rocke and Co., Furnishing Warehouses,
Collins Street. Wood engraving (1878), State Library of Victoria.

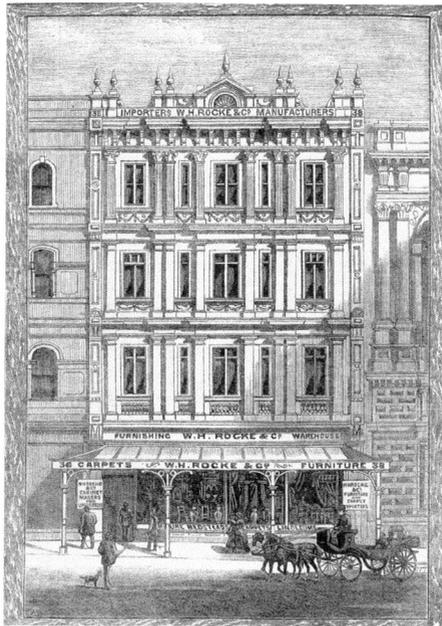

FIGURE 1.6. George Wharton and Albert Charles Cooke,
wood engraving of the new Rocke store (1883), State Library of Victoria.

a city now entirely unrecognisable from the dusty colonial settlement he arrived in only 25 years before. With extensive property in an exclusive stretch of Collins Street, William Rocke could proudly claim his 'success', and his position as equal to those he counted as customers. In 1880 he employed 150 workers; paid out £13,000 in wages; his acre of Collins Street real estate was valued at £40,000; and the stock it held, an astonishing £70,000.[87] When an average annual middle-class wage hovered at £200, Rocke was indeed a wealthy man, not merely an agent for the material needs of fortunate others. He was a member of a new antipodean order of good fortune. Unlike Britain where middle-class aspirations were pitched against the insurmountable riches of the aristocracy, the middle class in Australia were among its highest rank of citizen. Short of those who took office as governors, and the occasional visit by lesser royals, Australia was largely untroubled by the physical presence of the aristocracy, leaving the middle class to assert an English social construct and assume the roles of moral bastions, civic leaders and community builders. Rocke could count himself among them. As such, his authority on decoration was respected as that of a peer, not a lower-order shopkeeper. The great homes of Melbourne that had begun to identify the rank and status of its residents by the 1870s and '80s were not all owned by doctors, judges, financiers and bankers. 'Illawara' (Toorak, 1889) was the trophy home of Charles Henry James, a one-time North Melbourne grocer; and 'Ripponlea' (Elsternwick, 1860–80), the epicentre of Melbourne's society set, was the domain of Thomas Sargood, son of a city draper and himself a one-time warehouseman.

Importantly, theirs was wealth borne of the virtuous endeavour of 'work', not inherited privilege. In Australia hard work was valorised at every social level. Wage earning was a source of respectable identity for

men, and, as Linda Young explains, conveniently integrated 'necessity' with 'honour'.[88] Be it the nation-building efforts of the pioneer, the industry of trades, or, like Rocke, the managerial acumen that provided employment to a multitude of craftsmen, 'work' was the means by which colonial migrants could assert a life better than the one they had left behind in England.

W.H. Rocke & Co. would outlive its founders and survive well into the twentieth century. Following William's premature death at 46 in 1882 from Bright's Disease, W.H. Rocke & Co. was sold two years later to notorious land speculator and property investor Benjamin Fink. Fink already owned Wallach Bros Department Store, and the acquisition of Rocke made him the owner of the most salubrious purveyors of luxury goods in the colony. Fink would add to his retail portfolio with the construction of the Block Arcade, but the land crash of the 1890s would see the ruination of Fink and his sudden skip to London to avoid his creditors. Nonetheless, both the Rocke name and establishment remained untarnished.[89] Eventually all its stock was purchased by the Myer Emporium in the mid-1930s, having survived 80 years and spanned two centuries of changing taste and opinion. But the height of Rocke's influence over the city's elite interiors dates from the 1870s when his seductive discourse on Victorian furnishings appears in *Remarks on Furniture and the Decoration of Houses*.

The Victorian Domestic Advice Manual

Undoubtedly W.H. Rocke & Co. has secured its place as a reputable maker of quality in the history of furniture and ornamentation in Australia. Andrew Montana in his article 'Stylists for the Nineteenth Century' (2012) referenced Rocke as a genuine competitor to high-end English furniture exporters Smee & Sons and Gillows. They,

along with Rocke, found favour among the Melbourne establishment of the nineteenth century. Montana speculates that the presence of Rocke & Co. at the 1880 Melbourne International Exhibition may well have contributed to Smee and Sons' decision to not exhibit when they had readily done so at the Sydney exhibition the year before. The competition from such an accomplished colonial local was perceivably too great to warrant the expense of establishing a stand. Praise for Rocke's exhibition rooms in the English publication *Cabinet Maker & Art Furnisher* provides both Montana and Tracey Avery evidence of a local manufacturer who turned the heads of English critics at the 1880 Melbourne International Exhibition.

> It might naturally be imagined that in a 'young country' the reception rooms would receive lavish attention, but that 'anything would do for the bedroom.' We must confess to astonishment in inspecting the class of furniture 'turned out' by the Melbourne manufacturers… this [is a] new era of independence in colonial cabinet work.[90] ('Furniture at the Melbourne Exhibition. Messrs W.H. Rocke and Co.'s Exhibits', *Cabinet Maker & Art Furnisher*, April 1881)

The Rocke company, as both Montana and Avery have identified, produced work of exceptional quality that easily usurped much of the inferior product that was readily shipped to Australia from Britain, in the mistaken belief that colonial needs and middle-class aspirations were somehow lesser, and content with second-rate manufacture. Avery observed, 'Britain's apparent reluctance to send more middle-class and better-class furniture… suggests an inability to imagine the social mobility of migrants when they became financially successful in Australia'.[91] For Rocke, this was a tactical advantage that ensured a constant parade of newly wealthy customers through his Collins Street premises.

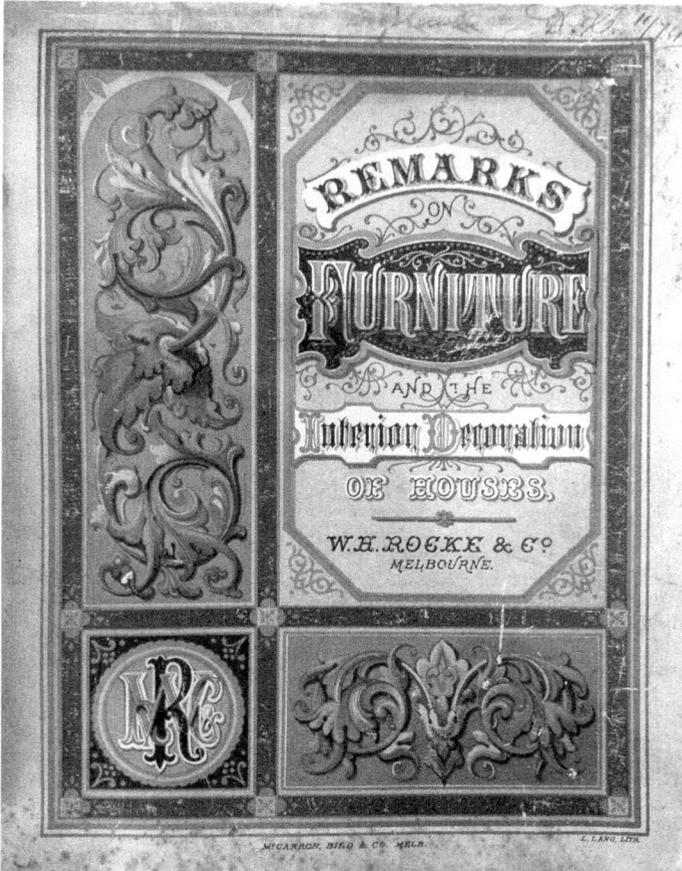

FIGURE 1.7. W.H. Rocke & Co.,
Remarks on Furniture and the Interior Decoration of Houses (1873),
State Library of Victoria.

It is, however, Rocke's much undervalued document *Remarks on Furniture and the Interior Decoration of Houses* of 1874 (FIGURE 1.7) that forms the principal focus of this chapter. The book belongs to a vast body of advice manuals and popular journals that proliferated throughout the Victorian era that ensured the material aspirations of the upwardly-mobile middle class of Great Britain were consistently applied throughout both the homeland and its colonies. The burgeoning

wealth and leisure of the middle class that began in eighteenth-century Britain had, by the Victorian period, escalated to a vast population of English and colonial well-to-do whose familial provenance had not, according to many contemporary critics, equipped them for the aesthetic responsibilities that came with a disposable income. The new rich, monetarily enabled by fortunes made from manufacturing, agriculture, mining and canny investment – not aristocratic inheritance – required documentary aids to guide their good taste in a sea of ever bewildering choice. Good taste, as some believed, was 'the peculiar inheritance of gentle blood, and independent of all training'.[92] The middle classes, however, required education.

Cassell's Household Guide to Every Department of Practical Life (1869) firmly situated the necessity for good advice in the elevated circumstances of middle-class Britain. 'Civilised' behaviour was increasingly governed by complex rules and expectations; and proper social conduct relied on an astute comprehension of these. 'Home' was at the very core of its education and was the space from which all good behaviour would emanate.

> In an age when, owing to the spread of education and the consequent growth of intelligence and of competition, the affairs of human life are becoming in every department more intricate and complicated, no apology can be needed for an endeavour to set out accurately, and in something like scientific order, the laws which govern, and the rules which should regulate, that most necessary and most important of all human institutions, THE HOUSEHOLD. It is there that the fruits of man's labour are ultimately enjoyed; there that woman finds her chief sphere of duty; there that the coming generation is being trained for the duties of life.[93]

Alongside Cassell's were other familiar manuals that collectively constructed a household library of English domestic advice. These included Isabella Beeton's *Book of Household Management* (1861), Charles Eastlake's *Hints on Household Taste in Furniture, Upholstery and Other Details* (1868), and the popular *Art at Home* series that included Lucy Orrinsmith's *The Drawing Room: Its Decorations and Furniture* (1877), Mrs Loftie's *The Dining Room* (1878) and Lady Barker's *Bedroom and Boudoir* (1878).

In 1868, six years prior to the release of the Rocke document, Charles Eastlake published *Hints on Household Taste in Furniture, Upholstery and Other Details*.[94] The Eastlake guide is arguably the most significant manual to later nineteenth-century English interiors, and set the fashion for learning the principles of 'tasteful habitation' from masterful (male) authority. Eastlake was well-bred and well-connected: the son of an admiralty law agent and judge-advocate, and the nephew of the painter and director of the National Gallery of London Sir Charles Lock Eastlake. He was an architect, secretary to the Royal Institute of British Architects (1866–1877) and eventually himself Keeper of the National Gallery of London from 1878 to 1898. As such, he cast his advice and aspersions over the popular fashions of Britain from a position of 'knowing'.

The British Empire had, by the time of Eastlake's publication, grown enormous, wealthy and socially complicated. No longer was it a simple division of ruling class, merchant and poverty. The middle class had grown with the empire both in size and wealth. It was itself a complex division of levels of belonging, governed by convoluted rules of good behaviour, taste and etiquette, the understanding and practice of which separated the upper from the lower orders of middle class. To elevate one's status from 'lesser' to 'higher' required an education

in 'honourable' living. Honourable living, as described by Veblen, was a lifestyle above 'the element of exploit, and especially those which imply subservience or submission, [which] are unworthy, debasing [and] ignoble'.[95] An honourable lifestyle was one which could be seen to be guided by the acknowledged rules of Victorian decorum and dignity, and only afforded by those who occupied the social positions above labourer and servant. Guidance within this convoluted landscape of belonging could be secured by following the advice of trusted manuals, not, as Eastlake bemoaned, the vagaries of fashion or the sales pitch of shopkeepers.

Eastlake deemed it essential that the new wealth of Britain curtail its taste for flamboyant fancies and the frivolous mass-produced ornamentation then readily available from high street promenades. These accoutrements, he believed, did little in the way of elevating popular taste or representing individual connoisseurship, but simply corrupted 'a national and unperverted tradition in design' and contributed to the 'extravagant and graceless appointments of the modern boudoir'.[96] He continues: 'It is a lamentable fact that this very quality [of taste] is commonly deficient, not only among the generally ignorant, but also among the most educated classes'.[97]

Eleven years later Lucy Orrinsmith would restate the claim that good taste could, and did, evade the well-to-do:

> There are plenty of errors in taste to be found in the mansions of the rich, and if wealth cannot do what we require, neither can intellect, without special culture... we must be aware that numbers of persons of knowledge and refinement – often, too, admirers of all that is good in art – are apparently content to sit down at home surrounded by ugly form, bad colour, and conventional deformity.[98]

16

The education of 'taste' as reflected through middle-class interior decoration remained a popular and lucrative topic for critics and advisors through to the end of the nineteenth century.

Eastlake's 1868 guide is undoubtedly informative but by contemporary standards appears pompous, condescending, patronising and sexist. To Victorian readers, however, it was the last word on purposeful decoration and informed, tasteful habitation. Before dispensing his advice he established the reason his book should exist at all: blame for the tasteless descent of the English interior lay firmly at the feet of women and their inability to resist the currency of fashion and the persuasive banter of upholsterers, furniture dealers and haberdashers.

> When Materfamilias enters an upholsterer's warehouse, how can she possibly decide on the pattern of her new carpet, when bale after bale of Brussels is unrolled by the indefatigable youth who is equal in his praises of every piece in turn?... The shopman remarks of one piece of goods, that it is 'elegant'; of another, that it is 'striking'; of a third, that it is 'unique', and so forth. The good lady looks from one carpet to another until her eyes are fairly dazzled by their hues. She is utterly unable to explain why she should, or why she should not, like any of them... In this dilemma the gentleman with the yard-wand again comes to the rescue, imparts his firm opinion as to which is most 'fashionable', and this at once carries the day. The carpet is made up, sent home, and takes its chance of domestic admiration together with all other household appointments. It may kill by its colour every piece of tapisserie in the room. It may convey the notion of a bed of roses, or a dangerous labyrinth of rococo ornament, but if it is 'fashionable', that is all-sufficient. While new, it is admired; when old, everybody will agree that it was always 'hideous'.[99]

Fashion and its ever-fluctuating reinvention and mass appeal to contemporary consumers was, for Eastlake, at the very root of Britain's aesthetic decline. Again Orrinsmith in the following decade would

continue to rue the curse of fashion and change: 'The latest thing of the day, be it even an old fashion revived, offers irresistible charms to some; but it should not be forgotten that frequent change of fashion is the most fertile source of inferiority'.[100] What is immediately obvious from both Eastlake and Orrinsmith's forthright opinions is that 'taste' was a procurable and desirable middle-class asset, but one that could not be simply purchased from stores nor defined by the fashion of the day. 'Taste was defined as an objective matter which could be achieved by obeying general principles of decoration', and was therefore learnable.[101] 'Indeed, instruction in taste was a moral necessity precisely because things had the power to influence people for good or for ill', explains Deborah Cohen.[102] Like any purposeful education, good taste was an intellectual pursuit; and sale-hungry retailers and their easily-wooed customers were the hindrance to its successful acquisition. Stemming the flow of poor taste – and thus moral depravity – lay in public education and the nineteenth-century advice manual would provide its most accessible and portable tool.

Eastlake's *Hints* became so influential it had, by 1887, gone through four editions in Britain and six in the United States. While he produced editions specifically for the American market, no special issue was deemed necessary for Australia. Good British taste was, after all, without domain. What was good for Britain was good for Australia. In 1879 Farmer & Co. in Sydney credited Eastlake for ending 'the mahogany reign of terror' evident in heavy and elaborately carved Victorian furniture.[103] The Eastlake endorsement was used to promote their new range of 'art furniture' that encapsulated his insistence on 'simplicity, rectangularity, and honest craftsmanship'.[104] Intriguingly the collection included a locally made 'Orrinsmith Cabinet', named

after Lucy Orrinsmith, such was the familiarity and influence of the authors in the colonies.

Undoubtedly W.H. Rocke and Co. would have been aware of the Eastlake manual. While their production of *Remarks on Furniture and the Interior Decoration of Houses* sits simply as another of the journals and manuals that proliferated throughout the later nineteenth century, it is perceivably also a reaction against them, in particular Eastlake's *Hints*. For Eastlake, the likes of Rocke were the enemy of good taste, and dismissively referred to throughout his book as simply 'the shopman'.

> In a large establishment... the eye is positively bewildered by a multitude of objects... I have seen people in such shops perplexed and wearied with inspecting one article after another, as the shopman drones out his oft-repeated remarks that this is 'elegant', that 'very handsome', the other 'just the thing for a drawing-room', and so forth.[105]

He continued:

> never attach the least importance to any recommendation which the shopman may make on the score of taste. If he says that one form of chair is stronger than another form, or that the covering of one sofa will wear better than that which is used for another, you may believe him, because on that point he can judge... But on the subject of taste his opinion is not likely to be worth more, but rather less, than that of his customers, for the plain reason that the nature of his occupation can have left him little time to form a taste at all... If he has any guiding principles of selection, they are chiefly based on two considerations; the relative price of his goods, and the social position or wealth of those customers in whose eyes they find favour.[106]

Such candid and brutal admonishment of the ability of retailers to advise on taste as much as manufacture would certainly have induced retort. While the Rocke document does not mention Eastlake directly,

there is little doubt as to who its criticism of Gothic design is aimed at. Eastlake, along with Pugin and Ruskin, thoroughly endorsed the revival of the English medieval aesthetic and the proud English integrity they considered lay in its adoption through both architecture and the interior:

> Mr. Ruskin has eloquently described to us the poetry of mediaeval art; Pugin and other writers have shown its practical advantages. It remains for the rising generation of architects to profit by the labours of these able apologists, and to show their patrons that the prevailing taste has not been called forth by the whims of a clique or the blind passion of an antiquary, but that, while based on the sound artistic principles of early tradition, it may be adapted to the social habits and requirements of the present age.[107]

Rocke disagreed. Gothic was 'quaint', but incapable of reflecting the luxury of modern adornment. Its effect was oppressively religious, appealing only to a minority elite, and unable to indulge the mass Victorian desire for sumptuous comfort:

> A word about those Gothic designs for drawing-room furniture which are so highly popular in certain, somewhat limited circles. Modern art has done wonders in imparting to ordinary drawing-room, as well as dining-room, and even bed-room fittings and decorations that quaint medieval aspect, which, albeit consistent with the utmost elaboration of ornament, is frequently marked by a tone, more or less, ecclesiastical.[108]

Unlike Eastlake's prickly condescension and dismay at the appalling taste of the public, which he derided as 'a body, utterly incapable of distinguishing good from bad design', Rocke applauded his audience for their sophistication and desire for domestic betterment.[109] Rocke positioned his book as 'guide, philosopher and friend' to those 'whose sufficient means and imperious good taste demand the higher style of

ornamentation'.[110] Rocke clearly understood his customer. The modern consumer had come to expect flattery and a multiplicity of choice rather than criticism and restraint.[111] The language used throughout the document is one of comforting embrace, but also exclusion. Rocke was *not* for everyone. While there is scant reference in the document that the store catered for a variety of purses with 'all the possible require-ments for the most modest as well as the most sumptuous household', its clientele was the colonies' moneyed elite; 'the pastoral prince [and] mining millionaire'.[112] *Remarks on Furniture and the Interior Decoration of Houses* deserves closer observation not merely as a local example of the ubiquitous nineteenth-century advice manual that dared to proffer a contrary opinion to one of the leading experts of the day, but one in which language is a carefully honed tool of social and commercial exclusion.

Literacy and the Victorian Consumer

It is important to establish that *Remarks on Furniture and the Interior Decoration of Houses* is not a catalogue of wares. While reference is made to their product, and two pages are dedicated to photographic reproductions of display suites from the store, the focus of the document is literary. It is rich with abundant Victorian hyperbole and laced with carefully chosen quotations throughout. This is not a document intended to persuade everyone to peruse their wares as a common catalogue might do. Its density of Victorian prose and the quotations were intent on singling out a very specific class of reader and clientele.

Literacy had undoubtedly improved throughout Victoria's reign and was reflective of the dramatic changes occurring in both social and economic domains. Increased literacy had shifted reading from an expensive privilege of the rich in the early nineteenth century to

an activity that engaged everyone from servant to mistress by the century's end. The Education Act of 1870 in Britain, and equivalent legislation in Victoria in 1872, formalised compulsory, free education and undoubtedly improved literacy throughout the UK and its antipodean colony. But the complexity of the English social classes was also reflected in the style of reading matter offered to them. The lower orders would indulge in cheap sensationalist penny-dreadfuls, weekly instalments of a story that would progress without conclusion until the public simply grew bored with it. The Bible and the works of respected Victorian novelists satisfied the literary needs of the middle class. Interestingly, a taste for the work of Dickens traversed both the lower and middle classes, but not without anxiety. Patrick Brantlinger, in his assessment of *Oliver Twist*, claims Dickens's capacity to publicly expose the situation of the underclass, which included criminals, presented not only a threat to the material comforts of the middle class but also their lives. Dickens's decision to publish his stories in mass, inexpensive instalments meant the very class he was raising awareness of could also be 'taught' the ways of the criminal behaviour which included theft, deceit, and even murder.[113] For learned Victorians, the carefully delineated class structure that had been the backbone of English society for centuries was perceivably now under threat by literacy, as even the criminal class could now read and learn. To delineate themselves from the classes below, the upper middle class would engage with texts of the highest moral tones, and for entertainment 'silver fork' novels written by contemporaneous well-to-do authors like Lord Bulwer-Lytton that detailed the affairs and complex relationships of high society and provided their (largely female) readership with suitable models of refined behaviour.

The Victorian era would witness an enormous rise in printed publications – newspapers, journals, novels, pamphlets and Bibles – as a direct result of inexpensive, industrialised printing and improved public literacy. But not all Victorian commentators favoured this new-found access to reading. Alfred Austin (1835–1913) was a London barrister, poet, and eventually Poet Laureate. Despite his literary credentials and editorship of the *National Review* he vehemently opposed reading among the masses and believed it to be a socially disruptive influence.

> Reading has become a downright vice – a vulgar detrimental habit like dram drinking... It is a softening, demoralizing, relaxing practice which, if persisted in, will end by enfeebling the minds of men and women, making flabby the fibre of their bodies and undermining the vigor of nations.[114]

Others applauded the democratisation of books and their easy reach of every level of society. Martha Loftie wrote in 1878, 'in a parlour books ought to have an honoured place. It is where the family work and play; and instead of being allowed to appear untidy and neglected, it should represent that culture and refinement which is now happily within reach of almost everyone however poor'.[115] However, Loftie's defence is somewhat protective of her own position as a successful author and that of her husband as her publisher.

Amid the prolific collection of Victorian print genres were the advice manuals, like Loftie's *The Dining Room*, that helped orchestrate and systematise the social practices of the day. Their audience was, quite definitively, the middle class, those thousands of Britons and colonials who could, for the first time, aspire to social betterment and class elevation. They did, however, require trustworthy manuals to advise on their progress. For this reason advice manuals were largely spared the venomous criticism levelled at the 'sewer' of mass-market literature

that threatened the moral standing of Britain and her dominions.[116] Advice manuals promoted the acquisition of knowledge and self-improvement in preference to the corruption of idle novel reading and pointless make-believe. And, despite their numbers, none ventured from the familiar trope of domestic virtue, its reflection through the home, and its ordinance presided over by women.

In her examination of nineteenth-century domestic advice manuals, Sarah Leavitt closely aligns their structure to that of novels. A familiar structure – a table of contents, the characterisation of furniture as having moral qualities such as 'honesty' or 'purity', and the positioning of the reader as a 'heroine' – associated women in particular with advice manuals.[117] Leavitt argues:

> The close connection with novels gave domestic-advice manuals a familiar literary form. This format probably helped women readers to understand the emerging genre and to know what to expect. The dozens of domestic-advice manuals published in the decades after 1830 followed a clear pattern, established to guide women readers through the house.[118]

There does exist an odd dichotomy in Victorian advice manuals. While at once valued for their ability to provide many with guidance towards self-improvement and genteel behaviour, those who were genuinely well-bred had no need of such books. Their behaviour was learned from childhood by emulating the society to which they already belonged by right of birth. For them, advice manuals simply provided the cheat-sheet for a mass of aspirant wannabes and fraudulent imposters fluent in codes of behaviour and aesthetic appreciation. As such the books challenged the presiding Victorian concept of 'knowing one's place' and the strict maintenance of social ordering. Such complexities were particularly prevalent in colonial environments where one's true

identity could be left thousands of miles away in England, and simply reinvented on arrival with no-one able to challenge any self-possessed claim to status.[119]

In 1859 Samuel Smiles wrote *Self Help, With Illustrations of Character and Conduct*, the ultimate English guide to negotiating the complicated path to (masculine) Victorian betterment. Within it he lamented the desire for gentility at the expense of truth:

> There is a dreadful ambition abroad for being 'genteel'. We keep up appearances too often at the expense of honesty, and though we may not be rich, yet we must seem to be so. We must be 'respectable' though only in the meanest sense – in mere vulgar outward show... What waste, what misery, what bankruptcy come from all this ambition to dazzle others with the glare of apparent worldly success.[120]

Australia's own 'Old Housekeeper' was equivalently scathing of falsified gentility. In *The Australian Housewives' Manual: A Book for Beginners and People with Small Incomes* (1883), she wrote, 'What can be more miserable than those wretched little makeshift, shabby-genteel homes one constantly sees among shiftless people, where nothing is what it pretends to be, and nothing is large enough for proper use'.[121]

Traversing the perimeter of a 'proper' knowledge of taste, material-ity and good behaviour, could, we were warned, so easily tip into the treacherous zone of pretence, falsity and vulgarity. Trusted man-uals in both England and Australia were essential to navigating this socially perilous path. Rocke's advice would position the importance of things – furniture, textiles and ornaments – as the requisite chattels essential to locating oneself at the centre of impeccable taste, far from the contested borders of tawdriness and pretence.

Remarks on Furniture and the Interior Decoration of Houses (1874)

Remarks on Furniture and the Interior Decoration of Houses is not large. At only 54 pages it is a self-confessed 'little brochure'.[122] It is, however, far richer in content than its size suggests. As indicated previously its language is high Victorian, that peculiar syrup of sycophantic compliment, and exclusionary class-encrusted language intent on separating privilege from riffraff. Its opening page is an 'Envoi'.[123] Immediately Rocke positioned his book, and therefore his premises, with the educated classes who were privileged enough to be able to decipher the meaning of foreign words, and excluded those whose literacy hovered only among common English phases. It implores those readers whose education is beyond a basic one to recall their knowledge of French, the long-respected language of aristocracy. For them, the ample sprinkling of *carton-pierre, déshabillé, salon, entremets, boudoir, jardinière, prie-dieu, papeterie, pendule* and *berceaunette* presented no literary intimidation. It permitted the 'correct' reader the right to indulge their knowing, and revel in the exclusivity of language that separated them from a less deserving underclass. Language was an important consideration in the successful translation of class-based ideals from Britain to Australia. As explained by Tracey Avery:

> The choice of words suggest that house size, room use, and the brand names of furnishing items were distinguishing features, legible to contemporary readers. As similar descriptors can be found throughout literature of the period, it could be assumed that consumers, both British and colonial, were familiar with terminology which linked house furnishing and class.[124]

The book is divided into chapters that reflect the real-estate privilege of the rich. Rocke provided the chattels for every conceivable

room, from the expected drawing room and dining room, to library, breakfast room and the ultimate in male indulgence, the smoking room. These latter rooms were spaces of privilege and luxury, afforded only by the elite who had amassed parcels of land big enough to build trophy homes filled with rooms unnecessary to survival, but essential to colonial pretension. Rocke would simply aid their desire to match their monetary wealth to equivalent material luxury; a far more conspicuous demonstration of worth than the secrecy of ledgers and bank accounts.

As an artefact the Rocke book is as sumptuous as the interiors he provided. Just as he employed the most accomplished cabinetmakers and artificers in his decorative schemes, he applied the same diligence to the production of his book.[125] The cover was designed and printed by Melbourne's leading lithographer, the German born Ludwig Lang (1834–1919). Lang is clearly acknowledged on the cover. Lang was, after all, a significant colonial artist, not a common everyday printer. The cover, and its acknowledgment of artistic authorship, ensured the book transcended any dismissal of it as 'ordinary'. As Michael Rock suggests, naming the maker 'legitimizes [the] design as equal to more traditional privileged forms of authorship'.[126] The Rocke cover, through acknowledging its creator, lifted the entire publication to Lang's plane of artistic expression and above a familiar but forgettable product of commercial endeavour.

Lang produced a design in a rich palette of Victorian colour: emerald green flourishes are entwined with pink, violet and scarlet on a golden background. The composition was undoubtedly influenced by Owen Jones's *The Grammar of Ornament* (1856), the extensive Victorian catalogue of graphic adornment that influenced the print industry as much as it did the decoration of spaces. The ambition of the Jones

catalogue was to curtail the random and unfiltered selection of any and every decorative form, and to encourage the use of those that were harmoniously located within stylistic or historic frameworks. In the forward to his book, Jones wrote:

> I have ventured to hope that in... bringing into immediate juxta-position the many forms of beauty which every style of ornament presents, I might aid in arresting that unfortunate tendency of our times to be content with copying, whilst the fashion lasts, the forms peculiar to any bygone age, without attempt to ascertain, generally completely ignoring, the peculiar circumstances which render the ornament beautiful because it was appropriate, and which... when thus transplanted, entirely fails.[127]

While clearly influenced by Jones's catalogue, Lang's composition is one of deliberate ornamental saturation, rather than a careful celebration of the cultural and historic significance of the forms lavished on the page. Elizabethan scrolls, marbled borders, a magnificent Gothic monogram and modern ornamental type coalesce within the same frame; just as the mix of historical styles did within the high-end interiors that Rocke decorated. Walter Benjamin described the 'eclecticism' of the nineteenth-century interior as the 'reign of a type of furniture that, having capriciously incorporated styles of ornaments from different centuries, was thoroughly imbued with itself and its own duration'.[128] The same can be said for the cover of Rocke's book. Superfluous ornaments drawn from a historical but disparate collection of styles were coaxed into a happy compositional union. And, importantly, the composition reflected the self-important, historically eclectic interiors procurable from the Rocke store. As explained by Anca Lasc:

the theatricality of the rooms, the accurate rendition of another world or period style, as well as on the creation of holistic design schemes could promote imaginary time-travel... carefully orchestrated decorative ensembles guided by the rules of historic revivalism and themed décor, attempted to create a collection of different times and places through interior decoration.[129]

In 1885 the Melbourne society journal *Table Talk* previewed 'Villa Alba', the sumptuous Kew home of William Greenlaw, and extensively furnished by W.H. Rocke & Co. The entrance hall was 'in the Italian style... the marble floor... is here and there covered with Indian and Persian rugs'.[130] The drawing room decoration boasted a valance of 'fine drapery of turquoise blue ground with a Japanese design in terra cotta and olive'.[131] A portion of the over mantel 'is in the Adams style'.[132] The dining room 'is in the Medieval style' and the breakfast room 'is Italian Renaissance'.[133] Mrs Greenlaw's boudoir window 'is fitted up with a Moorish archway... the roller blind [is] of fine embroidered Syrian handwork'.[134] As *Table Talk* concluded, it was 'a bewildering wealth of decoration'.[135] The cover of Rocke's book is the graphic synopsis of the Greeenlaws' abundantly decorated abode. And both are the products of talented craftsmen that Thad Logan describes as 'the most ingenious, most exhaustive and most fantastic race of elaborators'.[136]

Importantly, Lang's 'fantastically elaborate' lithography would ensure the book would take its place in the correct apartments of the house: the drawing room, parlour, boudoir or morning room. Its elaborate coloured ornaments and glints of gilt would ensure it, like its readers, did not find service in the kitchen or other rooms of utility. It was a beautiful artefact that could confidently take its place amid the profusion of 'things' that codified high Victorian dwelling.

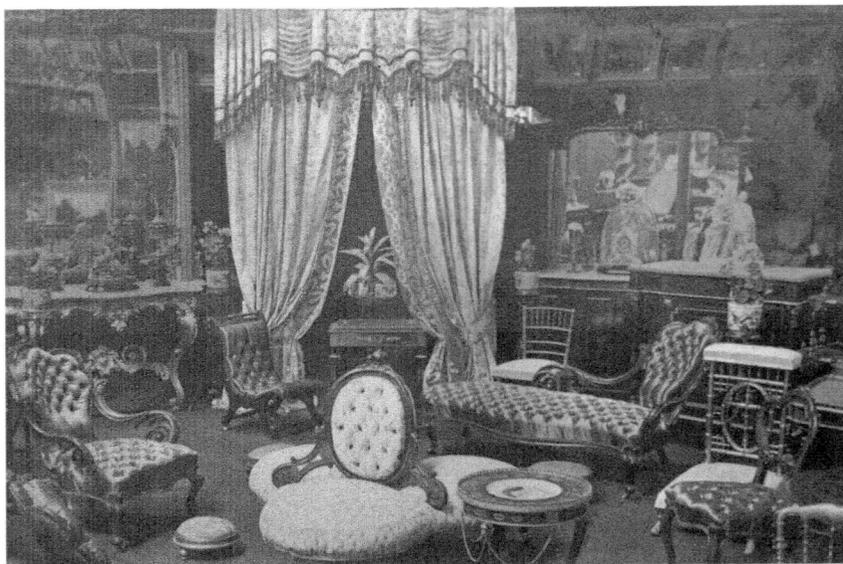

FIGURE 1.8. Joseph Parkin Mayal, 'Drawing Room Group', in *Remarks on Furniture and the Interior Decoration of Houses* (1873), State Library of Victoria.

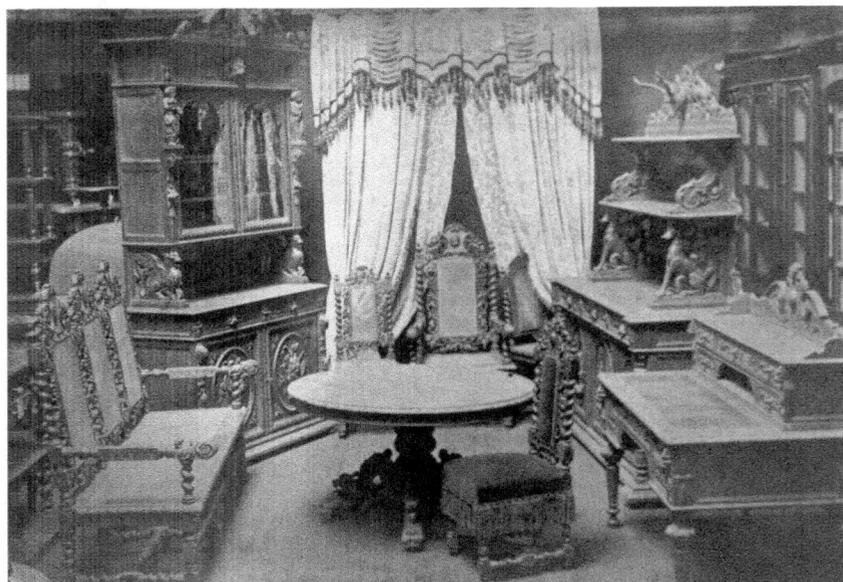

FIGURE 1.9. Joseph Parkin Mayal, 'Carved Group' in *Remarks on Furniture and the Interior Decoration of Houses* (1873), State Library of Victoria.

Its appeal would have been as ornament as much as literature, its materiality a prompt to the fetishism of Victorian collecting. But here, too, Rocke would be bound in the confusing duality of nineteenth-century literacy. A book's content, it was believed, should transcend the cover. The virtue of the words should be the marking of excellence in a book, not its elaborate binding or cover design. Being conscious of the book's material qualities signified either moral shallowness on behalf of its owner, or an absence of worthy content on behalf of the author.[137]

However, within the Australian context, the Rocke cover design represented the heights of colonial achievement and modernity. Here, in a city so far from the acknowledged centres of cultural production, a book of such lavish qualities was able to be made. The lithographic reproduction was equal to any to be found elsewhere in the world, much like the Rocke furnishings that could rival the best imported furniture from Europe and America. The insertion of two sepia photographs lifted the book to another level of modern print production. The interiors were photographed by Joseph Parkin Mayall, who had opened a Collins Street branch of his father's salubrious London studio in 1870. Images in publications were traditionally etchings or woodcuts. But here, the modern chemistry of photographic reproduction is exploited to present in acutely accurate detail the Rocke vision of interior splendour (FIGURES 1.8–1.9).

The Endorsement of Learned Others: The Rocke Quotations

While further investigation of the self-authored Rocke text will follow later in this chapter, it is the careful selection and ample use of quotations from other writers familiar to the educated Victorian

that are to become the focus of the ensuing text. Rocke gleaned his quotes from, among others, Shakespeare, Lord Byron, Lord Lytton, William Makepeace Thackeray, Charles Dickens, Thomas Carlyle, John Ruskin, Owen Jones, Dr Henry Chavasse, George Augustus Sala, and the Americans Edgar Allen Poe and Henry Wadsworth Longfellow. Through skillfully and selectively sifting through the words of these eminent men of letters, Rocke had aligned his own prose, and subsequently his interior wares, with the high culture of educated Victorian society. By so doing, he also elevated himself above the ordinary 'shopman' Eastlake was so dismissive of. Instead he is perceived as a well-read man of learning whose retail establishment is informed by his exemplary knowledge and capable navigation of culture, literature and the arts. While Rocke was careful not to alienate his less learned patrons – 'not every man of wealth has had the opportunity of cultivating literary tastes' – he was also conscious of the prevailing snobbery associated with pretensions to cultural literacy.[138] He asserts, 'A library for mere show is a piece of presumptuous hypocrisy'.[139] However, the quotations throughout the book imply his own 'wardrobes of literature' were extensive, genuine, complete and beyond the reproach of 'hypocrisy'.[140]

No less than 40 quotations from 27 sources are recorded in his 54 pages of text, each one cleverly endorsing an aspect of the Rocke inventory or his own philosophy on interior decoration. Through careful and selective editing he demonstrates his own capacity for educated prose; aligns his decorative schemes to intellectual pursuits; turns a would-be foe into an ally; and draws upon the currency of popular culture. Celebrity endorsement was, by no means, only a product of twentieth-century marketing.

George Augustus Sala was a member of a new Victorian literary collective: the mass-market celebrity journalist.[141] With the rise and popularity of newspapers, so too came the rise and popularity of those who featured in them. As James Button declares, 'the whole English-speaking world knew the rotund man with the walrus moustache, white waistcoat and red nose… Sala, in modern parlance, was a star'.[142] He counted among his circle Thackeray, Wilde, Rossetti, Whistler and Dickens, all of whom added to his literary authority and worthiness of inclusion in the Rocke publication. But it was not necessarily these highbrow associations that Rocke hoped to incite, but rather the popular sensation of celebrity. In the mid-1870s, at the time of the Rocke publication, Sala was at the height of his fame as London's most widely read page-one journalist for the *Daily Telegraph*. As Peter Blake explains; 'Sala's witty leaders for the *Telegraph* and his blend of sensational journalism, mixing "true crime", news stories, and personal accounts of royalty and celebrity, had… helped the *Telegraph* outstrip the circulation of *The Times* and made Sala one of its "young lions"'.[143]

Despite his popularity, or possibly because of it, Sala was regularly dismissed by more critical contemporaries. According to the poet Matthew Arnold he was the 'epitome of Philistinism'[144] and popular simply because he 'pandered to the sensational-loving nature of the populace'.[145] Nonetheless, journalism carried the mantel of publicly revealed 'truth': opinion informed by intelligent enquiry and thorough, thoughtful consideration. Newspapers could shape opinion quickly and daily, in a way no printed media had ever been able to do previously. And Sala, notwithstanding his critics, maintained an empire-wide public hungry for his observations.

Sala's quote appears on page one, prior to the colophon. His is the text that sets the tone for the entire book:

the works of the tailor cannot teach us more significant lessons in the history of our species than can those of the makers of chairs and tables. The furniture, the carpets, the ornaments, the mirrors and dressing glasses, the carved chests, and inlaid and enameled cabinets of an epoch, are a sure guide to its wants and pastimes, its passions and its feelings.[146]

Here, via Sala, Rocke asserts the significance of the domestic interior. It is a mirror to the history of civility; its refined processes and ornamentation evidence of a sophisticated culture that knows a fine interior can reflect the pride and passions of a civilised *white* populace.

As well as being a revered wordsmith capable of casting a knowing eye over the quality of a room's furnishings, Sala would also have been recognised by the Rocke reader for his vehement opposition to black emancipation. While he regularly championed the cause of England's poor, his compassion did not run to the plight of America's southern slaves. In 1864, a year prior to the end of the American Civil War, he famously wrote:

> I believe that he [the black man] is naturally inferior to the white man in mental organisation... willing and obedient only when he fears the eye or the hand of his master... always as lecherous as a monkey and often as savage as a gorilla.[147]

While it is only his musings on the interior that appear in the Rocke book, his abhorrent opinion of African Americans would have done nothing to taint his respected reputation in 1870s Australia, whose white population often lamented its own 'Aboriginal problem'. Similar opinions to those of Sala persisted in Australia well into the twentieth century. 'The Australian aboriginals have furnished the largest number of ape-like characters. The more one investigates, the truer does this statement prove to be', wrote W. Ramsay Smith in 1907, as the Head

of the Department of Public Health in South Australia.[148] Nor was Sala alone in his opinions in London. Charles Dickens wrote in his essay *The Noble Savage* (1853), 'I call a savage something highly desirable to be civilized off the face of the earth'.[149] Revered essayist and historian Thomas Carlyle had also published his *Occasional Discourse on the Nigger Question* in 1853 as a warning against black emancipation in the West Indies. Both Dickens and Carlyle also appear quoted in the Rocke book, but as learned men of their age, not as the anti-liberal opposition to human rights as they might now appear. But suffice to suggest Sala and his contemporaries, and indeed Rocke himself, would only consider white European culture to be the true measure of civilisation and human progress.

Rocke is at pains to immediately identify his workforce, and as such his furnishings, as European. 'We have… brought from England the best procurable workmen and so filled our Show-rooms and Warehouses with good things'.[150] While the appearance of the 'European Labour Only' stamp would not be mandated by the Federated Furnishing Trade Society until 1884, opposition to locally made Chinese furniture was rife at the time of the Rocke publication, particularly in Melbourne.[151] Rocke would have been keen to alienate his prestigious showrooms from the reputation of cheap, inferior products unfairly levelled at the Chinese furniture manufacturers in nearby Little Bourke Street. Even the otherwise liberal press lamented the presence of Chinese labour in the colonies, especially in the furniture trade. When a ban on Chinese manufactured chairs for the Exhibition Buildings was lifted, *The Age* lamented, 'the action of the Exhibition Committee proves that the "yellow agony" has reached Victoria'.[152]

Rocke would have been sufficiently versed in the etiquette of polite Victorian behaviour to know that a man of good standing should not

debase himself by sneering at those below him or grovelling to those above. 'One of the most marked tests of character', wrote Samuel Smiles, 'is the manner in which we conduct ourselves towards others. A graceful behaviour towards superiors, inferiors and equals is a constant source of pleasure'.[153] Rocke's language is carefully chosen, though reliant on his reader's ability to align it to current and presiding opinion: the Chinese were almost universally loathed in Australia, with Victoria imposing severe restrictions on Chinese immigration as early as the 1850s and implementing a Chinese residence tax of £4 per annum. By stating his workforce is procured from Europe is simply a statement of fact and some pride, but importantly eliminates any need of passing his own judgement on his far cheaper Chinese competitors. This is simply implied.

Sala's is the second quote in the Rocke book. The first belongs to William Shakespeare: 'These are but furnishings – *King Lear*'.[154]

There are nine Shakespearean references throughout the book, though none are credited as such. The title of each play sufficed as reference; the author went without saying. Should a reader be ignorant of the authorship, it is evidence that they were not, from page one, the intended audience for the book, nor the intended customer for the Rocke store.

However, the use of the *King Lear* quote slightly dents the author's inferred claim to literary acumen. The meaning of 'furnishings' is not, as the book would lead its reader to believe, in reference to the chattels of the interior. Those familiar with the play would undoubtedly know the word refers to the evidence of treachery laid against the outcast Lear by his ruthless daughters Goneril and Regan, and their respective husbands, the Dukes of Albany and Cornwall.

With mutual Cunning – 'twixt Albany and Cornwall.
Who have – as who have not, that their great stars
Throned and set high? – servants, who seem no less,
Which are to France the spies and speculations
Intelligent of our state; what hath been seen,
Either in snuffs and packings of the dukes,
Or the hard rein which both of them have borne
Against the old kind king; or something deeper,
Where of perchance these are but furnishings.[155]

This apparent misrepresentation of Shakespearean text would have done nothing to lessen the reputation of Rocke and his store. The inclusion of England's unsurpassed champion of wit and language was essential to identifying his library – and consequently his literary education – as a good and proper one. Though the quote exposes a patina of cultured literacy, it was sufficient to identify Rocke as 'learned'. As explained by Young, 'the intersection of money and learning defines the field of taste, and removes it from the popular meaning of either personal or universal aesthetic judgement, showing it instead as a cultural and mutable construct'.[156] The inclusion of Shakespeare infers 'historical' knowledge that elevates Rocke's 'taste' above the frippery of passing contemporary fashion. Like the Shakespearean texts, Rocke's opinion on 'taste' could be read as timeless and eternal, and as such worthy of his customers' trust.

Shakespeare is the oldest literary inclusion in the book. Most are nineteenth-century quotations from authors familiar to, or contemporaneous with, Rocke's clientele. Among them is Lord Edward Bulwer Lytton (1803–1873). Lytton was one of the Victorian period's most prolific and popular novelists, and it is his last, *The Parisians* (1873), that featured in the Rocke book:

> The Contessa di Rimini received her visitors in a boudoir furnished with much apparent simplicity, but a simplicity by no means inexpensive… the articles of furniture, each in exquisite taste, the cabinets, the china stored in them or arranged on shelves, the Bohemian vases, and the nick-nacks scattered on the tables, were costly rarities of art.[157]

Lytton was an important inclusion. His prose often detailed the notion of good taste being reflected in refined, elegant and expensive surroundings. But at the core of his text were always the three pillars upon which he believed the civilisation of Europe relied: marriage, worship and property.[158] Rocke could provide the material needs of 'property', which in turn would enable the first and infer the second.

The Spectator published a critical and ungenerous posthumous review of *The Parisians* in the same year the Rocke book was published:

> *The Parisians* is an overgrown book, with a great deal that is dull and poor in it, and a little that is very bright and clever. All the romantic part, that connected with the loves of Graham Vane and of Isaura Cicogna, is mere padding of a kind which any fifth or sixth-rate novelist could have done as well, and to which such a novelist would probably have given more vividness and probability.[159]

But *The Spectator* was a conservative magazine, in which a succession of male editors focused unrelentingly on the tumultuous political landscapes of Europe and America. Here there was little time for romance and the dalliances of the well-to-do. But for Victorian middle-class women omitted from the external world of politics and commerce, and sentenced to long periods of dull consignment to drawing rooms and boudoirs, Lytton novels provided a welcome escape from their hours of solitude and gracious inactivity. Within his novels they could 'find

relief in contemplating an ideal society where tedium is unknown and disappointment generally circumvented'.[160]

Lytton provided an insight into the lives of the aristocracy from the pen of one of its own, and permitted some level of comparison to his readers' own lives and surroundings. For Australian middle-class women and most of those in London, Parisian high-society was an unachievable social benchmark, but at least Lytton's ample descriptions of their interiors, and importantly their behaviour and beliefs, gave some guidance to their own. Consider, for example, his warning to intelligent women, thinly veiled in compliments for his heroine Isaura Cicogna: 'About her there was a charm, apart from her mere beauty, and often disturbed instead of heightened by her mere intellect'.[161]

Here Lytton affirms the Victorian conception that elegant women should be simply that; their charm uncorrupted by worldly intellect and opinions beyond those they required to effectively run their households. Their true calling lay inside the home as women – indeed 'inmates' – of taste.

> The room somehow or other – thanks… to a nameless skill in rearrangement, and the disposal of the slight knick-knacks and well bound volumes, which, even in travelling, women who have cultivated the pleasures of taste carry about them – had been coaxed into that quiet harmony, that tone of consistent subdued colour, which corresponds with the characteristics of the inmate.[162]

That Lytton appears in the Rocke book is also something of a contradiction. While Lytton applauded educational reform, he was opposed to the proliferation of mass-market subgenres of writing that diluted the literary space once held sacrosanct by the authors of high-end novels, history and poetry. These included Gothic romances, horror, crime stories and advice manuals.

Family libraries of all sorts have been instituted with the captivating profession of teaching us all things useful... excellent inventions, which after showing us the illimitable ingenuity of compilation have at length fallen prey to their own numbers, and buried themselves among the corpses of the native quartos which they so successfully invaded.[163]

Lord Lytton is one of several noted Victorian novelists cited in the Rocke book. The others include William Makepeace Thackeray, Charles Dickens, Sir Arthur Helps and the American, Edgar Allen Poe.

It is not, however, Poe's tales of the macabre that were drawn upon, but his 1840 essay 'The Philosophy of Furniture'. The inclusion of Poe's text was supportive of both the value Rocke placed on interior decoration, but also the claim of British superiority in the art of the interior. 'In internal decoration... the English are supreme... the Yankees alone are preposterous'.[164]

Rocke – and his Australian clientele – would have appreciated Poe's stance that the English interior was superior to all others; and further still approved of his claim that the English advantage was due to their sturdy rule of aristocracy. 'We have no aristocracy of blood', he wrote, 'and having therefore as a natural and inevitable thing, fashioned ourselves an aristocracy of dollars'.[165] Unlike America, Australia remained under English rule, but, like it, owed much of its own advantage to self-made personal fortunes. Unlike America, Australia could claim English taste as its own, with the benefit of also being able to afford it.

As with other authors he cites, Rocke is careful to avoid any comment that may contradict his own comprehension of good English taste. The voluminous billowing curtains, drawn back with tasselled cords and topped by an elaborate fringed pelmet illustrated in the

showroom photograph (Figure 1.8), would surely have irked Poe. 'An extensive volume of drapery of any kind is, under any circumstance, irreconcilable with good taste', he wrote.[166]

Similarly on carpets, Rocke is happy to approve Poe's opinion that 'the soul of the apartment is the carpet… a judge at common law may be an ordinary man: a good judge of carpet *must* be a genius'.[167] However, Rocke is careful to omit Poe's objection to Brussels as the 'preterpluperfect tense of fashion'[168] and follows the quote with his own admiration for it. 'In the present instance the carpet is, in our opinion, of the best possible kind for this country, viz., of five-frame Brussels'.[169]

Rocke's use of literary references to support his decorative schemes relied heavily on his artful capacity to edit them. Perhaps the most significant of these is his single, and purposeful, inclusion of John Ruskin.

Ruskin, like Charles Eastlake, was a revered commentator on the topic of material taste and architectural virtue. His inclusion in the book is pivotal to providing a sense of completeness to Rocke's education in the refined art of contemporary dwelling. Ruskin belonged to an expanding body of Victorian sage writers, his work assuming a righteous tone of wisdom through a voice that harboured an intense and judgemental Christian morality. His single inclusion in the book appears early, on page 9: 'You will be judged by your surroundings'.[170]

This short, single sentence served Rocke well on two accounts. Its prophetic, Old Testament tone of judgement – that cannot be read with any frivolity or joy – clearly aligns the English interior with devout Christian beliefs. Importantly it also serves as a warning. It underscores the prevalence of middle-class judgement of character and position via the content and arrangement of one's interior. The

importance of passing this critique does not need to be stated; those reading the book already know its consequences.

Had he known of his inclusion in this small, antipodean book, Ruskin would surely have disapproved. Rocke represented all the indulgences the Victorian middle-class consumer coveted, and the common traders that willingly peddled them. These Ruskin loathed:

> I would not have the useless expense in unnoticed fineries or formalities; cornicing of ceiling and graining of doors; and fringing of curtains and thousands such things which have become foolishly and apathetically habitual – things on whose common appliance hang whole trades... things which cause half the expense of life, and destroy half its comfort, manliness, respectability, freshness and facility.[171]

Of the abundant, modern ornament that characterised the Victorian interior – and the kind of merchandise within Rocke's store – Ruskin was equally as scathing: 'Ornament is an extravagance, an unessential thing and therefore if fallacious, utterly base'.[172] Such brutal admonishment for ornament would never appear in the Rocke book. The store's success and the continued wealth of its owner relied heavily on its continued popularity. And popular it remained. For all of Ruskin's, Eastlake's and Orrinsmith's objections, abundantly decorative interior schemes remained popular throughout the entire Victorian period and through until the First World War.

As already acknowledged, Owen Jones (1809–1875) thought it best to educate people in the use of decorative devices. He is among the Victorian commentators who championed the use of ornament, but its disciplined application beyond pastiche and gaudy renders of ribbons, flowers and birds of paradise. Jones was an architect, colourist and author of *The Grammar of Ornament*, the most significant source

book available to Victorian decorative trades for the application of ornament. But, for most Victorians, Jones was best known for his controversial colour schemes for the Crystal Palace, supported by the design-savvy Prince of Wales but largely condemned by the popular press. 'The eye is wearied and irritated in this Crystal Palace with what may be called polychromatic monotony', complained the Rev. John Eagles in *Blackwood's Magazine* in 1857.[173] In an era where criticisms of personal taste amounted to an insult of the highest order, Eagles continued, 'the directors of the Crystal Palace have inconsiderately and with the worst taste delivered up the Palace into Mr Jones's hands'.[174] Regardless, the Palace's cast iron structures were painted in hues of red, yellow and blue, and provided six million visitors with a taste for a new Victorian passion: colour. With advances in dyes and chemical processes, 'bright' was soon to usurp the chaste colours of 'earthy'. Jones and Ruskin would never agree on colour, or cast iron for that matter. For Ruskin, the former should only be dictated by God: 'The fact is certain that colour is always by Him arranged in these simple rude forms... and we shall never mend by refining its arrangements'.[175] Of the latter, 'Cast iron ornamentation [is] barbarous... cold, clumsy and vulgar'.[176] In the Rocke store customers would be exposed to both: the lustrous hues of satin, cretonne and chintz displayed in abundant layers upon cast iron galleries.

It is, however, Jones's opinions on the arrangement of breakfast rooms that Rocke recounts:

> Good-taste demands that a breakfast-room should never be too fine, or altogether divested with an air of comparative déshabillé, in unison with the purpose of its ordinary employment.[177]

In the breakfast-room chapter of his book, Rocke not only cites a learned English authority, but clearly assumes his reader possesses the

indulgence of a breakfast room. This room differed in both form and function to the dining room. It was a family room that could afford less stringent rules of behaviour and decoration. In a breakfast room a family could, within the constraints of proper Victorian decorum, relax their grasp on social protocol. *Déshabillé* (literally, 'partially dressed') referred to that peculiarly Victorian appearance of disarray that is, in fact, a carefully orchestrated narrative of homely objects that are seen, enjoyed and interpreted, but do not interfere with the utility of the room.

The breakfast room chapter also provides Rocke the opportunity of one final voice of authority: the modern medical practitioner. The Victorian period is not only identified through an increase in material values, mass market consumption and mechanical invention, but also advances in science and medicine. And, like men of cultural commentary, men of medicine turned to the popular press to both spread their knowledge and advance their personal wealth. Rocke was careful to include a doctor in his book, thus completing the inventory of his library. Dr Pye Henry Chavasse (1810–1879), via his own assertion, 'has been extensively published... and well-known wherever the English language is spoken'.[178] The claim is somewhat confirmed by the appearance of his quote in an Australian publication of 1874.

In *Remarks* Chavasse is called upon to qualify the value of breakfast: '[if] served punctually and satisfactorily, it gives an impetus and cheerfulness to the whole proceedings of the day'.[179] The quote immediately precedes Rocke's own claim that a 'well-arranged house must contain a breakfast room'.[180]

A room singled out for the sole purpose of morning rituals – 'it may often serve as the morning parlour' – is evidence of a family of

good fortune, and by aligning its presence to a noted English doctor is also a family of good health.[181] But, again, Rocke's selective editing is at play. Chavasse entirely opposed the fashions and practices of the Victorian interior, especially for women, for whom it was almost their entire domain.

In 1866, Chavasse published *Advice to a Wife on the Management of Her Own Health*. For its time it was remarkably frank and progressive. The word 'menstruation' is used liberally in lieu of the more acceptable expression 'feeling unwell'. He condemned the fashion for lacing waists, and supported the notion of wealthy women breastfeeding their own babies, which in high society was entirely shunned as a base and common act, better suited to a servant wet-nurse. It is, however, his strong opinions on interior practices that are at odds with the Rocke mantra of interior dwelling. Of luxury he is particularly critical: 'Unfortunately this is the age of luxury. Everything is artificial, and disease and weakness follow as a matter of course'.[182]

He continues:

> Hot and close rooms, soft cushions and luxurious couches must be eschewed. The more [a woman] indulges the more unhealthy, weak and inanimate she becomes – unfit to perform the duties of a wife and the offices of a mother... Rich and luxurious ladies are less likely to be blessed with a family than poor, hardworking women.[183]

If a woman of good fortune should fall pregnant, her long periods of inactivity in the drawing room are sure to cause her grief: 'A lady who lolls either on a sofa or on an easy chair during the greater part of the day... has generally a more lingering and painful birth'.[184]

Even the active practices of the drawing room are condemned by Chavasse, as too little and essentially meaningless:

> A husband soon becomes tired of grand performances on the piano, of crochet and worsted work and other fiddle-faddle employments – but he can always appreciate a comfortable, clean, well-ordered, bright, cheerful home.[185]

Clearly Chavasse opposed the long periods of sedentary female middle-class dwelling, but fully supported the notion of domestic space as one in which women assumed their role as vigilant domestic manager:

> Home is, or ought to be, the kingdom of women, and she should be the reigning potentate. That old order – God forbid it should ever change – which ordained that women should be the keepers of home, happy rulers of that happy little world.[186]

A Man's 'House' and a Woman's 'Home'

A middle-class woman's internment within the home had been revered as her most appropriate position for most of the nineteenth century. Coventry Patmore's *The Angel in the House*, first published in 1854, provided the enduring Christian metaphor for an English wife that was to become firmly established throughout Britain and its colonies. Within the confines of home 'the angel' could fashion a bunker away from the evils of the outside world and thus protect and nurture the moral milieu of her family. She was undoubtedly its vigilant keeper, but this did not infer that she also dictated its internal appointments.

Although set at the turn of the twentieth century, the drawing room in E.M. Forster's *A Room with a View* (1908) is indicative of a period in the nineteenth century when middle-class husbands presided over all the major household expenditure including its furniture. In explaining the ornamentation of the family living room, Forster's character, Mrs Honeychurch, states, 'no doubt I am neither artistic nor literary, nor

intellectual nor musical, but I cannot help the drawing-room furniture; your father bought it and we must put up with it'.[187] As further explained by Logan:

> The domestic environment was the primal scene within which male identity was developed, and for much of the Victorian era maintaining a home – which would be literally and figuratively ornamented by the wife – was a masculine duty.[188]

In 1870s Melbourne, Rocke understood his market. His prefatory text defined exactly who his document was for: recently wealthy men with a taste for luxury and a desire to show it off:

> It is a question which each reader must decide for himself, whether most of the observations that follow will or will not be of service. It seems to us however, that with many persons it is an article of faith that, with money in your purse, to furnish your house is one of the easiest things in life. So it is in one sense. For instance, there is the frequent case of a man to whom has come a sudden access of wealth – a pastoral settler, whose unusually large clip of wool has just got top price in London, or a mine proprietor, in whose claim a sea of wash-dirt or a wall of golden quartz has just been developed – who forthwith vows that the wife of his bosom shall no longer be annoyed by the dinginess of her house fittings. Accordingly he gives her carte blanche to the best firm in Melbourne to send up and re-furnish her drawing and dining rooms from top to bottom. And Lo! The thing is quickly done. With small delay come rich furniture, carpets, hangings &c., together with skilled artificers to adjust the upholstery work, and the rooms in question are made things of beauty and a joy for the next five or ten years, as the case may be. Indeed no wiser course could be suggested to those in remote country parts, who are unable to visit Melbourne, or those who have little experience in household adornment, or whose wealth comes – a not infrequent case – after a life so busy as to have afforded no opportunity with

the thousand and one elegancies and conveniences belonging to modern civilization and fashion.[189]

A husband and holder of the purse strings was undoubtedly Rocke's primary audience, but his wife was not neglected. She was keen to be rid of the 'dinginess' of her current appointments and desirous of what material riches Rocke could offer to reflect her husband's good fortune and satisfy her own societal need for well-furnished apartments. Victorian homemaking required the full attention of both husband and wife. For one, it implied his diligent and canny financial management and provided his sanctuary away from the 'labours' of work. For the other it reflected the status and respectability of the family she was moral proprietor of. Home was her site of 'work': constructing the virtuous retreat where her husband could relax and their family be nurtured in wholesome and respectable comfort.

On this the 'Old Housekeeper' (1883) was adamant. Victorian women were not be distracted from their 'work' as homemaker; not even by charitable acts or social engagements. She wrote:

> Work is your ordained lot, and you cannot get away from it. If you leave undone the work God gave you for your family, you are quite sure to interest yourself in bazaars, church choirs, missionary enterprises, and other devices for the destruction of home comfort.[190]

Rocke's text clearly identifies his particular Australian market: the urban and rural *nouveau riche*. In her analysis of the English drawing room, Anne Anderson describes the general opinion of this branch of the new middle-class in London: 'New furniture smacked of new money... these trappings of financial success, a veneer of respectability, cannot disguise moral failure'.[191] However, any condescension towards new money in a new city like Melbourne was difficult to impose. It

was peopled largely by migrants who arrived with little more than hope and ambition, not a cache of family heirlooms that revealed an honourable lineage. Rocke provided the new furniture that declared the good fortunes of a new life in a new city. 'New' was an unavoidable, but also admirable, quality.

For Rocke, the cashed-up squattocracy that lived in remote isolation deserved the same access to luxury as those who had colonised the salubrious south-eastern suburbs of Melbourne. Money afforded luxury irrespective of geography. Furniture, drapery and carpet were infinitely portable vessels of good taste, provided one got it right. To ensure they did, procuring the services of an expert was advisable; and inevitably this expert was a man. Men like Rocke sold the goods that both men and women bought. His employees – the cabinetmakers, decorative painters, upholsterers and paper-hangers – were all men. There can be no question that men influenced the middle-class domestic interior as husbands, tradesmen, retailers or authors.

Despite the apparent dominance of men in interior expenditure, certain rooms assumed a clear, demarcated gender bias. Dining rooms were predominantly masculine; the space retained by men after dinner once women withdrew to the drawing room. 'Its chief characteristics ought to be of a more sober and massive kind than becomes a chamber devoted to lighter more feminine purposes', wrote Rocke.[192] He did not counter the prevailing English opinion of the room's purpose, or its highly prescriptive, gendered ornamentation. He continued, 'the carpet should be geometrical or close figured than of an open floriated pattern… on the buffet may be displayed testimonial plates, race or regatta cups, silver services and the like'.[193] Dining chairs should be 'substantial' and the leather stretched smooth

to permit the imprinting of 'a monogram or coat of arms in gold'.[194] But amidst this inventory of club-like opulence, Rocke advises on one particularly male convenience: 'circular footstools... with highly ornamental tops, which, when taken off, discover disguised spittoons'.[195] Of course no mention is made of the servants required to empty these vessels of their potentially infectious contents. It is assumed the reader is sufficiently wealthy enough to employ the requisite staff that are, as Veblen explains, 'called in to fulfil the routine of decency [that] is commonly distasteful to the occupants of the house'.[196]

Although a man may have paid for it, the drawing-room was a woman's domain: furnished profusely but with items less cumbersome than the baronial pretensions of the dining room. It was the room that 'defined cultural notions of feminine identity – a physical and ideological space that framed a woman's actions and thoughts'.[197] In here, in a room shared by family and visiting peers, a woman could construct a narrative of respectability, loyalty, grace and devotion. Whether store bought or crafted by her own hands, the tableau of decorative objects and furnishings within the drawing room implied her family's level of taste, cultural engagement and alignment to established middle-class systems of belief. 'It must tend to exalt, refine and enrich the mind. And when wealth is at hand to heighten the ornamental effect, the case is all the stronger.'[198] According to Rocke, the drawing room was a site to impose the Victorian duty of 'betterment'. The more you could afford to impart on the drawing room assemblage, the more 'exalted' you became: intellectually richer, socially better, spiritually higher. He describes in lengthy detail the vast inventory of a worthy drawing room: chairs, tables, cabinets, paintings, mirrors, consoles, glass, ornaments, busts and

'a few precious morsels of antique art'.[199] A touch of 'antique' would offset the gloss of the expanse of newness. The contents appear in the Mayall photograph within the book (FIGURE 1.8). It is an extensive and purposeful arrangement of furnishings; cluttered to the modern eye, but each piece fit for purpose. A gilt *prie-dieu* reflects the wealth of the owners, but visualised their devotion to Christian beliefs. The ottoman permits a lady to extend a comfortable seat to a number of visitors, and centres them as the most important in the room. It permits them a position from which to survey the room's riches and make a favourable judgement upon it. Armchairs offer comfort to men, and armless ones do not crush or distort the fullness of Victorian dresses. Footstools extend a note of leisurely comfort to all. 'Pretty little children's chairs, polished and inlaid so as to be eminently presentable' indicate the room is for the entire family; its youngest members equally fluent in the requirements of elegant repose.[200] Abundant, layered drapery partitions the room from the conservatory, in which the occupants and their visitors could observe the wonders of God's natural world and the floral bounty of empire from the comfort of an interior vantage point.

The abundantly draped and decorated drawing room, reflective of the monetary wealth of its possessors, presented the Victorians with something of a spiritual quandary. Notwithstanding the presence of a *prie-dieu* and perhaps an ornamented family Bible, how could such excessive and visceral displays of wealth be commensurate with holiness and Christian devotion?[201] Deborah Cohen explains:

> The Victorians, caught between the commands of religious constraint and the lure of their newfound wealth, came up with an ingenious solution. Things had moral qualities. Urged on by clergymen who preached that beauty was holy, Victorians

evaluated the merits of sideboards and chintzes according to a new standard of Godliness. A correct purchase could elevate a household's moral tone; the wrong choice could exert a malevolent influence.[202]

Rocke certainly claimed to provide for the 'correct' drawing room purchases. As already discussed, his decoration and furnishings were intended to 'exalt, refine and enrich the mind'.[203] But the gentle, physical activity permitted within the room also required specific needs. Scattered about the space are the tables that gave it purpose:

> Disposed in different parts of the room are two of those little Japanese... receptacles for ladies' work, supported on light bamboo frames that no modern drawing room ought to be without. Elsewhere is a more massive ladies' work table, of walnut, sumptuously carved and inlaid; its top is doubled, and when opened and turned half round, is found inlaid for the purposes of chess, backgammon and cribbage... The only other tables in the room are two or three of those small round-topped tripod sort, known variously as 'monkey' or 'gipsy' tables, which have of late come into extensive demand not only for ordinary drawing room purposes but also those of the new-fashioned 'five o'clock tea'.[204]

Rocke describes the place of family entertainments and middle-class women's 'work'. The feminine accomplishments of needlepoint and other worsted occupations required tables to perform it on, and receptacles to hide it in during times of peer visits. But it is here that she performs her most pivotal role: as hostess during the five o'clock tea and the middle-class preoccupation with 'visiting'. Key to middle-class success was a woman's competence at the visiting ritual; the brief but crucial drawing room interaction with other women of equal or better standing. Within the prescribed 20 minutes a woman needed to present and defend her family's right of belonging

somewhere within the fickle layers of middle-class society. Her time in another woman's drawing room would permit her the opportunity to present her case but also to survey the worth of the family being visited. If sufficiently impressed she would pray that a reciprocal visit would be accepted and a favourable review imparted to the other women who participated in this complex circle of social interaction and exclusion. The drawing room was the space in which women worked hard to establish and maintain the reputation and social acceptance of their families.

Although each room possessed a predominant bias, the drawing room and dining room were used by both genders and by all members of the family. But if one's income and home extended to it, specific rooms could be fashioned exclusively for each sex. For men, the luxury of a smoking room was matched by a woman's boudoir. Each maintained their gender exclusivity, defined by the acts that occurred within them and their decoration. Smoking was a pastime deemed only appropriate for men and its room should be decorated in order to dissuade female entry:

> On the walls sporting implements, arms, and aboriginal weapons and utensils, fancy German and Turkish pipes, &c., may be picturesquely arranged... the point is to give the chamber an easy somewhat luxurious air, coupled with a tone denoting that it is not devoted to the purposes of the softer sex.[205]

On boudoirs Rocke gives little advice beyond the abbreviation that it 'should be a sort of sublimated drawing room'.[206] Perhaps, as a man, Rocke knew little of the boudoir. It was a woman's domain and regularly cast as a selfish space. Lady Barker lamented that the very word 'boudoir' 'signified a place to idle and sulk in'.[207] For Rocke, it was a space best left well alone.

There was, in a word, everything that comfort could desire, and the most elegant taste devise. A London drawing-room, fitted up without regard to expense is surely one of the noblest sights of the present day. The Romans of the Lower Empire, the dear Marchionesses and Countesses of Louis XV, could scarcely have had finer taste than our modern folks exhibit.[208] (William Makepeace Thackeray)

Via the words of Thackeray's Arthur Pendennis (above), buried amid the sea of quotations in his book, Rocke reveals his own uncompromising devotion to the interior.[209] It embodies a philosophy of middle-class domesticity to which he fully subscribed: comfortable, desirable, noble, modern, expensive and English. 'Home' was far more than a collection of rooms tastefully furnished. It was a tangible and unbreakable link to a 'home' that transcended any misfortune of actual geography. Reconstructing an exact likeness of an English well-to-do interior displaced any sense of loss, in identity (forever English), status (forever genteel), or virtuousness (forever good). His rooms were part of 'a revolution' that did not overthrow any administration, but the democracy of ordinariness.[210] Anyone can be ordinary, but those who subscribed to Rocke's book knew, with his guidance, how to be 'magnificent'.

Chapter 2

EVERYTHING IN ITS PLACE

Harriet Frances Wicken and

The Australian Home

The Rocke book was a rare, locally-authored document that specifically dealt with the ornamentation and furnishing of the wealthy Australian house, albeit one aesthetically in servitude to Britain. Its content and context drifts occasionally from the mantra of good English taste, but largely it is evidence of an evolving, sophisticated, metropolitan society reflective of a British one. It is also perceivably self-serving, as one would expect of a document published by a retailer then or now. While it is definitely not a catalogue of wares, it makes perfectly clear where the material realisation of comfortable English living was to be found. The Rocke book was a tempting portal to an 'English-like' life achievable via a simple visit to his warehouse with sufficient funds to purchase the covetable possessions of European luxury. Rocke, however, made no attempt to educate his audience on the behaviour of the interior. He could provide 'the set', but 'the script' would need to be procured from elsewhere. There were, after all, ample texts available to advise on the practices of middle-class Victorian interior dwelling, especially for women. Instruction on behaviour could be easily procured from

texts like *Mrs Beeton's Book of Household Management* (1861). Of the 1,112 pages that constituted Beeton's book, 900 related to cookery. The remainder dealt with the subjects of cleanliness, duties and treatment of servants, the etiquette of dining procedures, visiting rituals and friendships, child rearing, and domestic legal issues. In order to cover such a diverse range of topics in the remaining 212 pages meant that the advice had to be succinct, direct and without alternatives. For example, on the subject of 'friendship' Beeton advised a cautious, almost suspicious approach. Friends in middle-class circles could make or break one's own reputation, meaning that careful judgement was required in their formation. She states:

> Friendships should not be hastily formed nor the heart given to every new-comer. There are ladies who uniformly smile at and approve everything and everybody, and who possess neither the courage to reprehend vice, nor the generous warmth to defend virtue. The friendship of such a person is without attachment, and their love without affection or even preference.[211]

Rocke made no specific mention of correct social behaviour nor advised on explicit acts of gentility, simply because they were presumed to exist already. Patronage of the Rocke store was already evidence of his customers' social position and carried with it an implied expertise in 'cultivated' ways:

> It was to us a high gratification when, a few weeks since, a Victorian gentleman, of cultivated tastes and enormous wealth just returned from Europe, observed, "To look at your stock, Mr Rocke, is to me an intense disappointment. I have spent weary months in London and Paris, searching and selecting furniture for my new house, and now I find that I might have saved my trouble. For all I did, I have obtained nothing better than I can now select in your establishment in Collins Street."[212]

For Rocke, good taste and wealth were inseparable qualities: to have one inferred the existence of the other. If instruction on good behaviour needed to be procured, for most Australians who aspired to middle-class status, English books provided the best advice. Cassell's, Pearson's and Beeton's domestic manuals were as easily procurable in Australia as they were in Britain.

However, as the country began to assume its own semi-independent Anglo-Australian identity towards the end of the nineteenth century, the need for advice for Australians by Australians would be realised. Like Beeton's and Pearson's, most Australian advice was harboured inside cookbooks. Food, like furnishings, made an important contribution to the sense of a shared English identity. As explained by Adele Wessell, food consumption 'could provide a practice by which members of the empire could make themselves feel "at home" or "in place"'.[213] The proliferation of cookbooks was also indicative of the late nineteenth-century shift in middle-class women's site of control from drawing room to kitchen. Idling about in drawing rooms being waited on by a regiment of servants was an ageing privilege and denied to most contemporary Australian women with aspirations to middle-class membership. With limited access to servants and the progress of science revealing the importance of cleanliness and hygiene, the late nineteenth-century home became an increasingly labour-intensive space for middle-class wives. It required more cleaning and close attention to the preparation of food, but with less help. Advice books were an essential tool to relieving the burden of modern homemaking.

The works of Harriet Wicken and Wilhelmina Rawson have frequently been identified by Australian scholars as significant to our reading of the Australian colonial domestic experience. Blake Singley, Barbara Santich, Jacqui Newling and Adele Wessell have

made considerable reference to Wicken and Rawson in their historic analyses of Australia's colonial food culture. But it is Wicken's and Rawson's opinion on the domestic interior that is of principal interest to this book. Even the physicality of their publications has relevance to the shifting paradigm of female middle-class engagement with domestic spaces.

Rocke's lavishly ornamental cover defined its location in the 'superior' rooms of the 1870s well-to-do home. It was decorated to mirror the riches of those who had made their fortunes in the economic dazzle of the Victorian gold rush. Wicken's book (Figure 2.1), however, produced 17 years later, reflects the altered currency of the Victorian interior, and the state of the colonial economy that had been plunged

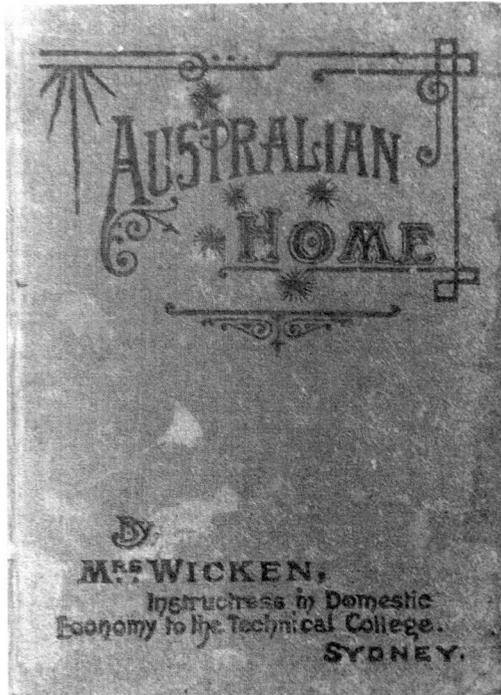

Figure 2.1. Harriet Frances Wicken, *The Australian Home* (1891), Monash University Rare Books Collection.

into financial recession in the late 1880s. Her interiors were not a decadent confection available only to a moneyed class, but respectable spaces governed by the principles of sound economic management. The position is reflected in the book design. It is printed in economical black, rather than the excesses of colour. Its cover is cloth bound and as such is resilient to firmer treatment. It is not a luxury item but one of practical content.

It belongs in the kitchen or another space where work might take precedence over pretensions to grandeur. There is far more economy in Wicken's cover than Rocke's, but still it employs a semiotic language of popular graphic symbols. While Rocke's Elizabethan scrolls honour the rein of another powerful English queen, the Southern Cross is proudly printed on Wicken's cover. It is reflective of an emerging nationalism that suggested, though did not insist upon, independence and self-sufficiency.

Rawson's book cover (Chapter 3, FIGURE 3.1) is even more elementary. Like Wicken's it is cloth bound and hard covered to ensure its survival in the work stations of the house. But unlike Wicken's, advertising banners top and tail her book, one for Empire Cocoa and the other for Silver Star Starch. This was a book whose readers spent time in both the kitchen and laundry as much as the drawing room. Unlike either Wicken or Rocke, the price of the book is blatantly on display. At only two shillings and sixpence it was an affordable alternative to her more costly competitors. Everything about her book speaks plainly of economy not luxury, including the underdesigned standard letterpress fonts used to construct the cover, which is entirely bereft of any ornament or fussy detail. Her situation in the isolation of Australia's outback, and driven by financial necessity to be frugal, meant her book was also required to appear chaste and economically sensible.

The inclusion of Wicken and Rawson is important for reasons that will become evident in the ensuing two chapters, but in summary they represent a female perspective on middle-class Australian domesticity. Where Rocke's book was upper middle class, male and materialistic, and good behaviour was tenuously evidenced through good things; Wicken and Rawson provided alternative advice that was driven by moral female propriety, sound economic management and 'knowing one's place' within the demarcation of social class. For them membership of the middle class was a right of privilege, but one that should not induce flashy aspirations to higher levels. Rocke's book and commentary was a tempting lure that suggested – provided ample money was available – good society could be purchased alongside drawing room furniture and ornamental interior detail. For Rocke and his aspirational customers, elevation to the higher ranks of Australian society was inextricably linked to the material evidence that you deserved it and belonged there.

For Wicken and Lawson the notion of societal belonging was defined by a very different set of experiences, shaped by their origins, gender, time and location; one English and suburban, the other Australian-born, remote and isolated.

The role of women in the colonies – whether they resided in the cities or the bush – was an important one: the semiotics of conventional morality bound up in Victorian womanhood was perceived as a useful and civilising force in Australia.[214] By the 1840s Australia had begun its social reconstruction from one of a godless, desperate penal settlement to a community driven by respectable Anglocentric bourgeois ambition. As explained by Anne Summers, the taint of 'damned whore' assigned to convict women had dissipated, and colonial women emerged as the vital ingredient to normalised social behaviour. 'Colonial society

needed to be totally restructured and those who urged the facilitation of the establishment of the bourgeois family all saw the securing of a safe and respectable position for women as integral to this.'[215]

Summers continues:

> The condemnations and abuse associated with the Damned Whore stereotype had been replaced by the respectful tributes seen as being the due of women fulfilling a moral policing and civilizing role within family and society.[216]

The authorship of advice manuals by Australian women would assist this widespread belief in Australian feminine virtue. Through them women were reassured that, regardless of situation or circumstance, their home-oriented contribution to Australian society was both valued and essential. On the national imperative of female domestic capabilities Wicken would write:

> If women could awake to their high mission and consider it an honour instead of a degradation... hundreds and thousands of happy homes would spring up where they are counted in units now; and from these would arise a strong and powerful people ready and able to take a prominent place among the nations of the earth.[217]

Both Wicken and Rawson would contribute to the notion that the home was the domain of female expertise. This expertise, honed from their own experiences in the colonies – and for Wicken, carried with her from London – was best shared via the agency of print. Print was a portable authority, able to be carried and shared among the most populated as well as the most isolated parts of the country. In an Australian context this was an important consideration. Not only was the notion of good behaviour bound up in womanhood and protected within the framework of domestic space, the distances in

Australia often meant women were isolated from the guiding influence of other women.[218] This included their mothers, the traditional role model of womanly virtue and feminine capabilities. Wicken and Rawson provided a virtual voice of female authority in the absence of a real one.[219] Importantly, they shifted the practice of 'homemaking' to one of 'home economy'. 'Homemaking' was the work of Rocke's middle-class women; profusely decorated 'havens' that were the sum of their families' moral and societal worth. 'Home economy' was a cautious approach to interior management that did not alter the sanctity of home as a virtuous haven, but its costs were carefully monitored and its operation influenced by the science of cleanliness. Prudence and hygiene happily cohabited in the late nineteenth-century home. Importantly, 'home economy' liberated the kitchen from the drudgery of service and for the first time it was considered a suitable place for middle-class women to excel.

As noted by John Bowden Fewing, late nineteenth-century Australian women needed to be in control of their home, both aesthetically and economically, from front door to back:

> A clean and tidy housewife welcomes and entertains you in her drawing room where there is a piano, sofa, soft chairs and much of the paraphernalia that goes to form the equipments of the drawing room of a lady of opulence and fashion. If a further and furtive glance at the kitchen discloses a state of cleanliness and order you depart with a kind of joyous conviction that the house is blessed with a husband of sobriety and industry supplemented by the efforts of a busy, thrifty and tidy wife.[220]

The 'busy, thrifty and tidy wife' was the ideal middle-class female role-model, and for Harriet Wicken the audience to whom she would address her books.

Harriet Frances Wicken (1847–1937)

Harriet Wicken was born in Lambeth, England. She was widowed at 26 and only two of her seven children would survive to adulthood.[221] In 1886 she took the decision to follow her eldest son Percy to the colony of Victoria. She arrived in Warrnambool in September of that year with her only other surviving son, Arthur.

Wicken, however, arrived with credentials that would stand her well in the Australian colonies. Her position as a respectable middle-class woman and mother aligned her exactly to the colonies' new feminine ideal. But she also possessed specific and useful training. Following the death of her husband in 1873, she enrolled in and received a diploma from London's newly opened National Training School for Cookery in South Kensington. Cookery and home economics were now deemed suitable areas of education for middle-class women. *Cassell's Household Guide*, New and Revised Edition (c.1880), under 'Occupations accessible to women', identified the limited range of paid work best performed by middle-class women: music and art teaching, nursing, and cookery tuition.

> Presuming that the persons whose case we are considering possess moderate strength and fair health, but have no taste for nursing, the work of a cookery instructor may afford a pleasant occupation… Schools for teaching cookery are being formed all over the kingdom, and, from what we hear, we believe that the preference is to be given to women of some education as instructors; to ladies, in fact, who possess the advantages of a higher order of intelligence, greater powers of speech, and superior manners.[222]

Cassell's continues its praise of cookery instruction by quoting a 'chief promoter of the *School of Cookery* in Liverpool':

I cannot conceive… of an employment more suitable to gentle-
women, and I know of none other for which there is at present
such an overwhelming demand. There is much in it to satisfy the
most intellectual tastes, for it affords scope for any amount of
intelligence, and even for scientific study; while it is also phil-
anthropic, sociable, and never monotonous. Our teachers travel
from one place to the other, generally staying in private houses,
with the clergy, &c.; and as they associate almost entirely with
educated people, their position as gentlewomen is always fully
recognised.[223]

This was not a plea for middle-class women to cook. This of course
occurred, but more by default. Cooks were still part of the regiment
of servants that provided the labour required to run the aspirational
middle-class home. This was a plea for them to undertake an edu-
cation in the *education* of cooking: a cookery teacher, not a cook in
servitude to a house of equal standing. If one is to believe the *Cassell's*
rhetoric, the position was reflective of superior intelligence and man-
ners, and could afford women the opportunity to be 'philanthropic'
rather than 'employed', by generously sharing their expertise with
others, even those in lower social positions than theirs. The position
was safe, and even spiritual if lodgings for travelling instructors could
be taken with the clergy. The text is determined to dismiss any sense
that the job lessened one's social standing. However, a teaching post
would also provide an income for middle-class women of between £50
to £100 per annum, which in its own right was a dramatic shift in
acceptable middle-class female ambition.[224] The usual status of a wife
dependent on a husband's income was being notionally challenged,
though marriage would remain the most highly coveted 'occupation'
for women. Nonetheless, an income from a respectable avenue like
cookery instruction would have provided a welcome alternative for

women like Wicken: mother, widowed, in need of money, but keen to retain their social status as 'gentlewomen'.

In Dicken's *Dictionary of London* (1882), the National Training School for Cookery curriculum is described briefly:

> The instruction is given by practical illustrations, and is designed for ladies, from a lady's point of view, and not for the training of servants. It includes all that is necessary to make home comfortable and attractive, and a lady an accomplished ruler of her own house.[225]

Dickens was clear to distinguish that the qualification did not demote the graduate to the underclass of 'servant'. While the avenue of respectable female income from such a course was a new one, the curriculum was predominantly focused on reinforcing the accepted place for middle-class women in the home. Middle-class homemaking was no longer simply an exercise in decoration. Central to its success was the managerial capacity and economic leadership of the mistress of the house: its 'accomplished ruler'.

This attitude was prevalent through much of the advice literature at the time. Dr Pye Henry Chavasse, whose guidance was channelled through the Rocke book, weighed in heavily on the subject. Keen to displace women from the idle pursuits of the drawing room, he recommended an imposing station in the kitchen, not as cook but its commander. 'The kitchen is the heart of the kingdom and the true seat of government in domestic economies – who rules there rules supreme', he wrote.[226] Under no circumstances was this role to be assumed by a servant. Their place in the underclass below stairs predisposed them to dishonest behaviour, particularly if they were not diligently managed. A thorough knowledge of the kitchen and its workings, Chavasse argued, would mean a mistress 'effectually breaks the rod of power in her cook's

hands, and can sweep away at once the "perquisite" system, the waste, and the dishonest understandings with the tradesmen; because she is in a position to know... what is really and honestly needed'.[227]

Isabella Beeton also defines the role of mistress of the house to be akin to 'the Commander of an Army or leader of any enterprise'.[228] A mistress's first order of the day was to 'make a round of the kitchen and other offices, to see that all are in order, and that the morning's work has been properly performed by the domestics'.[229] She also recommends personally handing the day's supplies from the store cupboard (presumably locked), which suggests her own distrust of servants who would be prone to abuse any privilege of access.

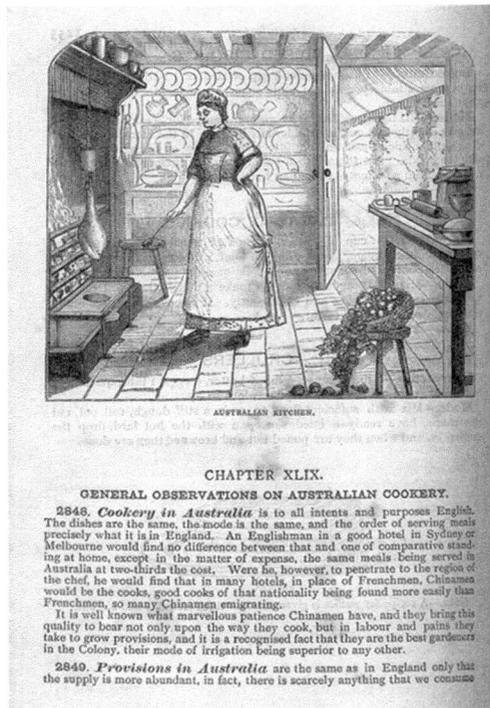

CHAPTER XLIX.
GENERAL OBSERVATIONS ON AUSTRALIAN COOKERY.

2848. *Cookery in Australia* is to all intents and purposes English. The dishes are the same, the mode is the same, and the order of serving meals precisely what it is in England. An Englishman in a good hotel in Sydney or Melbourne would find no difference between that and one of comparative standing at home, except in the matter of expense, the same meals being served in Australia at two-thirds the cost. Were he, however, to penetrate to the region of the chef, he would find that in many hotels, in place of Frenchmen, Chinamen would be the cooks, good cooks of that nationality being found more easily than Frenchmen, so many Chinamen emigrating.

It is well known what marvellous patience Chinamen have, and they bring this quality to bear not only upon the way they cook, but in labour and pains they take to grow provisions, and it is a recognised fact that they are the best gardeners in the Colony, their mode of irrigation being superior to any other.

2849. *Provisions in Australia* are the same as in England only that the supply is more abundant, in fact, there is scarcely anything that we consume

FIGURE 2.2. Introductory page to the Australian section of the 1888 edition of *Mrs Beeton's Book of Household Management*, Monash University Rare Books Collection.

Harriet Wicken would shamelessly paraphrase both Chavasse and Beeton in her own book, *The Australian Home* (1891). 'A household is like a community: it must have a head or commander in chief, and every member of the family should feel confident in her ability to rule'; and '[home] is the true woman's kingdom, and if she can wisely wield the sceptre there, she holds the power to rule the world'.[230] Similarities of language aside, the emerging ideal of a strong woman confidently in charge of her house – from the kitchen not the drawing room – had begun to counter the prevailing Victorian stereotypes of quiet, chaste, obedient 'angels' or indulged frivolous creatures whose only concern was their own vanity and pandering to the fluctuations of fashion; or as Chavasse would dismiss them, 'silly, simpering, delicate, lack-a-daisical non-entities'.[231] In the Australian context this would be a welcome shift. The prerequisite of middle-class feminine behaviour being dependent on ample time to do 'nothing' was near impossible to achieve. In rural environments especially, women were often part of the labour force required to make a living from the land, but this would not excuse them from also keeping a sound, tidy and pretty house, raising children within a Christian paradigm and delivering meals of reassuring English origin. These multiple roles meant women did indeed require sound advice, and advice that was drawn from those who experienced the same colonial living conditions as they did.

Like Beeton, Wicken was to make her name from recipes. Her *Kingswood Cookery Book* (FIGURE 2.3) was first published in London in 1885, then revised in 1889 for her new Australian market. It would prove so successful it was republished six times, the last appearing in 1913. On her arrival in Victoria Wicken quickly pursued the advantages of 'good connections'. The sound advice Mrs Beeton dispensed for the necessity of carefully selected society friendships was

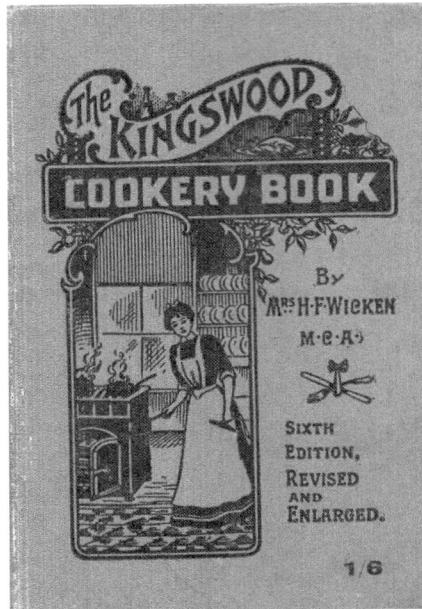

FIGURE 2.3. Harriet Wicken, *Kingswood Cookery Book*, 6th Edition (1913), Monash University Rare Books Collection.

not lost on Harriet Wicken. She befriended Lady Loch, the wife of the Victorian Governor, Sir Henry Loch. In Australia's roughshod but nonetheless pronounced observance of the English class system, a friendship with the wife of a peer of the realm, and indeed the Queen's own representative, was as high as one might hope to aspire socially. Wicken would ably build on this single connection. The second edition of her *Kingswood Cookery Book* would be dedicated to the Countess of Jersey, wife of the Governor of New South Wales, Sir Victor Albert George Child-Villiers, 7th Earl of Jersey; and her next major publication, *The Australian Home* (1891), would honour Sir Joseph Curruthers, the Minister for Public Instruction in New South Wales in recognition of his 'eminent services in the cause of technical education'.[232] Curruthers was an important ally. Not only was he well connected, but

an advocate for women's education, and thus, for Wicken, an advocate of her profession and livelihood.

In 1892 Curruthers introduced a bill to endow a women's college within the University of Sydney. While the formal establishment of higher educational opportunities for women signalled a major shift in nineteenth-century attitudes to (white) female ambition, the administration of the college was keen to calm any public anxiety that it would also irreversibly upset the distinctive gender roles that were seen to be the foundation of a normal and balanced society. At the official opening of the college's new building in 1894, the principal, Louisa MacDonald, would try to dispel any suspicion of female higher education by reassuring her audience that a woman's place in the home was not in jeopardy:

> The woman who has trained mind and thought and understanding is not the less a woman, less practical, less helpful, less truly womanly, because of that. I think her mental training will render her better in all those ways… Surely it is no Utopia to picture in Australia…when the mother may guide her household and train her children the better in that she has studied more deeply the history and expression of human thought.[233]

Higher education would not damage but enhance the role women played in the home, guiding their families financially, intellectually, socially and morally. But cookery and home economics were by their very nature home-centred, therefore already perceived as suitable to the natural skills of women. Instruction in them soon emerged in Australia as it did in England. As explained by Grace Lees-Maffei, 'Women's authorship of published domestic advice is a demonstration of the accepted credibility of their domestic expertise as a result of conventional divisions of labour according to gender'.[234]

In the introduction to Wicken's *The Australian Home*, Mrs Edgeworth David wrote that the study of domestic economy was 'a wide subject, a downright practical subject and distinctly a woman's subject'.[235] She also assured her reader that it encouraged personal habits that were 'conducive to comfort, health and happiness'[236] and therefore at no risk of disrupting the proper order of home as it had always been: a space of comforting respite and a display of wholesome family respectability. Harriet Wicken would eventually assume a role as 'Instructress in Domestic Economy at the Technical College Sydney' where both the *Kingswood* book and *The Australian Home* would become key texts in the instruction of cookery and home economics.[237]

The Australian Home (1891)

In the preface to *The Australian Home*, Wicken begins with something of an apology for contributing further reading on a subject that was already abundantly catered for, but in doing so established why her book was of value to Australian women befuddled by too many domestic advice options:

> I cannot send this little book out into the world without a word of explanation of how I came to write it. When it was first suggested to me that I should compile a handbook on domestic economy, I replied that there were already too many works on that subject; but upon reflection it appeared that although there were many excellent books on the science of domestic economy, there was not one work which gave the epitome of the whole, so I determined to write this booklet, and in the simplest possible language give the result of my experience, and my readings from many authors who have given much time and thought to this study.[238]

Like Rocke's, Wicken's text is a self-confessed 'little booklet'. At just over 250 pages it is more substantial than Rocke's, but a quarter

of the size of Beeton's *Book of Household Management*. Within her more manageable text, Wicken compiled the extent of her reading and experience. She relayed the essentials and omitted the trifles. The busy colonial housewife had no time to indulge in a profusion of lengthy Victorian prose, or sojourns into occasional French, or excessive quotes from learned others. Her text was not trying to impress the well-to-do as Rocke's was, but relay educational information to ordinary middle-class women on the importance of their calling within the home. Lolling about in decadent drawing rooms was not contributing to the country. 'It will greatly "Advance Australia" if her women study household science', she claimed.[239] Homemaking was no longer just about outward displays of taste and competitive one-upmanship; it was a 'science' informed by sound 'theories' and practiced by intelligent, educated women aware and embracing of the changes occurring towards the end of the century. City homes, and the lives within them, were in the process of modernisation. Attitudes to interior dwelling were being formed by advances in health and hygiene, urban infrastructure (plumbing, gas fittings and electricity), and an array of domestic gadgets like ice chests, sewing machines and carpet sweepers that were addressing a future in which an army of servants was no longer requisite to living well. Wicken's was the textbook within which all the knowledge of Australian domestic control could be gleaned. 'The epitome of the whole' was covered within 250 pages of pragmatic advice.

The first half of *The Australian Home* is more or less devoted to defending the knowledge of housekeeping for middle-class Australian women. 'Housekeeping' was the work of 'housekeepers', therefore the province of servants. But servants were hard to find in Australia, and even harder to keep, particularly towards the end of the nineteenth

century. In a country where the male population far outnumbered women, good domestics were often lost to the marriage market.[240] In Twopeny's *Town Life in Australia*, he bemoaned the absence of reliable servants in the colonies, insisting that 'four fifths are... liars and dirty'.[241] He did concede that 'there are some good servants, but unfortunately for their employers, the butchers and bakers generally have a keen eye for such, arguing with great justice that a good servant is likely to make a good wife'.[242]

This was combined with the job market alternatives that Australia's burgeoning cities offered – shop assistant, telegraph operator, seamstress, even factory worker – which were perceived as preferable to domestic service. The role of servant was one in which a girl surrendered herself bodily and spiritually to the needs and scrutiny of her mistress. As Margaret Anderson explains:

> [They] led arduous and lonely lives, isolated in individual houses with little contact with friends (either female but more especially male), or family and under the constant supervision of a mistress whose interest extended far beyond the work itself, to encompass the moral and, not infrequently, the spiritual well-being of her employee. Small wonder that colonial girls were notoriously reluctant to enter domestic service where other employment was offered.[243]

The basis on which the working class in England migrated to Australia would also account for a lack of servants. Why travel over 10,000 miles and numerous months to an uncertain future just to do what could be achieved at home? Immigration was a risk taken for betterment not continuum. As Anne Summers explains:

> Australia... became the fragment within which the bourgeois ideal of 'family' was able to flourish and to be adopted by all classes long before it would have been possible for them at home... From

the late 1840s onwards, thousands of migrants were able to turn their aspirations of emulating middle-class lifestyles into some kind of reality.[244]

For Australian-born girls, service was also an occupation of no attraction. Twopeny cuttingly explains:

> In a democratic country like this, where young people are brought up with the idea that one man or woman is as good as another, we can easily understand that any assertion of superiority on the part of employers, or attempt to exact an outward show of deference, is very galling to undisciplined minds.[245]

Wicken makes no special mention of servants though they are assumed to exist for the reader. On the selection of a house she advises, 'the position of the kitchen to the dining room should be studied, particularly if there is to be only one servant'.[246] Although difficult to secure, a single servant was an essential key in the smooth running of households even in smaller, lower-middle-class Australian homes. However, unlike wealthier homes where their presence was to be felt but not seen, less endowed households would show them off as part of the domestic chattels. As explained by Moira Donald:

> The aristocratic dream of the smoothly functioning household with its invisible cogs and wheels was the model for the aspiring middle-class. Oddly though, at the lower levels of the middle-class it was the labour of the housewife that had to be kept invisible, while the labour of the servant was displayed publicly to ensure status.[247]

A servant was not only essential to the running of a house, but provided the conspicuous evidence that you could afford to be waited on and therefore belonged to the ranks of the middle class. However, in households with a single servant a wife was often required to work

alongside her maid in order to maintain the visible displays of control, order and prosperity. Without her assistance the virtues inherently present to the Victorians in cleanliness and order would be impossible to achieve. However, this was an unspeakable secret; no self-respecting middle-class woman would ever admit to participating in the drudgery of domestic duties. Wicken challenged this. She lifted women's domestic capabilities out of the shadows of secrecy, and declared that they were beyond reproach and of immense national importance:

> The wives and mothers of old buckled on the armour and sent their husbands and sons to fight for faith and freedom, and the women of the present day can do the same by sending out to fight the battle of life husbands, sons and brothers strong and fearless because they come from well-managed homes where scientific knowledge is brought to bear upon the daily necessities of food and clothing and the comforts so necessary for health... it can only be pointed out how important it is to teach our girls that in the history of nations success and failure, happiness and misery rest just as much with them as with statesmen and philanthropists.[248]

Wicken reaffirmed the absolute belief in family, and of a wife being central to its cohesion and moral propriety. It was a belief shared by both private citizens and public administrators. 'Family' was part of a powerful political rhetoric that reflected the conservative, sexually normalised social systems that the colonial community was committed to. The prominent politician and advocate for Federation, Sir Henry Parkes, would write: 'Our business being to colonize the country, there was only one way to do it – by spreading over it all the associations and connections of family life'.[249]

The content of Wicken's book did challenge some accepted notions of middle-class womanhood while it simultaneously reinforced many prevailing stereotypes. For example, where once the accomplishments

of music and languages were key signifiers to good breeding and good taste, she advocated a knowledge of home management as a far superior life-skill. In the foreword to *The Australian Home*, Wicken's colleague Mrs Edgeworth David observed:

> How is it that years of a girl's life are spent in learning music and painting – which she will probably not practice when she is a wife and mother – and yet no time is spent learning what will help her to become a great success as a housewife?[250]

For Wicken the accomplishments of art, music and poetry required special skills that if not present in a girl, her pursuit of them as an adult was pointless. But any woman through the study of her book and sufficient practice could become the consummate housekeeper.[251]

Wicken did not dismiss music altogether. Her advice on the furnishing of drawing rooms demanded the presence of a piano, the only piece of furniture she deemed appropriate to purchase on a hire system. Everything else could be saved for with diligence and good management, but the joys of the piano should be present immediately a young wife sets up her house. The instrument is not, however, a tool to demonstrate to admirers her musical acumen, or provide the material evidence that you possessed the leisure-time to become proficient.[252] Music was a small luxury due to her at the end of her day's work. 'Music has a refining influence on the mind and cheers and solaces one after a day's toil'.[253]

The positioning of Wicken's middle-class wife as one domestically capable, rather than artistically inclined, had already begun to emerge in earlier Victorian advice manuals. Some authors were less inclined to elevate a woman's abilities in the role of housekeeper as Wicken did, but instead preferred to simply denigrate their cultural education as being of no practical use to their husbands.

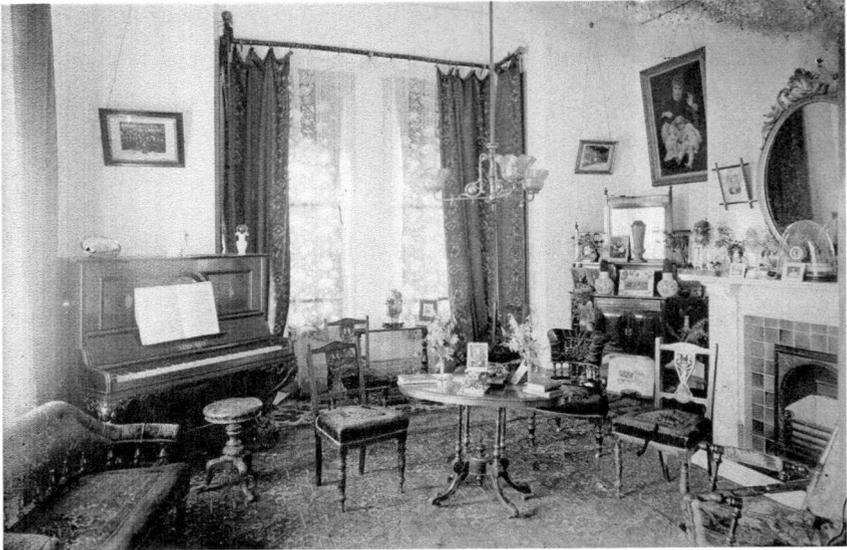

FIGURE 2.4. G.G.M. photographer. Interior of Victorian drawing room, c.1914–16, State Library of Victoria. The piano takes pride of place in the room. The date of the photograph demonstrates how resistant to change Australians were towards their late Victorian interiors.

Dr Chavasse warned his lady readers thus:

> As soon as a lady marries, the romantic nonsense of school girls will rapidly vanish, and the stern realities of life will take their place, and she will then know, and sometimes to her cost, that a useful wife will be thought much more of than an ornamental or a learned one… A man is, in general, better pleased when he has a good dinner upon his table than when his wife speaks Greek.[254]

For Wicken, good housekeeping was inextricably linked to the kitchen, and, although her text did not harbour the same brittle condescension that Chavasse's did, she would concur that knowledge of cooking and the management of the kitchen was a paramount skill for women of all stations, including those of higher rank. In fact she elevated the status of the kitchen, a space once only the preserve of cooks, scullery maids and skivvies, to that of the highest spatial rank:

the drawing room. She states, 'education and culture will be found of just as much service in the kitchen as in the drawing-room, and will turn drudgery into artistic work'.[255] She continues:

> Anyone who desired to be thought of as a 'lady' considered it a degradation to know anything about cooking but now it is the reverse... This is as it should be, for if we are so favoured by fortune that we never have to cook our own dinner, a practical knowledge may be turned to good account by instructing our servants, and perhaps some of our poorer fellow creatures who are not so fortunately placed as ourselves.[256]

Capabilities of the higher ranks in the kitchen were thus not to be secreted away, but encouraged, celebrated and shared. Wicken evoked both class-consciousness in her text and an odd egalitarianism; though this manifests itself as 'sympathy' rather than equity. 'Sympathy' was a peculiar Victorian luxury, offered only by those who could afford to dispense it, to those in no position to refuse it. Ideas that an army of upper-middle-class woman would administer instruction on the benefits of modern cookery to a poverty-stricken underclass seem somewhat far-fetched. It does, however, reflect the familiar Victorian theme of 'pity' – sometimes genuine but often heartless – so regularly played out in both literary fiction (Dickens) and real administration (poor houses, orphanages and missionary settlements).

Class is an important consideration in the Wicken book. While the aforementioned text is encouraging of well-to-do ladies in the kitchen, her book is not for them. She collectively gathers her readers to her own site of belonging:

> We belong to that large class of society who have to work hard for their daily bread, where economy is more needful than ever... with true economy, peace and plenty will prevail and order and contentment will follow.[257]

Her succinct reference to Christian doctrine (give us this day our daily bread) created a deliberate union between home management and Christian behaviour.[258] Unlike the Rocke book, Wicken did not suggest that riches will make a comfortable house; but an almost evangelical devotion to economy would. Even the wealthiest home, poorly managed, would not be comfortable.[259] 'Comfort' was a prevailing concept in Victorian advice, but did not necessarily imply the enjoyment of leisurely repose. The 'comforter' was the Holy Spirit; therefore to be 'comfortable' was to be enveloped in the spiritual beliefs of Christianity.[260] Home was the space in which one could impose comfort and thus align both it and its inhabitants to a plane of righteous, spiritual belonging.

For Wicken, 'comfort' was also attached to knowing one's place – what Linda Young describes as 'the exquisite consciousness of self in society'.[261] Awareness of one's social position and the rules of behaviour inherently linked to it required both effort and instruction. The familiar Victorian trope of 'self-improvement' could be achieved through Wicken's lessons in better domestic skills, the honour and gravitas of which far outweighed any material show of fashionable furniture. Household goods needed to be commensurate with income and therefore commensurate with place. 'We must not allow ourselves to be the slaves of fashion, but study comfort as well, and above all, what is suitable to our position in society'.[262] For Wicken, a family's possessions must reflect accurately their social situation, not pretentious aspirations above their station or mean degeneracy below it. Whereas Rocke encouraged those recently rich from the goldfields or agricultural land holdings to reflect their bank balance rather than the origins of their class, Wicken warned against showy displays of riches or extending finance to cover the cost of furnishings:

> It is a great mistake to have costly furniture and effects unless
> we are prepared to renew them as required and can have servants
> capable of taking charge of them; we are not writing for those
> highly favoured people, but for young people who have not much
> to spend and yet want a pretty home.[263]

'Knowing one's place' also extended to the physical position of home. Location was then, as it is today, a determining factor in the selection of a middle-class house. Wicken advised:

> Choose a good neighbourhood… the position of our dwelling
> place often settles our own position in the world… it is a difficult
> matter for us to keep up our own self-respect when we have to
> contend continually against depreciating influences.[264]

From this advice we can assume that one's position in middle-class society revealed itself in the physical site of middle-class suburbia, which by the 1890s was the well-established mode of urban development in every Australian capital. The suburbs provided the space in which the like-minded middle-class could gather with a shared ambition for a comfortable life, removed from the business and filth of the city, the poverty of inner-city slums and the terror and isolation of the bush, none of which were deemed appropriate spaces in which to nurture homely female virtue. Instead a husband, a family and a house in the suburbs became the keynotes of respectability.[265]

Indistinguishable from 'comfort' was 'order'. As John Gloag explains, 'Comfort was inseparable from tidiness. Victorian homes would have been hopelessly chaotic without a known and settled place for the innumerable objects that occupied every available space.'[266] For Wicken order went beyond the careful arrangement of ornaments and knick-knacks. It was not linked to wealth or the number of servants, but control and discipline of self and those in her charge. Order was not

just a priority, but an evangelical mission. 'Order is Heaven's first law and without it no comfort can be found in our homes however much money may be spent or whatever may be the number of people employed to do the work'.[267]

Wicken was not offering new or contradictory advice, but reinforcing a long prevailing construct of Victorian femininity. The maintenance of 'order' was regularly posited as a woman's most valued attribute. It was particularly valuable in a colonial context but also imported as a sign of English conformity. In *Sesame and Lilies*, Ruskin would write:

> [A] woman's power is for rule not battle – and her intellect is not for invention or creation, but for sweet ordering, arrange-ment and decision... Her great function is Praise; she enters into no contest, but infallibly adjudges the crown of contest. By her office and place she is protected from all danger and temptation... This is the true nature of home – it is the place of Peace, the shelter, not only from all injury, but from all terror, doubt and division.[268]

Wicken endorsed the honour of 'knowing one's place' and remain-ing there content and capable, but undesirous of change. She was particularly keen on maintaining a woman's place: higher education was an excellent proposition for women, provided it still bound them to a domestic code of behaviour *inside* the home. While the establish-ment of female suffrage and political equity was beginning to gather momentum around her, she remained steadfastly opposed. In her book, she writes:

> There is great talk now-a-days about 'women's rights', and some seem to think she can only obtain her rights by rushing into the world of business and politics, but surely this is a mistaken notion. The greatest opponent of what is termed women's rights never for a moment tries to wrest her own kingdom from her

– her home – here, without question, she is allowed to reign supreme… There may be cases where a woman of exceptional ability, and without home occupations, can take part in public business without detriment to her womanhood, but these cases are rare and merely prove the rule that women's best and highest rights lie within the four walls of home… Here she can train the young, who are to go forth by-and-by to fight life's battles, and in her hand lays the power to send them out strong and valiant, strong to withstand temptation, valiant to fight for all that is noble and great.[269]

While it would be easy to admonish Wicken for reinforcing the restrictive boundaries of female domesticity that would prevail well into the twentieth century, there is a time-appropriate value in her advice. Her text was steeped in the comfort of spiritual and national belonging. Beneath the cover of her book, emblazoned with a stylised Southern Cross, urban Australian women were alerted to the binding qualities of ordinary domestic life codified by distinct gendered roles. For many Australians 'ordinary' was an admirable quality. It did not possess the unflattering taint of humdrum mediocrity, but was a cultural bond of reassuring commonality in which people subscribe to a shared system of beliefs and achievable ambitions. Wicken offered instruction in sameness; the reassurance of being indistinguishable from other middle-class Australians and, for that matter, middle-class Britons. Her book celebrated the middling mainstream. It discouraged the unruly human condition of raw frontier settlement by imposing a system of polite – but not genteel – behaviour. She also preserved her readers from the ridicule of others who might see through any pretence at being exceptional. In *Town Life*, Richard Twopeny, one of the judgemental 'others', was ruthless in his criticism of Australia's new-money imposters with no training in society ways – the parvenu:

wealthy ladies 'to the manner [sic] born' are not so numerous in Australia that I need dwell long on the drawbacks of their position. It is at any rate happier than that of the parvenu, unless the mere fact of being arrivée confers any special enjoyment. At what has she arrived? At carriages, at dresses, at houses and furniture, and at servants of a style she is totally unaccustomed to and unfitted for. When you tremble before your butler, and have to learn how to behave at table from your housekeeper, wealth cannot be unalloyed pleasure. Without education and taste, the parvenu has small means of enjoying herself except by making a display which costs her even more anxiety and trouble than it does money. Wiser is the rich woman who contents herself with the same style of life as she was accustomed to in her youth, adding to it only the things that she really wants – a more roomy house, a couple of women-servants, and a buggy. Thus she can feel really comfortable and at home; but unfortunately for their own and their husbands [sic] 'peace of mind' these poor women are too often ambitious to become what they are not. Even leaving aside the discomforts which are always allied to pretentiousness, the poor rich woman has a hard time of it. What can she do with herself all day long? She has not gone through that long education up to doing nothing which enables English ladies of means to pass their time without positive boredom. She has no tastes except those which she does not dare to gratify, and becomes a slave to the very wealth whose badge she loves to flaunt.[270]

Wicken, unlike Rocke, provided decorative advice to counter material pretensions. This is best exemplified in her suggestions for the ubiquitous 'cosy corner'; that personalised little nest constructed by Victorian women in sitting rooms when they could not afford the decadence of a boudoir, and probably did not approve of one. 'Cosy' is completely at odds with 'magnificent'. It denotes small and humble, but also what 'magnificent' cannot achieve: warm and homely. Bachelard defended corners as essential to the practice of habitation:

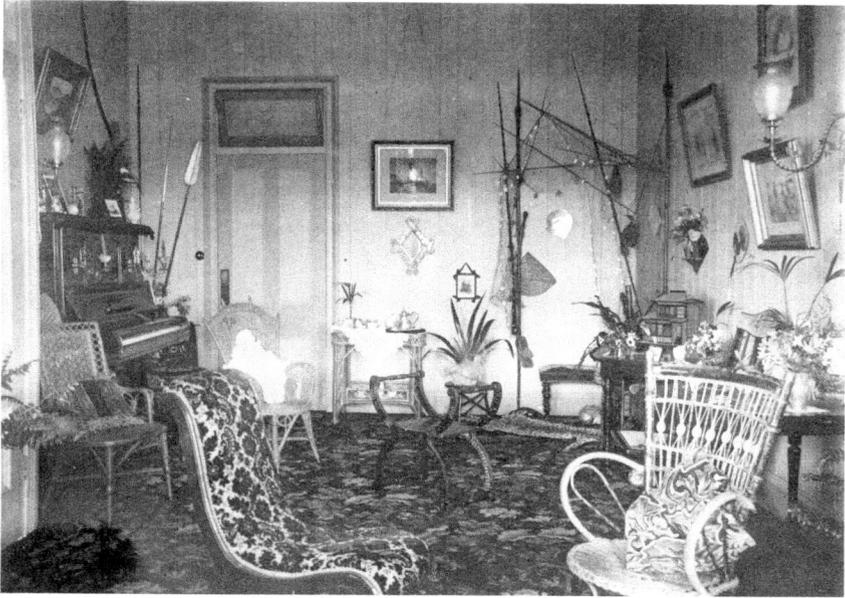

FIGURE 2.5. Drawing room interior of the Clayfield residence, Elderslie, in Brisbane (no date), State Library of Queensland. Room decorated with palms, souvenirs and a unique 'corner' constructed of Aboriginal spears and fishing net.

> In our house we have nooks and corners in which we like to curl up comfortably. To curl up belongs to the phenomenology of the verb to inhabit, and only those who have learned to do so can inhabit with intensity.[271]

To 'curl up' is more a twentieth-century delight, but Bachelard's ideal of 'intense' habitation would echo the nineteenth century's staunch devotion to interior dwelling. A cosy corner encouraged long sojourns into quiet but profound inactivity during which the remainder of the room could be admired, the day's toils forgotten, and a woman reassured of the wholesomeness of her house.

Unlike Rocke's rooms of opulence, Wicken's little corner is furnished cheaply. But its economy is thoroughly disguised under layers of fabric and fringe:

A carpenter can make a deal bench to fit or it can be made from some packing cases. If the latter, remove the lids, stretch sacking across; make some broad cushions, and cover them with pretty cretonne, and… border it with ball fringe… A shelf may be put up, painted with enamel and used for books or ornaments. A Japanese curtain draped on the wall above completes the whole. There is no furniture more artistic and pretty than wicker.[272]

Rocke would never advocate packing-case furniture, nor Wicken's elevation of cane and wicker. 'You can never divest it of an air of plainness that is almost distressing', he said of the material.[273] But Wicken was equally scathing of the high Victorian furniture of Rocke's generation, denigrating it as 'ponderous certainly, but not beautiful… Far lighter and prettier is the style adopted in the present day'.[274] For hallways she advocated 'a wicker table and two or three chairs draped with liberty silk to match the carpet, and a few pot plants, hardy ferns or palms standing about, and some pictures on the wall'.[275] In the dining room, 'shelves can be filled with books and ornaments, and some brackets screwed onto the sides on which may stand a cup and saucer or other nick nacks'.[276] The drawing room is where a wife can 'indulge her little fancies: and it is astonishing what wonders clever fingers and a little ingenuity can accomplish in transforming a bare room into a nest of beauty'.[277] The mantle shelf of any room should be draped with 'art muslin, and one of those pretty artistic screens in the middle'.[278]

Wicken's status as a recently migrated middle-class English woman had predisposed her to an English prejudice in ways of thinking domestically. Her advice on home decor was particularly aligned to English precedents, and what she advocated for the Australian home was without doubt a mirror of what she left behind in London. Though she makes no direct mention of it or its leading exponents, the English Aesthetic Movement was undoubtedly referenced in her approval of

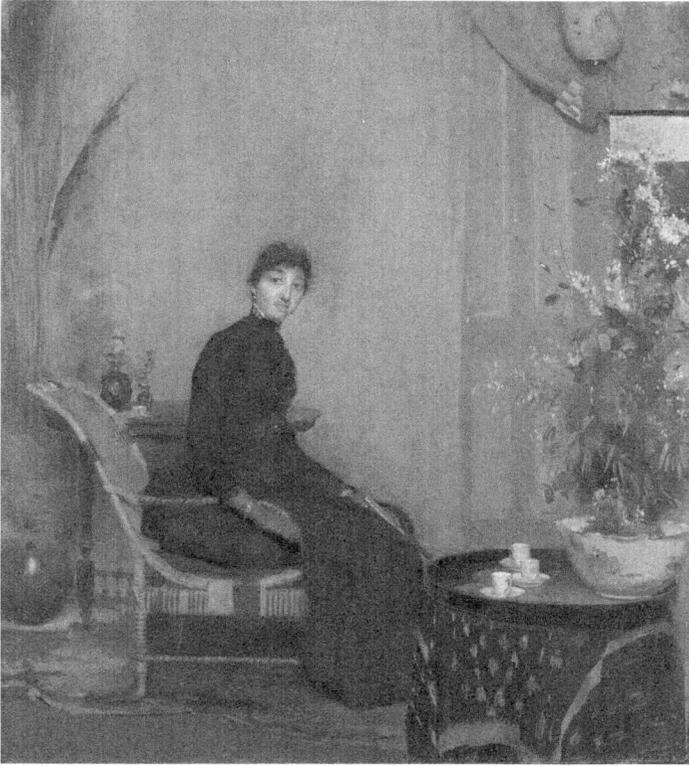

FIGURE 2.6. Tom Roberts, *Mrs L.A. Abrahams* (1888), National Gallery of Victoria.
Roberts's fashionably decorated studio in Grosvenor Chambers, Collins Street
demonstrates the influence of the English Aesthetic movement in Australia.
The wicker chair, Japanese lantern, fan, bowl and tray subscribed to
Wicken's interior advice.

liberty silk, Japanese curtains, art muslin and 'pretty artistic screens'.
These, however, are a minor concession; a diluted acceptance of the
look for its prettiness rather than any acknowledgment of the move-
ment as an intelligent retort to the meretricious detail of the Victorian
interior. She simply slots the elements of the look into her hallway,
drawing and dining rooms among the usual heterogeneous collection
of wicker, sentimental keepsakes, knick-knacks and potted palms.
Wicken's advice represented an appropriation of the modern English

interior, but arguably skimmed over, or even ignored, its intellectual position within contemporary design reform. As Tony Fry posits:

> Australia has been historically constituted by the processes and forces of import as a diverse and nuanced range of social appearances. This can be regarded as marginalised bricolage formed from eclectic patterns of objects of immigration and appropriation, drawn from the forms of a modern world elsewhere.[279]

Wicken's interior furnishings were part of Fry's 'pattern of immigration and appropriation, drawn from the forms of a modern world elsewhere'. Appropriated though they may have been, her interiors also clearly referenced the vast body of English middle-class who, like her, cared little for high-brow 'intellectual' assertions of interior dwelling, and were content to sit in rooms formulated on a more commonly understood principle of decoration: personal taste that aligned with a vast community of others, not a minority of aesthetic cognoscenti. Lucy Orrinsmith would have dismissed her room as the 'ordinary lower middle-class drawing-room... the very head-quarters of commonplace'.[280] And Eastlake would have had no time for her 'little fancies' made by 'clever fingers':

> the so-called 'ornamental' leatherwork... so much in vogue with young ladies was – like potichomanie, diaphenerie, and other drawing-room pursuits – utterly opposed to sound principles of taste... Such work as this may be the rage for a few seasons, but sooner or later must fall, as it deserves to fall, into universal contempt.[281]

But Wicken had her own following of a different sort, to whom she was an exemplary role model and an intelligent authority. We cannot put aside that *The Australian Home* was not only publicly available, but also issued as a tertiary education textbook and as such found its

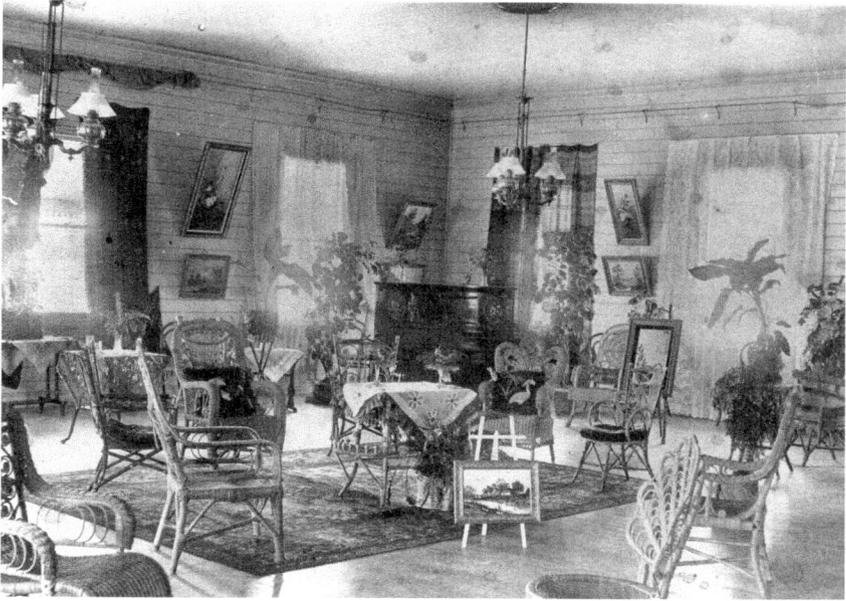

FIGURE 2.7. Room furnished in wicker furniture and ornamented with potted palms
and aspidistras in a residence at Bowen, Queensland (c.1895),
State Library of Queensland.

way into the satchels and homes of innumerable girls who undertook
an education in domestic economy throughout the country. There is
authority in a textbook. It is an acknowledged source of correct infor-
mation sanctioned by the wise governors of an institution. *The Australian
Home* would become the basis upon which many young women would
build their own 'nests of beauty' in the assurance that they were doing
it correctly and under the auspices of a proper education.

Wicken's interiors were not new, nor were they original. They were,
however, embedded in a network of familiar meaning. Her advice
on the interior is mainstream reassurance rather than adventurous
arrangement, or worse, pretentious folly. Her room descriptions conjure
up the innumerable images of respectable middle-class homes of the
late Victorian period: draped, patterned and, although edited, still

profusely furnished apartments. Her rooms were the type that would have reassured new English arrivals that they had not left 'home', but remained cocooned inside the protective clutches of Imperial rule. And for her local audience the message was no different. On his visit to the Australian colonies in 1885 the English historian James Anthony Froude remarked with some delight that he had found 'English life all over again: nothing strange, nothing exotic, nothing new or original'.[282] His description mirrors exactly the rooms of Wicken: nothing strange, nothing exotic, nothing new or original. The familiar interiors and domestic patterns advocated by Wicken would persist, thrive and indeed survive well into the twentieth century. Her predictable but respectable suburban interiors were those that two generations later would remain the bond of conventional middle-class identity. In 1936 George Orwell would describe with disdain the persistence of the compliant middle-class interior and the political code that it identified:

> The lower-middle-class people in there, behind their lace cur-
> tains, with their children and their scraps of furniture and their
> aspidistras – they lived by the money-code, sure enough, and yet
> they contrived to keep their decency. The money-code as they
> interpreted it was not merely cynical and hoggish. They had their
> standards, their inviolable points of honour. They 'kept themselves
> respectable' – kept the aspidistra flying.[283]

However, for Harriet Wicken and all those women who apprec-
iated and followed her advice, compliance to a familiar framework of middle-class respectability was a comfort that could not be measured via a money code. Their unremarkable but carefully composed interiors located them in a currency of unfaltering stability. They could awake every day, confident that they could contribute to known conventions that protected their place in a system of reassuring ordinariness.

Chapter 3

THE BUSH BOURGEOISIE

The Works of Wilhelmina Rawson

> Almost every young matron has among her wedding presents a
> good cookery book, either Mrs. Beeton, Warne, or some other
> equally good and useful for town use, but which in the bush
> or country, owing to the scant material to work with, becomes
> nearly useless.[284]

The above quote is the preface to Wilhelmina Rawson's first book,
Mrs. Lance Rawson's Cookery Book and Household Hints, first published
in 1878[285] (FIGURE 3.1). From the outset Rawson identified the need
for specific and localised advice to rural Australian women. Rocke
and Wicken wrote for two distinctly different, but largely urbanised
audiences; one the well-heeled, new-money upper middle class, the
other the lower-middle-class suburban majority. Towards the end of
the nineteenth century Australia was moving rapidly towards becom-
ing one of the most urbanised societies in the world, and it stood to
reason that most advice on dwelling should concentrate on town life.
By 1891 two-thirds of the population were living in cities or towns.[286]
A majority for sure, but one cannot discount the remaining third living
in rural environments. Wilhelmina Rawson did not.

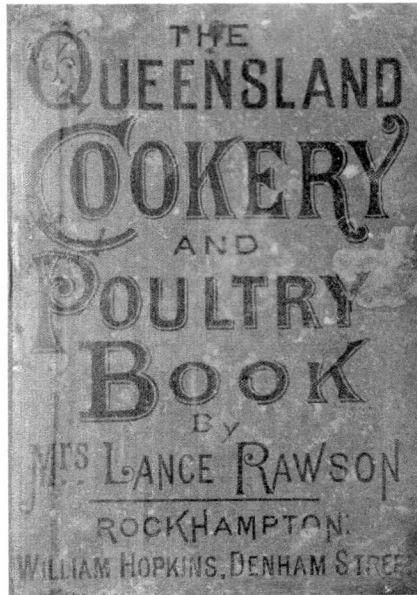

Figure 3.1. Wilhelmina Rawson,
The Queensland Cookery and Poultry Book (1890),
Monash University Rare Books Collection.

Wilhelmina (Mina) Rawson (nee Cahill) was born in Sydney amid the city's now well-established genteel community.[287] Her father James Cahill was a solicitor, a profession that then would easily provide access to a life of middle-class contentment. However, his premature death in 1863, when Rawson was 12, would displace her from a life of middle-class city comforts, though never from middle-class aspirations. Her mother, Elizabeth, remarried, to a doctor, James Cadell, whose property outside Tamworth would provide the incubation space for her very specialised skills in bush-based middle-class living; a hybrid existence that united the necessities for basic survival with the decorum of bourgeois pleasantries. Her newfound situation was one of familial complexity which helped hone her capacity for forthright independence and 'resourceful' domesticity. Her mother had

married a man who already had 11 children from his first marriage, to which she would add another four. In 1920, amid her serialised memoirs, she wrote:

> When I was barely twelve years of age, my mother took it into her head to marry a man with eleven children. I, being an only and much adored child up to that time, found her ideas of pioneering more tragical than comforting, and as she added four more to the family it is hardly to be wondered that I am somewhat resourceful.[288]

At age 20 Mina would marry Lancelot (Lance) Rawson in 1872, and move with him to the Rawson Brothers' cattle station, 'The Hollow', near Mackay in Queensland (FIGURE 3.2).[289] Lance and his brothers, Charles and Edmund (Ned), were English squatters whose ancestral home was Wasdale Hall in Cumbria. As such, Lance was an appropriate match for Mina, keen to protect her middle-class provenance. The Hollow was not, however, any match to the stately pile of Wasdale Hall.

Nonetheless, the Rawsons represented white Australia's ideal couple. Raymond Evans and Kay Saunders articulate this ideal as 'women with advanced homemaking skills and men with the wherewithal to provide homes for them were prescribed as the ideal recipe for colonial success'.[290] But colonial success in the bush was a hard and continuous battle that required risk, perseverance and for some a transient, nomadic lifestyle. A succession of relocations would see Lance and Mina – and by 1880, four children – move through several remote sites including an isolated sugar plantation, 'Kircubbin', and a fishing station near Wide Bay. The Rawsons would be the first European settlers at 'Boonooroo', Wide Bay, and it is her experiences here that Rawson credits with honing her bush acumen.

FIGURE 3.2. Edmund Rawson, *Distance View of The Hollow, Mackay* (c.1872), State Library of Queensland.

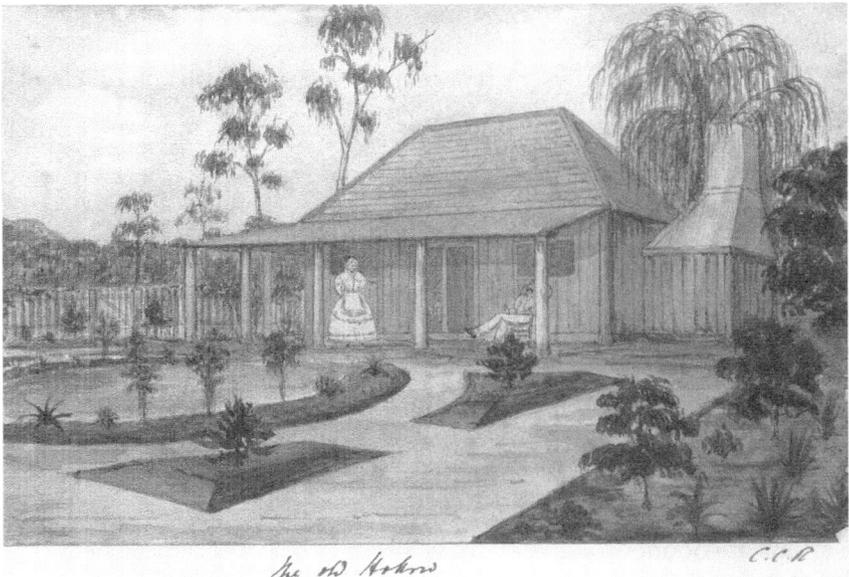

FIGURE 3.3. Charles Rawson, *The Old Hollow*, watercolour, c.1870, State Library of Queensland.

My experiences gained during rather a hard two years, when I lived on the coast of Wide Bay, sixteen miles from the town of Maryborough. When I with my husband and his partner went to live there, no woman or indeed man either, until they took it up had ever put foot there… the place was in its primitive state; for seven long months I lived there without seeing a white woman.[291]

No advice gleaned from either Australian or imported English city-centric texts were in the least bit suitable for the requirements of frontier survival let alone support the complexities of feminine middle-class behaviour that, despite isolation and hardship, remained an enduring desire among the wives of Australia's rural squattocracy. Rawson would author her own in the hope of addressing the plight of other women who found themselves in her situation: middle class and keen to retain the status, but isolated and removed from any vestige of middle-class society.

The Bush

The bush was a hostile, alien landscape that bore no relation to the English prescription of 'countryside', captured on every chocolate box as quaint thatched cottages between majestic trees, within a buggy-ride distance of a town centre, a church, stores, public house and people. At best it was described as 'ugly' by English tourists. Anthony Trollope would remark, 'we, at home in England, are inclined to believe that Australia, as a country, is displeasing to the eye. The eternal gum-tree has become to us an Australian Crest, giving evidence of Australian ugliness.'[292] At worst it was a place of inconceivable fear, best encapsulated by Frederick McCubbin's 1886 painting *Lost* (Figure 3.4) in which a helpless girl is represented entirely overwhelmed by the disorientating sameness of the Australian landscape.

FIGURE 3.4. Frederick McCubbin, *Lost* (1886), National Gallery of Victoria.

If able-bodied and capable men like Burke and Wills were to succumb to the terrors of the bush, what hope had a child?[293] The bush was, as Kay Schaffer argues, 'non-nurturing and not to be trusted'.[294] It was not a site predisposed to the gentleness, warmth and controlling order of the virtuous Victorian mother. It was, as Henry Lawson would declare it, 'no place for a woman'.[295] In *The Drover's Wife* (1892), Lawson revealed some of the brutal realities of a woman's existence on the land. Her days were spent tending to cattle during her husband's extended six-month

absence. The herd had been thinned by a disease that she could not stem. She was charged with protecting her children and keeping them safe from flood, fire, 'villainous-looking sundowners' and 'gallows-faced swagmen'.[296] In Lawson's story a large black snake is the metaphor for constant – and deadly – impending danger. Crying was her only solace. Lawson describes her mothering instinct as something quite different to the 'angel' mythologised within Victorian middle-class narratives:

> She loves her children, but has no time to show it. She seems harsh to them. Her surroundings are not favourable to the development of the 'womanly' or 'sentimental' side of nature.[297]

Lawson described the drover's wife's home and its location:

> the two-roomed house is built of round timber, slabs, and stringy-bark, and floored with split slabs. A big bark kitchen standing at one end is larger than the house itself, veranda included. Bush all around – bush with no horizon, for the country is flat. No ranges in the distance. The bush consists of stunted, rotten native apple-trees. No undergrowth. Nothing to relieve the eye save the darker green of a few she-oaks which are sighing above the narrow, almost waterless creek. Nineteen miles to the nearest sign of civilization – a shanty on the main road.[298]

Her home was one of a woman whose husband had fallen on hard times. A great drought had ruined his hopes of an abundant and independent living from the land as a well-to-do squatter, and he had returned to droving for someone else, resulting in long absences from home. She was isolated from the white construct of civilisation – a shanty was only 'a sign', not a confirmation – by a great expanse of Australian landscape that for many Europeans offered nothing of value either aesthetically or economically. This was Rawson's reality also, but she was determined not to become a victim of Lawson's hellish bush. She would not only survive her isolation at Wide Bay, but conquer it

with skills that moved outside of the regular framework of bourgeois femininity, but without ever truly deserting it.

Rawson's books offered a plethora of advice that could only be gleaned from actual participation in the process of rural colonisation. In one book she could proffer solutions for curing tapeworms in lambs, clearing scum from the eyes of cattle, advise on basic house construction and, in another volume, suggest appropriate table decoration for a luncheon party:[299]

> As every experienced hostess knows, the table decoration and appointments are everything towards success... The young hostess should be careful not to overdress her table, a fault even worse than the other extreme. She should decide on her scheme of colour and work with it. For instance, suppose she takes white and gold – of course the tablecloth must always be of fine linen. In the centre of the table she can have a pretty gold gilt basket of white and yellow flowers, marguerites, with yellow centres, and a sprinkling of maidenhair fern or asparagus foliage interspersed.[300]

Because the needs of the land required Rawson to frequently abandon the Victorian predilection for interiorised 'lady-like' behaviour, this did not deny her the pleasures of occasional but explicit acts of middle-class gentility. What may now read as meaningless, even ridiculous behaviour, the protocols of English ceremony – whether domestic, like luncheon and afternoon tea; or public, like the excessive pomp of royal visits – were essential in demarcating 'coloniser' from 'colonised'.[301] The physical display of a tea service, linen and table decoration combined with the class-conscious behaviour that hovered around them were key signifiers that the (white) participants understood and conformed to the acknowledged goals of civilisation. It provided both the material and behavioural evidence that they were

born to, and understood, advanced social constructs that elevated them above 'primitive' and 'savage'.

Even within Lawson's woeful tale of *The Drover's Wife*, bereft of any vestige of middle-class comfort, a woman found solace once a week in a single genteel act. Here he describes her Sunday ritual:

> on Sunday afternoon she dresses herself, tidies the children, smartens up baby, and goes for a lonely walk along the bush-track, pushing an old perambulator in front of her. She does this every Sunday. She takes as much care to make herself and the children look smart as she would if she were going to do the block in the city. There is nothing to see, however, and not a soul to meet.[302]

Despite the depth of cultural descent the bush imposed on the woman, Christian convictions and the observation of a Sabbath ritual were her last but resilient memories of civility.

European wives and their observance of social protocols were also seen to protect their husbands from falling prey to the primitive. The bush was a masculine challenge, a potential hero-maker, but it was also a temptress. Removed from the moral compass of Victorian civility, the bush provided an adventure for men that could not be matched by the predictable niceties of urban, 'gentlemanly' behaviour. The moral authority embodied in women was seen to curtail the risk of the 'adventure' descending into 'depravity'. They provided the evidence of conventional marital relationships, an unadulterated European blood-line in children, and the perceived absence of unspeakable sexuality: homosexuality and relationships with Aboriginal women.

For Rawson, and others who endured her isolation, an adherence to middle-class acts of polite behaviour bound her spiritually to a generic body of middle-class women of the British Empire: sacred, righteous, faithful and valuable. 'God's Police – wives and little children – good

and virtuous women', as Caroline Chisholm had long before described them.[303] Although Rawson advocated a hybrid womanhood that both honoured the sacred qualities of a wife and mother, and encouraged a resilient survival instinct that empowered her to confront whatever unpredictable situation the bush threw at her, underlying her advice was a strict code of female conduct that bound women to the highly gendered space of 'home'. Rawson acknowledged and participated in her immediate exterior – the bush and the outback – but her view of it was predominantly from the inside: the domestic space that required her expertise in cookery, decoration and the management of servants.

Like Harriet Wicken, Rawson would build her reputation through recipes, but, unlike her, they did not linger in the culinary traditions of Britain. In methodology they certainly did, but not in terms of ingredients. Rawson advocated the cooking and eating of a vast array of Australian wildlife: parrot (as a soup boiled and flavoured with salt and pepper, with the birds served separately in pools of melted butter), mud turtle (cooked in hot ash), goanna tail ('makes an excellent curry and a young one just skinned and grilled... is an excellent breakfast fit for anyone'), bandicoot (scalded, scraped then baked or boiled), wallaby (stewed or baked), ibis (soaked in vinegar then stewed), white grubs, grasshoppers, snakes and flying foxes.[304]

> Flying foxes are excellent eating, though anything but agreeable creatures to touch, or indeed to have anything to do with on account of the strong unpleasant smell they have, but once you get rid of the wings and skin ... you will hardly know the flesh from pork.[305]

In *More than Just Recipes: Reading Colonial Life in the Works of Wilhelmina Rawson*, Blake Singley claims that 'food was a central element in the articulation of many colonial societies and became a

lens through which to observe the operation of colonialism'.[306] Food was more than essential sustenance, but a means to connect colonial participants through the sensorial experiences of taste, smell, ceremony and memory. Rawson's ingredients were unique, but also readily at hand. Her methodologies, however – baked, boiled, grilled, stewed or steeped in vinegar – were distinctly English in origin, and, as such, comfortingly familiar and aligned to 'civilised' culinary processes. Even 'currying' speaks of connection to the Anglo-Indian food practices of empire. Hot ash is, however, one concession to Indigenous cooking methods. Nonetheless, via food preparation and her other personal colonial triumphs, Rawson's 'desire was to tame what she deemed to be a "savage" land through the cultivation of European crops and to alter the landscape surrounding her into her own personal vision of civilization'.[307] Singley suggests that she even sought to tame native animals to make them equate to how she believed European wildlife behaved.[308] As her books reveal, Rawson also relentlessly strove to impose these same qualities on the remote Australian interior.

It is difficult to imagine Rawson's recipes would convince any squatter's wife with pretentions to gracious living to indulge in 'the great amount of pleasure… gained in trying new dishes with primitive materials'.[309] It was probably more the abundance of traditional recipes among the experimental ingredients that secured her success. Nonetheless, the recipes set her apart as distinct and independent of every other nineteenth-century lifestyle advisor, including Rocke and Wicken. She was Australian born; wrote for and from a uniquely Australian perspective; was rurally situated not city-centric; and, most unusually, acknowledged her debt to the Indigenous population. Wicken declined to mention them at all. They had no place in middle-class suburbia. Rocke suggested their weapons and artefacts

might make an appropriate display for a gentleman's smoking room, but as decorative ornaments not as an acknowledgment of cultural worthiness. When the majority of white Australians were determined to loath them, fear them or at best sympathise with their unfortunate but inevitable decline, Rawson cast into print a white woman's praise for their abilities on the land. Her language does harbour some of the vile collective terminology ('blacks' and 'gins'), and she certainly positions herself above them socially. They were servants and she was their superior. Nonetheless, she acknowledges their contribution to her understanding of bush food and survival. In *The Antipodean Cookery Book* (1895), she wrote, 'speaking personally I am beholden to the blacks for nearly all my knowledge of the different ground game'.[310] Earlier, in *The Queensland Cookery and Poultry Book*, she devoted a considerable number of pages to her experiences with Aboriginal women and the indentured Melanesians ('Kanakas') she employed as servants. Rawson, without fear of judgement, relayed multiple stories of learning about food and bush medicine from her black employees. One anecdote tells of a painful sting being relieved by her servant chewing a root and smearing the saliva on Rawson's affected hand.[311] For most European women of her rank, white domestics were denigrated as unequal, but black workers were held in the lowest regard.[312] The very thought of their spittle being smeared on white hands would surely have been, for many, more repellent that the pain itself.

While Rawson presents in her books an unusual tolerance for her black employees, she does concede to the prevailing Victorian belief in their inevitable non-existence:

> Many a life has been lost in the bush through not knowing what
> roots, leaves etc, were eatable, or what trees to tap for water...
> I have seen the blacks find it... these are the lessons white men

should learn from the blacks before the work of extermination which is so rapidly going on has swept all the blacks who possess this wonderful bush lore off the face of the earth.[313]

For the Victorians, Australia's Indigenous people were either a pitiful 'otherness' or a criminal menace. It is only in her 1890s books that Rawson showed any empathy towards her Aboriginal and Melanesian servants. In 1919 she began a series of reminiscences in *The Queenslander* titled 'Making the Best of It'. In one entry of March, 1920 titled 'The Law of Sanctuary', she recounts her disturbing approval of shooting Queensland Aboriginals who raided cattle stations for food in the 1870s. She writes, 'The Squatters ... went out in parties, and, to use the term most in vogue, "dispersed the niggers with Winchesters and revolvers"'.[314] Rawson's approval of Aboriginal slaughter, like the opinion of Sala, did not raise the ire of an outraged public. She was a revered voice who exposed an appalling shared opinion. Without rebuke, Rawson continued to write for *The Queenslander* for the following two years. On her death in 1933, *The Brisbane Courier* wrote that Rawson was 'a notable woman resident of Queensland's earlier days... [who] told thrilling stories of experiences among the aboriginals and the kanakas'.[315] Despite her books' appreciation of their 'wonderful bush lore', she revealed in *The Queenslander* her true opinion of Aborigines: 'It wasn't any love or even liking for the blacks, for I hated them all', she wrote.[316]

Rawson's disregard for those beneath her class extended also to white servants. Like many middle-class men and women of her time, she bemoaned the absence of good domestics. The first chapter of *Mrs. Lance Rawson's Cookery Book and Household Hints* is devoted to advice on servants, and her second sentence declares them 'a plague'.[317] This was a common opinion. Twopeny's own chapter on Australian

FIGURE 3.5. Charles Rawson, 'Katherine, the new servant at The Hollow, "turns out a rank duffer" setting the table incorrectly after being shown three times how to do it properly' (1871), State Library of Queensland. Charles diligently documented family life at *The Hollow* throughout the 1870s, before he returned to England in 1886.

servants opens with the statement, 'that servants are the plague of life seems to be an accepted axiom amongst English ladies of the upper middle-class'.[318] Martha Loftie in *The Dining Room* (1878) persistently described servants as 'clumsy', 'careless', and 'lazy' amid constant references to breakages and mistreatment of household objects. But Mrs Beeton set the tone some 10 years prior: 'Matronly ladies and ladies just entering on their probation… talk of servants, and… wax eloquent over the greatest plague in life while taking a quiet cup of tea'.[319] The condescension the Anglo middle-class heaped upon those who served them appears to have been among their most persistent – and global – class connections.

In Rawson's book the appearance of the subject itself indicates the presumption that a class demarcation identified through a servant–mistress relationship should be transposed into the bush; and, as her first topic, it was also of paramount importance.

Rawson expands on her servant problem:

> Servants of late years have certainly become a perfect pest, particularly in Queensland. Many of those who come as emigrants

are no more fit for their business than if they came to be plough-men... it is beyond me to say with whom the fault lies, or how it is we get such an inferior class of servants from England. Many of those who emigrate are the very scum of large cities, who find it convenient to come to Australia, and these often contaminate good and honest girls.[320]

The use of 'scum' and 'inferior class' clearly indicates her general distaste for those who choose to go into service and their absolute position well below hers. But, interestingly, she confers the insult only upon English girls, not locally born Australians who are apt to be corrupted by their influence.

On the wages procured by servants, she is equally opinionated:

The wages asked by servants is quite appalling; it has become impossible for people of limited and small means to have suff-icient servants to conduct their households as they would wish... Something will have to be done soon, or every lady of small means will be reduced to doing her own work.[321]

This is not to suggest that Rawson advocated a lifestyle of idle luxury for a mistress. On the contrary she insists: 'keep hands and minds occupied; there is nothing so hurtful to a man or woman than idle-ness'.[322] A middle-class woman in the bush had to work. And, like her city sisters, *alongside* her servants if she wanted to keep up the appear-ances of a smoothly-run haven. In the bush the requirement was even more pronounced. To run a middle-class home in the bush required exceptional effort. Supplies were rationed or simply not accessible. Dirt, dust, insects and vermin constantly challenged the quest for 'sweetness and cleanliness'. The outback heat was intensified by the cooking and laundry processes and some, like starched and glossy collars, seemed time consuming and pointless but pursued nonetheless. Where a city wife could predict her day with concise though monotonous regularity,

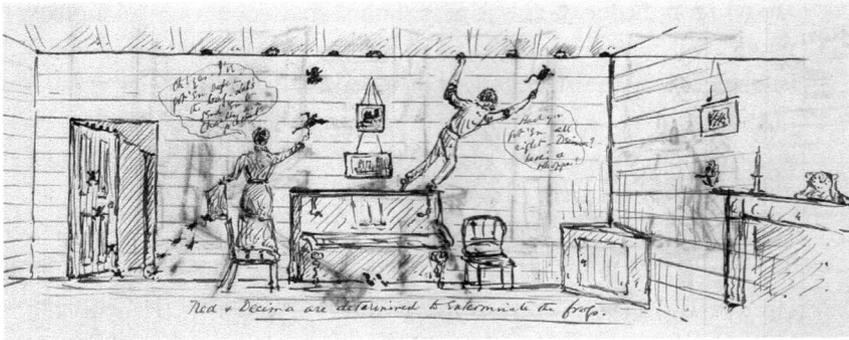

FIGURE 3.6. Charles Rawson, 'Edmund and Decima Rawson in their dining room at The Nyth, Mackay, trying to exterminate an invasion of frogs' (1877), State Library of Queensland.

the bush did not permit any consistency of routine. Flood, drought, fire and plagues could immediately, and without notice, complicate the smooth running of the home.

Unlike their city equivalents, for whom the home was a public representation of worth and regularly shown off to visiting peers, bush women endured months of lonely solitude. An admiring audience of their hard work was largely absent. Nonetheless, a well-kept home presented a stoic resistance to the bush; a steadfast refusal to be consumed or beaten by it. The home was their way of satisfying their own need of feeling 'valuable' by imposing the Victorian predilection for order in a space entirely opposed to it. For this a bush wife required the aid of servants; and for Rawson to dictate how to engage them and treat them: firmly but not in anger; as fellow creatures, but knowing their place. Despite being thrown together in desperate isolation often with little more than each other for company, Rawson advocated that a mistress and her servant should not be friends:

> (A) very great fault with some mistresses is over-familiarity with their servants. Nothing spoils a young girl so much as to be talked

to about subjects that don't concern either herself or her work. I don't mean never say a kindly word, but don't make a confidante of your servant.[323]

Her words are a warning against any erosion of the class divide that may manifest itself in the peculiar society of the bush. Should the division become clouded or be removed, servants are apt to become 'saucy and above their work', thus of no use whatsoever.[324] Their usefulness depends on their knowing their rightful rank. The bush was not to be used as an excuse to relax social conventions. On the contrary this space, more than any, required its full devotion. Order and control within the microcosm of the servant–mistress relationship inferred their existence in the vast environment beyond it.

Refer to Me: *The Australian Enquiry Book* (1894)

Having a servant for Rawson meant time for other types of work; both practical – cooking, cleaning and tending to smaller livestock like chickens and goats (FIGURE 3.7) – and, importantly, those related to beautifying the house. It is in this section of *The Australian Enquiry Book of Household and General Information: A Practical Guide for the Cottage, Villa and Bush Home* (FIGURE 3.8) that she truly demarcates herself as quite independent from any other advisor of Australian nineteenth-century domesticity. Her advice clearly revolved around the familiar canon of a 'pretty and homely nest', but her suggestions were unlike those of either Rocke or Wicken. They were a bush interpretation of the class-conscious ornamentation as advocated by Rocke, and reflective of Wicken's 'little fancies' created by 'clever fingers'. But bush economy, limited access to retailers and a manipulation of the middle-class comprehension of domestic taste would result in some astonishing suggestions for homely beautification.

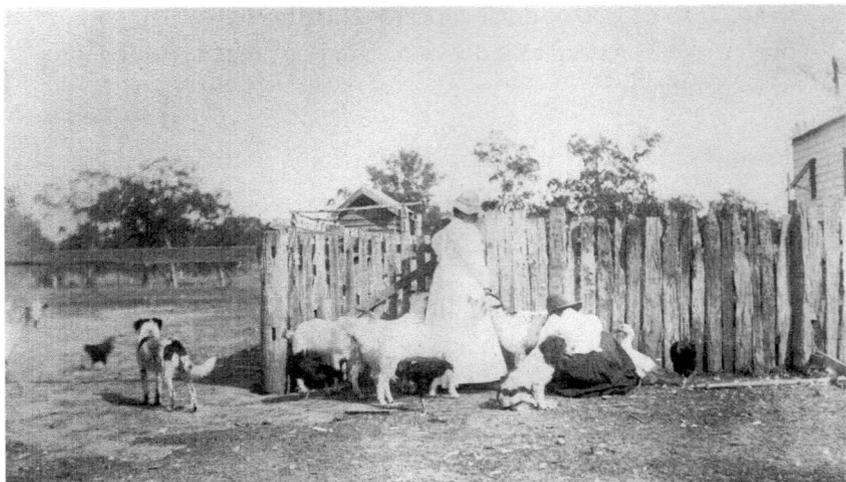

FIGURE 3.7. Photographer unknown, 'Mina and Winnie Milking Goats' (undated), State Library of Queensland. Wilhelmina and Winifred, the wife of Charles Rawson and Wilhelmina's sister-in-law, tending to the domestic livestock at *The Hollow*.

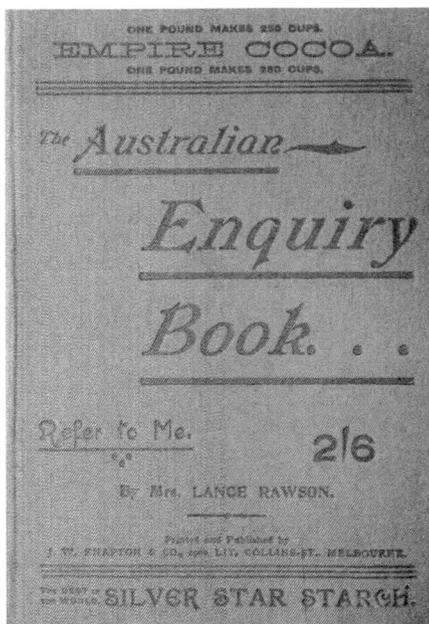

FIGURE 3.8. Wilhelmina Rawson, *The Australian Enquiry Book of Household and General Information: A Practical Guide for the Cottage, Villa and Bush Home* (1894), Monash University Rare Books Collection.

It drew on the rudimentary building materials available to her, and a reinvention of ornamental English home crafts appropriated from popular texts like *Cassell's Household Guide*.

> Many a lady in the far interior is at her wit's end… to know how to beautify her bush dwelling. Possibly she has any quantity of materials by her, only requiring a few hints and details to become quite the expert house decorator and carpenter. Most women have sufficient taste to make pretty things out of odds and ends for their personal adornment, and yet have no idea of setting about the same for their bare walls and empty rooms. There is an old saying that a good cook will make a dinner out of nothing; it might be very truly said of some housewives that they beautify their homes from the same mysterious source. I have really seen the most unpromising rooms and materials by a little cleverness and taste made to harmonise so well that the same rooms were rendered quite unrecognisable as the bare unfurnished apartments of a few hours before. I am not writing theoretically only, but from real practical experience; every one of the ideas, suggestions and arrangements given in this book has either been tried by myself or I have seen it tried, therefore they are quite possible and not beyond the ingenuity of any tolerable handy lady. A few of them may need the stronger hand of a man to arrange – such as shelves and tables put up, carpentering done and such like. There is really no reason why a lady should not be able to use a hammer as well as a man. If you can only get possession of the tools and a supply of nails you can be independent. A room that one furnishes and decorates entirely by one's own exertion is thought more of, I think.[325]

This is the introduction to Rawson's chapter 'To Beautify the Home' in *The Australian Enquiry Book*. In her characteristic, forthright manner she both reinforces the accepted role of women as the arbiters of interior styling and good taste, but blurs the gender divide with affirmations of carpentry and independence. Even though it is via a domestic tableau, Rawson challenged the established myth of the bush, as one that can

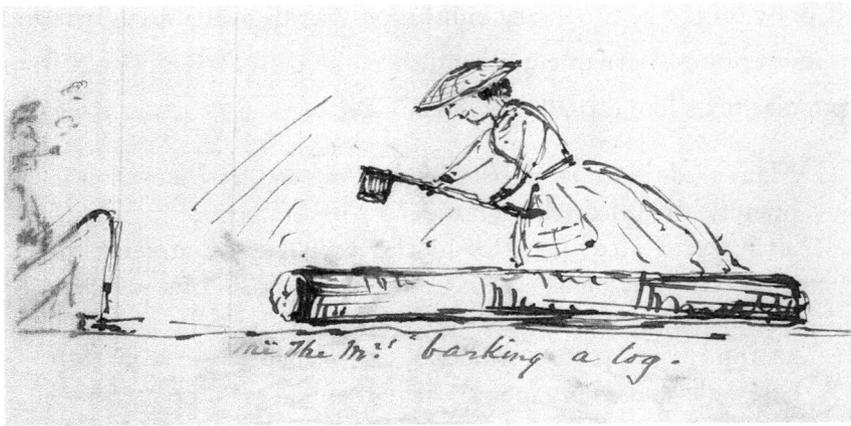

FIGURE 3.9. Charles Rawson, 'The Mrs' Barking a Log (1871), State Library of Queensland. Winifred Rawson chopping a log with an axe.

only be tamed by a man, and dismissed Lawson's declaration that it was 'no place for a woman'. By manipulating her bourgeois sensibilities, not denying them, she empowered bush women with a new femininity that broke down the common belief that men and women had distinctly different talents and zones of expertise (FIGURE 3.9). She rejected the weak and helpless stereotype, beholden to a husband or tradesman for every act of manual labour, but freely admitted that they could be called upon for a *few* heavier domestic tasks. Hammers and nails were not requisite to a middle-class woman's trousseau, but for Rawson they were as essential as linen and china. Her use of 'lady' was important. She was not a labourer or a servant but a member of a refined class well above them. Yet still she was equally adept at wielding a hammer as she was with appointing an elegant luncheon table. As Harriet Wicken determined it appropriate for the middle-class wife to admit to, and be proud of, her command of the kitchen, Rawson celebrated the same liberties in the workshop. Whereas the kitchen was the site of women's work, albeit for the working class, the workshop

was not. This was not just a working-class space, but a man's territory. Rawson insisted that life in the bush required the workshop and its tools to be mastered by women, and not just by 'matrons' but girls. Capabilities in carpentry should be taught young. Within the 'Fancy Work' chapter she includes 'carpentry for young ladies' in which she recommends her 'gentle readers'[326] become acquainted with hammers and nails in their artistic education, making small picture frames and 'many little ornaments'.[327] This was not altogether original. Well-to-do English girls were encouraged through *The Young Ladies Treasure Book* (c.1880) to take up a hammer and 'busy themselves with such purpose as to astonish their more helpless sisters'.[328]

Rawson's approach to decoration was very much grounded in the Victorian devotion to comfort, order and conspicuous displays of 'good taste' evidenced through an abundance of things: furniture, collections, sentimental keepsakes and ornaments. What differentiated hers was that they were almost entirely handmade. Rawson gave rise to a DIY culture long before the make-do-and-mend mantra of the Second World War. She gave instruction on how to crystallise grass and leaves for ornaments; decoupage old Christmas cards to screens; embroider tablecloths (intriguingly with the signatures or calling cards of visitors, which one suspects were quite infrequent in her location); and a vast variety of other standard, nineteenth-century interior practices.

Their inclusion in her book, like her standard cooking processes, normalised the bush space and her advice. These instructions were proof that the bush did not – and should not – deny a middle-class wife her right to participate in and enjoy the pleasures of decoration. But like her extraordinary recipes for ibis, bandicoots and mud turtles, the bush also demanded its own idiosyncratic approach to decoration, founded, as she suggested, on the ability to make 'something' from 'nothing'.

TO BUILD A FOUR-ROOMED HOUSE.

Always build your house on the highest part of your land, unless it should happen to be among hills in that event you might possibly choose a low part of the allotment. But of all things be sure you are within reach of good water, as it is very inconvenient to have to carry water a long distance, or indeed any distance at all. Water you must have, and plenty of it, so build your house so that there will be no difficulty about it. The next thing is the aspect. A westerly aspect is the most unpleasant, on account of getting the full force of the afternoon sun, so you require to study the question a little, noticing which way the sun shines, and from which quarter the wind and rain comes most severely and then decide upon the position of your house. A southerly or easterly aspect are the favorite positions Having settled this matter, take a tape measure and measure and mark your ground plan as in the diagram below, putting in pegs at all the places where piles are to go, or if you do not intend to raise the floor, but build your house on the ground, mark the spots where the posts will go. The plan is 20 ft. by 20 ft. and requires ten stout, strong posts.

The plan is made with a small hall, or passage at the back, because it is much more convenient and comfortable, and the very little bit of space taken for it does not make any noticeable difference in the back rooms. If you prefer to leave it out you can do so without altering the plan, merely leave out one post and alter the doors. but I would advise a passage in all houses however small.

Now dig your post holes and at the *very least* three feet deep, they would be better four; but I know what hard work this is, so we will suppose the holes three feet deep all round. In picking

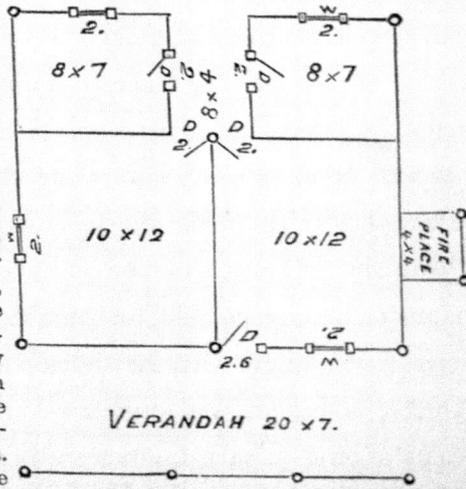

FIGURE 3.10. Wilhelmina Rawson, *The Australian Enquiry Book – Instructions to Build a Four-Roomed House* (1894), Monash University Rare Books Collection.

'Nothing' was, for many white Australians, the summation of the bush: 'the everlasting, maddening sameness… that monotony which makes a man long to break away and travel as far as trains can go, and sail as far as ship can sail – and farther'.[329] It also described what families arrived at their isolated destinations with. Like the Rawsons, it was common for outback families to be transient; a year or two managing one remote property before moving to another. Unsealed and often non-existent roads, like the track to 'Boonooroo', meant lugging enormous quantities of non-essentials (expensive, delicately carved drawing room furniture, Persian carpets, ottomans, ornaments and gilt-framed paintings) was impractical and largely impossible. Occasionally a piano, as both an important sign of class status and the only item of furniture that could not be reproduced in a rudimentary form, was carefully transported. But largely opulent drawing room furniture was not.

Rudimentary building materials were essential to colonisation. As Phillip Drew explains, they made for a 'portable architecture that served well the needs of an expanding colony'.[330] The interior, however, was largely left behind. The packing cases that carried the supplies required for survival constituted the supply of materials for building the furniture. Thus, from nothing came something.

Rawson's instructions – in text without diagrams – were not to make common utilitarian furniture. Hers were not just upturned cases, or discarded tree stumps used as stools as a man might do (FIGURE 3.11). They were very specific class-conscious items of feminine drawing room dwelling. Her instruction on how to build a central ottoman is a prime example. A large barrel constituted the central backrest, around which packing crates were cut to shape to create the seat then securely nailed together. The seat was then upholstered.

FIGURE 3.11. John Skinner Prout, *Interior of a Settler's Hut in Australia* (1849), National Library of Australia.

'There are many ladies [who are] capital upholsters', she claimed.[331] For the padding she recommended the 'fluff' harvested from swamp rushes that 'makes as comfortable a mattress as feathers, almost'.[332] Once padded it is covered in chintz. She declared, 'I saw an ottoman made in this way the other day and it looked so well that no-one would have guessed what it really was'; or, one suspects, where they really were.[333] The ottoman's aim was to disguise its crude location as much as its crude construction.

Her ottoman is followed by instructions for an armchair. 'A very good armchair can be made with a case and some boards and battens', and of course cloaked in chintz 'to match the ottoman'.[334] In the same breath, 'a kerosene case makes a very good bedroom chair turned upside down... and the whole dressed in cretonne or chintz'.[335] Fabrics like cretonne (unglazed calico) and chintz (glazed calico) were

light, non-breakable and effective packing material so could be easily carried into the bush, then employed by women as the essential cloak and camouflage for all sorts of rudimentary structures. This was by no means a new idea. In his description of the first convict-built houses, Robin Boyd describes them as 'ramshackle single or double room huts. The floor was mud and the furniture improvised... later when women arrived floors went in, chintz covered the windows and wooden stretchers and the plain deal tables were scrubbed white'.[336]

Chintz obviously played a very important though underacknowledged role in the establishment of Australia's settler communities. It was transportable and therefore easy to carry into the bush. It was malleable, so could be draped over any number of surfaces to disguise their real construction. Although of Indian origin the chintz Australians knew was imported from England, therefore a genuine fragment of 'home' was evident inside their 'house'. It was widely accessible and ubiquitous to middle-class interiors in the cities and towns of Australia and England, therefore a physical manifestation of a transnational social bond. It was a fragile, interior fabric with no use externally, and therefore explicitly decorative. It was pretty, floral and brightly coloured, and therefore feminine. The very reason many would come to despise the fabric as a symbol of dull bourgeois compliance is exactly the reason it appealed to outback Australian women. It provided a tactile link to the pleasure, luxury, and comfort of middle-class dwelling, even if it was only a thin veneer of fabric draped over old packing boxes masquerading as furniture. What the eye could not see, the mind could be deceived into believing to be real.

For a dressing table Rawson advises ornamenting it in festoons of 'blue and darned net', reflective of the common Victorian practice of

superfluous layering of fabrics to act as both preservers and beautifiers of furniture.[337] 'To live', wrote Benjamin, 'means to leave traces. In the interior these are accentuated. Coverlets and antimacassars, cases and containers are devised in abundance. In these the traces of the most ordinary objects of use are imprinted'.[338] For Rawson her festoons of netting disguised the traces of exceptional ordinariness: another furniture carcass constructed of little more than rubbish. But the 'ordinariness' moved beyond just its rudimentary construction. It was part of Rawson's bond to other 'ordinary' middle-class Australians who engaged in similar acts of furniture dressing. The body of the furniture may have differed but the middle-class identity traced beneath the festoons of net was identical to her city contemporaries.

Describing his great grandparents' first homestead on the Birdsville Track in the mid-1880s, Australian Author Rick Morton affirms the delusive qualities of fabric so valued by women in their quest to normalise their isolated dwellings. The homestead of Alexander and Mary Scobie 'was made of cane grass and had no windows. Undeterred Mary hung curtains where she thought windows ought to have been, which I think says a lot about the kind of mutilated optimism one needs to get by out there'.[339] Optimism had to rally for the likes of Mary and Mina. Pessimism, fear or anxiety were the crushing alternatives that would cruelly defeat any advancement or pleasure gleaned from their outback experience.

Rawson's bush house had only four rooms. As such she could not afford the multiplicity of sitting rooms her city contemporaries enjoyed. Wicken advocated the necessity for three sitting rooms: a dining room, drawing room and a morning room for domestic tasks. 'Mending and repairing in the Drawing-room is quite out of place'.[340] Despite its humble structure, bereft of plastered walls, gasoliers, architraves and

ornamental ceilings, Rawson still acknowledged the importance of the drawing room. In here, spacious enough to house her chintz-covered ottoman and armchairs, she would add handmade bookshelves and a writing desk, trimmed in scalloped fancy work. All of these inclusions aligned her room to the spatial traditions of the English drawing room. It was one of comfort (for family and rare but honoured visitors), cultured education (bookshelves are pointless bereft of books) and the civil communication of letter writing. This inclusion Wicken would have agreed with: 'a writing table is almost a necessity… and the mistress should always see that this table is always kept well supplied with writing materials'.[341]

With the furniture organised, the walls and fireplace would provide Rawson with her next challenge:

> In many bush houses the mantelpiece is merely a broad shelf of rough wood, the sideboards quite plain and very often not varnished. Now these can be made really most artistic in appearance by ornamenting them with ferns in splash work.[342]

Here Rawson adapted her exterior to the interior. Stencilled ferns, presumably cut from her outside environment, are used to ornament the fireplace. It both embraced the available materials of the bush, but aligned her room with an interior currency of exotic forms. The ferns readily available to Rawson were an exotic inclusion to an English home that required a special glass Wardian case or conservatory to grow them.[343] They represented part of the bounty of empire as much as a nineteenth-century fascination with the natural world. Here Rawson was both economical and up-to-date with her interior styling.

> There are other ways of ornamenting the sides of fireplaces, for instance they can be draped with bright chintz and tied back like

115

window curtains... The handsomest I had was of velvet, half an inch wide sewn onto ticking, and small flowers worked upon it. The slips of velvet were three colours – purple, yellow and black; on the latter pansies were worked, on the yellow violets, and daisies on the purple. Between each stripe of velvet there was one of gold braid; and the whole was lined with blue silk and edged with deep gold fringe.[344]

One of the great benefits of the Victorian taste for draping and layering meant that anything, even the most basic fireplace surround, could be dressed in the same opulent manner as the other items of furniture. As stated earlier, fabric was an easily transportable material. Expensive, heavily carved and ornamental fire surrounds were not. Draped with fabric the unseen frame of the mantel underneath became inconsequential and the most rudimentary could rival the decadent confections of the city. In London *Cassell's* would claim, 'a good mantel-shelf is improved by a velvet hanging'.[345] Rawson was clearly in step with English advisors, and one suspects in possession of the *Cassell's* book.

Before the fireplace is one of Rawson's more unusual interior inclusions.

Fire screens are very easily made with the wings of birds spread out and securely fastened in that position, and the tail feathers arranged so as to hide the join, the head of the bird being fixed in the centre. I made a pair of parrots' wings in this way and had good cane handles put into them; they were looked upon as curiosities.[346]

On first reading this may appear as one of Rawson's most peculiarly Australian efforts at bush decoration.[347] However, bird screens were among the many devices used in English drawing rooms for shielding the heat from fireplaces.[348] Again, she mirrors the advice of *Cassell's*

Household Guide. Under 'Household Decorative Art', *Cassell's* provides quite detailed instruction on the creation of 'feather screens':

> Most of our readers have seen, no doubt, in the windows of bird stuffers' shops, screens made from the wings and head… and often the tails of different kinds of birds; but few perhaps know how easily they are made by amateurs and what exceedingly pretty screens may be produced with a comparatively small amount of trouble and practice… We have seen some very good ones made by ladies though the sight of raw flesh and the necessity of getting over scruples about touching it with the fingers often deters them.[349]

Although her suggestion is not as original as it may first appear, the screen aligned Rawson closely to English domestic doctrine. Taxidermy provided interiorised access to the natural environment with examinable specimens: dead, but mercifully clean, quiet and motionless. As such, taxidermy was deemed an appropriate pastime for women and girls.[350] With the aid of a sharp knife and a modern alignment to scientific principles, it provided a thorough education on the wonders of God's natural world. While 'learning' was encouraged in girls, the outcome was a decorative household ornament, not an enticement to pursue a formal education in science, or a paid profession.

Rawson's admiration for her dismembered parrot would not meet with the approval of all English nineteenth-century advisors. Taxidermy was loathed as much as it was admired. Rosamund Marriott Watson would classify homemakers as 'latter-day Vandals' for 'immoderately disfiguring their walls and floors with stuffed beasts'.[351] In her admonishment for women to always insist on entertaining visitors in the drawing room, Mrs Loftie sarcastically complained of 'the privilege of seeing the precious bugle mats and the stuffed weasel'.[352]

FIGURE 3.12. Charles Rawson, *The Old Hollow Living Room*, pen and ink, c.1865, State Library of Queensland. Brothers Charles, Lancelot and Edmund in the original drawing room of The Hollow. The rebuilt homestead and drawing room can be seen in Figure 3.13.

FIGURE 3.13. Edmund Rawson, *Drawing Room at The Hollow, outside Mackay,* c.1874, State Library of Queensland. The new drawing room in the new, extended house after the Rawson brothers had married.

Lucy Orrinsmith counts 'footstools of foxes startlingly lifelike with glaring glass eyes' as among the decorative 'evils' of the drawing room.[353] But such thorough condemnation also meant the practice was popular and widespread, thus Rawson's fire-screen was entirely in sync with the interior decoration of her English counterparts.

Rawson's claim that her specimen was looked upon as a 'curiosity' is itself high praise, and further aligns her interior to the standard practices of middle-class dwelling. Curiosities were indicative of individualised taste within the mainstream. They could customise the home as different to others, but their presence still complied with the expected content of the rooms. As Penny Sparke argues, the practice of decorating with collections, curios and furniture permitted women the ability to 'exercise their aesthetic sensibilities in creating decorative details in the home which helped them construct their own self identities, and communicate to their peers and others the level of their families' social aspirations and achievements'.[354] Collections and curios were identity makers and provided the clues that a conversation with the lady who possessed them could extend beyond the weather and the current dearth of good servants.[355] She was educated, interesting, and most importantly invested in the construction of her home as a *personal* nest of beauty.

To completely disguise the drawing-room walls, Rawson recommends 'papering'. This was not rolls of flocked, printed or gilded wallpaper, but pictures cut from illustrated magazines pasted to the walls.

> I saw a room done very nicely with all the pictures of scenes in the Soudan [sic] war. Each one was cut and trimmed to fit the next; not a scrap of margin was left... When all were arranged, and the whole room covered, they were varnished and the effect produced was capital.[356]

The celebration of a war painstakingly collaged to the living room walls may well be among those Victorian decorative ideas that offend modern sensibilities. But in the 1890s this paid homage to both the exotic and the glories of empire. Even though the 1885 English campaign in the Sudan was abandoned as a failure, it marked the first time an Australian military contingent (specifically the colony of New South Wales) would contribute to an Imperial war. 'It marked an important stage in the development of colonial self-confidence and was proof of the enduring link with Britain'.[357] The British Empire was vast and powerful. Images of the exotic locations under its reign, used domestically, were a means to personally assert the global superiority of the English.

If not papered, Rawson recommends covering the walls in fabric: cretonne and, of course, chintz:

> Both are to be bought very cheaply nowadays... I once saw a slab hut lined throughout with cretonne; it was fastened down with brass headed tacks, rows of them placed close together round the doors and windows. The effect was better than paper.[358]

With the absence of English architectural references in the landscape – the bush possessed none of the reassuring silhouettes of arches, domes and church spires – English civility could be incubated within the intimacy of domestic rooms.[359] Yards of chintz draped over objects and nailed to splintery slab walls ironically helped to solidify the borders between an unruly barbaric landscape and sweetly civilised domesticity. This was 'the reflection of total order, bound up with a well-defined conception of decor and perspective, substance and form. According to this conception, the form is an absolute dividing-line between inside and outside'.[360]

Jean Baudrillard's analysis of objects within a twentieth-century construct of a western home is as valid, if not more so, to Rawson's nineteenth-century bush home. Differentiating between inside and out was vital; one was safe, the other was not. As Drew explains, 'the strangeness of the Australian landscape coaxed a zone of protective space... around the periphery of dwellings to keep them safe'.[361] In the city, a suburb – the space Wicken insisted needed careful consideration – could be regarded as 'safe'. So could public buildings – churches, libraries and galleries – but these do not exist in the bush. Safety was entirely bound to the clearly demarcated space of the domestic 'inside'.

With the walls, fireplace and furniture complete, all that was left were the requisite ornaments to cast about the room to demonstrate one's interests and engagement with the world. Rawson gives detailed instructions on cleaning shells, preserving ferns, creating bamboo picture frames and weaving decorative baskets. These are not specific to the bush, although her basket techniques are based on those she learned from the Aboriginal communities at Wide Bay.[362] Largely they are part of the standard currency of Victorian interior decoration. One notable inclusion among her suggestions is for fish-scale flowers. Again, these are not entirely original. *Cassell's* advocates a similar decorative practice under 'fish scale embroidery':

> The production of beautiful objects of decoration by no means necessarily involves great outlay and expensive materials... A species of exquisitely graceful embroidery may be produced, in which the chief material employed is nothing more than the scales of one of our commonest fresh-water fishes. Fish-scales, sewn upon silk or satin, may be arranged so as to form flowers, leaves, ornamental borders, and also birds, to enrich many of those small articles of taste.[363]

While not identical to *Cassell's*, Rawson's instruction for fish-scale flowers are among her most detailed, leading to a suspicion that it was appropriated from elsewhere. Whereas the making of an armchair was completed in two brief paragraphs, the flowers required two full pages of detailed directions, from the curing of the scales to the variety of flowers one can simulate: fuchsia, rose, dahlia, geranium and jessamine. These were flowers that did not, without careful propagation, thrive in the bush. They were, however, a determined alignment to English middle-class floral arrangements, window boxes and ornamental gardens. And, like *Cassell's* fish-scale inventions, Rawson's flowers were intended to 'throw an air of refinement over a home, and give the visitor a favourable opinion of the occupants' – elegant, feminine and unscathed by the roughness of the bush.[364]

Her flowers were not 'embroidered' but were attached to wire stamens and bundled together to create sprays that could be set into vases or under glass domes. They are particularly pertinent to Rawson's interior. They were artificial, stubbornly resilient to their environment and a simulation of something they were not. Arguably her entire interior was that. 'To simulate is to feign to have what one doesn't have', claimed Jean Baudrillard. 'But it is more complicated than that because simulating is not pretending. Simulation, on the contrary, stems from the Utopia of the principle of equivalence.'[365] Rawson's flowers, her furniture and her stencilled patterns were all formulated on the 'principle of equivalence', but not an equivalence of material worth. Hers was distinctly advice for those of limited means. She sought equivalency in something far more valued: identification with the Australian urban middle-class and, through them, a broader affiliation with those in England. The bush was not predisposed to this 'equivalency', but she worked hard to enforce it. Every raw, rude surface was disguised in chintz, papered

in cut-outs or stencilled with ferns. Ornaments abound. The bush and its associated terrors were undeniably omnipresent, but Rawson's handmade assemblage of middle-class homeliness utterly defied it.

> It is the reflection of a profound reality; it masks and denatures a profound reality; it masks the absence of a profound reality; it has no relation to any reality whatsoever; it is its own pure simulacrum.[366]

Within her rooms Rawson could disguise her true location in the bush, and mask the absence of her desired site of belonging amid the urbanised Anglo middle-class by reflecting, as best she could, all the material trappings of their dwelling. But, hard as she tried, her chintz-draped packing cases and barrel ottomans were not really a match for their city equivalents. Her roughly mimicked, class-encoded interior became something else entirely. As Baudrillard suggests, it became 'its own pure simulacrum'; a believable copy without a referent.

Baudrillard also argued, 'objects… play a regulative role in everyday life in so far as within them all kinds of neuroses are neutralised, all kinds of tensions and frustrated energies [are] grounded and calmed'.[367] Rawson's reinterpretation of middle-class interiority was essential for this very reason. Without it, feelings of isolation and abandonment would surely surface. The systems of middle-class conformity – self-respect, family values, Christian morality and social order – would perish and the primitive and the barbaric would be the victors. 'Home' had to act as both the essential shelter from a disorderly exterior, and an alternative world of material pleasures and codified acts of middle-class identity. Rawson's rooms were a sign of permanency, civility and the flimsy material evidence of white superiority over black Indigeneity. But it was a peculiar 'permanency', more akin to Benjamin's 'trace'. At a moment's notice the whole production may be deconstructed

or abandoned when the family moved on to another land-holding to begin the process all over again, spreading the 'trace' of middle-class white civility further into the Australian wilderness. But the bush was far too powerful to be completely conquered by it.

A 'trace' was all they could impose.

CONCLUSION

An Entanglement of Colonial Class,

Space and Gender

> The nineteenth century, like no other century, was addicted to dwelling. It conceived the residence as a receptacle for the person, and it encased him with all his appurtenances so deeply in the dwelling interior that one might be reminded of the inside of a compass case, where the instrument with all its accessories lies embedded in deep, usually violet folds of velvet.[368]

Despite its obvious alignment to the traditions of European bourgeois dwelling, Benjamin's compass case seems an appropriate metaphor to conclude this interrogation of Australia's nineteenth-century relationship to domestic space. Like the compass, the Australian Victorian interior was an unwavering directional signifier: of morals, class, gender and identity. And, also like the compass, it always pointed north; back across time and space towards an unfaltering belief in the authority of English ideals. Benjamin's 'compass case' is purpose made; a self-reflective, carefully fashioned construct of bourgeois identity. Within it the middle class could reside in absolute, motionless comfort. The 'compass' and its extraneous accessories belonged inside this space, because it was made to fit them perfectly with precision, with care and with insight into the idiosyncrasies of their physical and emotional being. Every fold of the rich purple velvet gently nests a delicate, sophisticated and intelligent instrument. Here it could rest, cossetted in its elegant plush, until its directional opinion was

sought, which of course was always trusted, then gently return to its rightful place. Benjamin's compass is the perfect metaphor for the self-reflective middle-class aspirants of the English and European nineteenth century; culturally fitted to familiar but subtly different and individualised interior space.

Can the same be said of nineteenth-century Australian interiors and those who inhabited them? Not entirely. Something happened to the European compass and its case on the long journey out. Perhaps it became dislodged, dented or carelessly mixed up with other, less sophisticated devices of utility, those essential to basic survival but far less elegant: hammers, chisels, shovels and other tools of trade. When it was eventually returned to a case the fit was almost right, but not quite. It was tarnished and slightly misaligned; no longer a snug, perfect fit but forced into folds that were made for a different instrument altogether. But regardless, it settled in its less than perfect interior, and, as all compasses do, continued to summon north, forever suggesting a return to another hemisphere.

For Benjamin, the nineteenth-century European middle-class pre-dilection for domestic nesting was a deeply personal experience. Within the sanctity of 'home' – their dark, draped and plush interiors – they could safely nurture their bourgeois identity with gentle but persistent attention. Inside they could carefully separate themselves from the class below by emulating the class above. What was once only the preserve of the aristocracy, through the liberation of the mass consumer market of the nineteenth century, was made available to all who could afford them: houses, furniture, bibelots, servants, manners and reputation. The ever-increasing complexity of bourgeois identity was entirely realised in the domestic realm; a private sanctuary mercifully distant from the fast, public, unpredictable and corrupting exterior.

Australia's middle-class interiors emulated the same ideals, fully importing from England a European devotion to home and its rich semiotic language of furniture, textiles and knick-knacks. Through them they could fashion their own little kingdom of European belonging that served a multitude of functions beyond the rudimentary needs of shelter. Inside was a showcase of comprehension; of acknowledged ideals pertaining to taste, gender roles, class distinction, European identity and habitation. The Victorian ideal of 'sanctuary' was a powerful one. It denoted comfort, safety and security.[369] The Australian interior was an achievable victory; a 'sanctuary' of individual control. As explained by Linda Young, the core of middle-class culture was 'control', of self, community and environment.[370] Within their homes, 'control' could be orchestrated through a strict observance of aesthetics, interiorised rituals and the protocols of etiquette. The same could not be said of its outside. The Australian exterior cares little for rituals or etiquette. Australia's exterior was an entirely alien and terrifying otherness that required power and resilience above polite gentility. 'The bush [is] a mysterious presence', observes Kay Schaffer, 'which calls to men for purposes of exploration and discovery, but is also a monstrous place in which men may either perish or be absorbed'.[371]

Regardless of how small its presence was within the Australian landscape, 'home' spoke clearly of conquered adversity. The centre panel of Frederick McCubbin's *The Pioneers* (1904) (FIGURE 4.1) is the visual representation of this significant victory. Surrounded by a dominant and ever-present bush, a couple is engaged in an ongoing quest to somehow tame it. Sometimes they win, but ultimately they don't. Human mortality was no match for the bush. With mythical, Hydra-like qualities, it continued to regenerate and grow. It is only when massed in an urban environment that Europeans showed any real

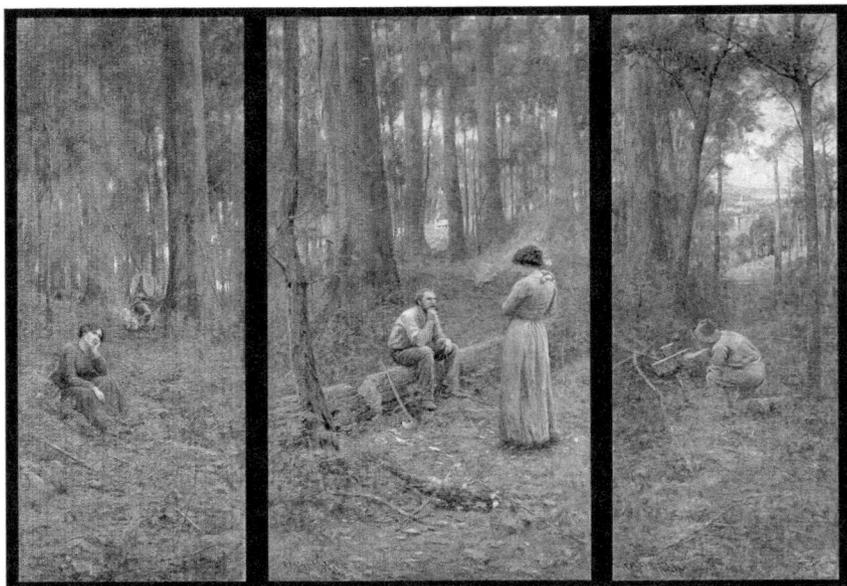

FIGURE 4.1. Frederick McCubbin, *The Pioneers* (1904), National Gallery of Victoria.

capacity to dominate the landscape. Nonetheless, within McCubbin's narrative of heroic Anglo-Australian endeavour a small cottage can be seen in panel two. Into this, at the end of each day, his heroes could retreat and restore, and prepare themselves for the same battle of survival that would undoubtedly ensue the following day.

The depiction of a woman in this Australian fable of stoicism reflects their valued role within the colonising process. Through them Victorian ideals of moral propriety, normative sexual behaviour and European lineage could be asserted, even in the most inhospitable environment. Beverley Skeggs argues that 'femininity brought with it very little social, political and economic worth'.[372] But their worth in colonial terms was measured in a different currency: in morality, care-giving and nurture. McCubbin's image is not one that panders to middle-class aspirations. Instead it celebrates a belief

in a nation-building Australian work ethic. Despite its distinctly non-bourgeois overtones, the feminine virtue of maternal nurture was believed to be instinctual in all classes, and is foregrounded in McCubbin's triptych. A mother was the Victorian angel whose presence and civilising influence was the antidote to godlessness, lawlessness and depravity.

Even though the interior of their cottage is unseen, the presence of a wife implied it was tidy, homely, comfortable, welcoming and pleasant. While the spatial alignment of women to 'interior prettiness' and men to 'exterior work' is a simplistic gender stereotype, its affirmation in nineteenth-century Australia was pivotal to the construction of European identity. As explained by Daniel Miller:

> the exchange between male labour and female aesthetics had become the means by which people in transforming their environments exorcised [an] alien presence… and in effect took possession of the place in which they lived.[373]

The demarcation of gendered roles within gendered spaces was pivotal in establishing a global continuum of English belonging. It helped shape the migrant experience and quelled the destabilising effects of alienation, displacement and abandonment. Although hybridised – Australian women could rarely afford to dedicate themselves to interior dwelling and often worked alongside their husbands in order to survive – they could still clearly align themselves to the Victorian construct of 'family': benevolent husband, faithful wife and obedient children. 'Family life', explains Penny Sparke, 'took on a new significance… as a symbol of Christian values, nationhood and Empire'.[374] With men preoccupied with livelihood, the responsibility for 'family' fell to women, and 'home' was the ideal site from which to wield their leadership of it.

'It is the province of women to make home whatever it is', decreed one nineteenth-century commentator. 'If she makes that delightful and salutary and the abode of order and purity... she may send forth from her humble dwelling a power that will be felt around the globe'.[375] A house, even the crude, roughly constructed pioneers' cottage, provided the requisite site for women to deploy their 'power' and ensure the maintenance of a family's moral obligation, just as other women, of all classes, were believed to be doing throughout the empire. From their domestic milieu, women could facilitate their spread of moral influence, first through family and, through them, entire communities.

Anne Summers argues that 'safe and respectable positions for women were integral to restructuring Australia's colonial settlement'.[376] While replicating English femininity and maternal virtue was a requisite part of identity construction, Australian women performed an entirely different role to their counterparts in Britain. In Britain, middle-class women were the vigilant caretakers of complex social constructs delineated by rank and gender. Ensuring this was properly managed was arguably onerous, but largely a task of maintenance, not change. In Australia, women were charged with being facilitators of a restructured society, from 'penal' to 'respectable'. This was not maintenance, but a total rebuild upon which there were very few useable foundations present. Australia's European origin as an enormous and hellish prison was not an easy hurdle to clear. Regardless of the minor pettiness of their crime, women sent to the colonies were classified as evil and denigrated as whores.[377] Unlike men – or English women – Australian middle-class women had to manage the burden of reputation, and through their actions and behaviour were required to carefully reposition it from a vile but established stereotype to one of respectable mother: As Caroline Chisholm would describe them, 'God's police and little children, good

and virtuous women'.[378] Hers was a difficult but essential role in the establishment of acknowledged civilised behaviour.

A house, as a component of architectural practice, was one of the acknowledged goals of European civilisation. As Dagmara Zabiello argues, 'architecture played a key role in the visual transformation of colonised lands… and clearly delineated the distinction between the colonised and the coloniser'.[379] Regardless of how rudimentary or simple, a house and the art of dwelling were among the fragments of evidence that the white settlers used to prove they deserved their place of governance. The Indigenous people were believed to be bereft of built structures and other 'sophisticated' arts. They provided no visible evidence to early white Australians of a cultured comprehension of 'civilisation'. The English journalist Anthony Trollope would, in 1875, summarise the European perception of Australian Indigeneity with brutal brevity: 'covered by gum trees and peopled by savages'.[380] Neither were considered to be of any value. Colonised people were denigrated as lesser because they did not understand, care for, or engage with buildings and the subtleties of Christian dwelling. Like the bush itself, the Aboriginal population were peculiar 'others', entirely opposed to the ideals of European civility. Spurred by their own abhorrent belief in racial superiority and the ethnographic nonsense masquerading as 'science', white Australians would assume their dominance over a people believed to be less evolved, and so far behind the markers of civilisation that their fate was irreversibly sealed in extinction.

The materiality of houses and other architectural forms, developed and engineered over the progress of centuries, were, as far as the white settlers were concerned, proof of a superior European intellect, a superior spirituality and a superior culture. Clifford Geertz defines the complexities of 'culture' simply: it is 'an ordered system of meanings

and symbols... in terms of which individuals define their world, express their feelings and make their judgements'.[381] For nineteenth-century white Australians, the physical manifestation of civilised culture was realised in the built: public buildings and private dwellings within cities, towns and rural isolation. Heavy Victorian architectural reference opposed the 'anti-culture of the frontier' and presented signs of permanency in a fickle, transient and dangerous space.[382] It embodied a network of symbols and meaning that were shared among a disparate global community of English citizens. The premise was simple. A supply of similar objects, within similar buildings, similarly decorated, became a uniting bond between the English and their dominions. Jane Robinson, in her account of the mutiny against the English in India in 1857, describes the thin facade of protection they believed could be realised in interior dwelling:

> They sought security in an extremely strange land in creating for themselves a hidebound home from home involving all the parochial strictures of English provincial life. Pianos and plush-draped dining tables and dismal prints of *The Monarch of the Glen* would be shipped over to furnish their parlours.[383]

A similar system of English illusion was imported into and manufactured within Australia, creating a codified backdrop of visual assurance that harboured a much deeper dependency below a surface of velvet, chintz and wood veneers.

> The art would be to feel homesick even though one is at home. Expertness in the use of illusion is required for this... this is the formula for the interior.[384]

Here Benjamin reveals the core of the middle-class home and, although written in relation to another continent altogether, is peculiarly relevant to the nineteenth-century Australian interior. Victorian

interiors in Australia were constructed according to a formula of English aesthetic dependence. To do so was an assurance of both subservient colonial compliance and equivalent English belonging. Within their rooms, layered with an inventory of material reference to Britain – floral carpets, ribbons of wallpaper, velvet drapes, lace curtains, elaborate passementerie, tea tables, what-nots, suites of brocaded upholstery, gilt framed mirrors, prints of cherubic children, knick-knacks, curiosities, needlepoint and other craft works, collected souvenirs, wax flowers, and china tea-sets – colonial Australians could sit and imagine themselves 'at home' somewhere else entirely. A profusion of things obscured the view of their real Australian situation. Benjamin's at-home 'homesickness' is entirely realised in this space; the melancholic, but not entirely unpleasant feeling that the room is 'like home' but not actually 'at home'. The assemblage of interior memories hadn't quelled the sickness, but intensified it. The superfluity of interior objects whispered, in layer upon layer, day after day, that they and their owners – especially women as the predominant authors of this interior tableau – belonged in a concurrent but entirely dislocated elsewhere.

To negotiate the illusion, the colonial middle-class required guidance. As discussed in the preceding chapters, advice manuals proliferated throughout the Victorian period in the hope of casting a familiar, middle-class homogeneity across all the empire's dominions. The authors of good behaviour and good taste that prevailed in England – Beeton, Cassell, Eastlake and Orrinsmith – did so in Australia as well. The highly scripted practices of domestic Victorian gentility required consistent and universal handbooks to aid their adoption. This would help explain the scarcity of Australian-composed manuals. Independent colonial authorship would risk jeopardising

the fluid consistency of social practices that helped identify white Australians as belonging to Britain, and indeed being British. While the adoption of English ways was a prevailing construct in white Australian Victorian society, it would be hindered by the very nature of the colonial space. Established English city and provincial life was no comparison to the raw, fledgling towns and brutal Australian frontier that awaited most migrants on their arrival in the colonies. For middle-class women this reality would present an odd duality to their domestic roles. Most, except for a very privileged few, had to share in the burdens of colonial livelihood and could rarely idle away their days in abundantly appointed interiors as their English sisters were thought to be doing. However, the desire to be perceived as the good wife, champion of moral behaviour, and safekeeper of the family home in which all the virtues of their sex were protected, remained intact despite the many environmental hurdles in its way. Advice manuals provided the authoritative text on English home life, its aspirations and its practices. They also provided Australians with the know-how to conjure an alternative site of belonging that permitted them to believe they were acting and dwelling in equivalent, interchangeable spaces.

However, the advice penned from the perspective of a different geography, impacted by a different climate, built within a different environment, governed by a different class economy and shaped by a different history fell short of realising the idiosyncratic needs of Australia's colonial middle-class. To retain their Englishness, or perhaps more bluntly their 'whiteness', Australians continued to subscribe to a fervent belief in English administration and ways of living. But as they grew more confident, and colonial experience began to mould the Englishness (rather than the reverse) into a hybrid Anglo-Australian

identity, they required advice from authorities that operated within the same framework of colonial challenges.

The three texts analysed in this book provide an insight into Australia's adaption of the English codes of middle-class dwelling and behaviour. Never would their authors consider a complete abandonment. This would be tantamount to anarchy. Instead the prevailing idea was 'adjustment'. William Rocke, as the oldest contributor, did not stray from the path of Britishness at all. He wrote, in 1874, of 'our role in the revolution'.[385] Far from being a revolt against authority or civil administration, his 'revolution' was to rally against a lower-order of provincial furniture makers and decorators who could not meet the aspirations of Australia's – and in particular, Victoria's – new-found wealth. The 'revolution' he spoke of had shifted Melbourne from a settlement of tents and dust, to one of grand boulevards and ornate Victorian edifices. Its rigid rectilinear grid was fast becoming lined with the commercial monoliths that visibly constructed the modern vernacular of 'city'. This was no place for regressive, parochial backward glances, but instead a forward lunge into complete immersion in European material sophistication. Rocke saw himself as the conduit between the distant tastemakers and Australia; a direct and flawless link, without kinks, diversions or any weakening of flow in the consistency of unadulterated high style. This was procured via 'a round of observations of the interiors of the dwellings of the great and rich in England and the Continent' and by procuring 'the most skilled workmen' to 'supply in Melbourne that which the wealthy classes at home could procure in England, France, Germany or Switzerland'.[386] 'Home', notably, was not Melbourne, but its dislocation from its true site in Europe could be remedied, Rocke believed, by one simple act: shopping. Culture, identity, class, commodities and commerce came

together in a potent union at his Collins Street premises. 'All the articles that suitably furnish and decorate the abodes of those whom Providence has given wealth and taste, whether they desire grandeur, glitter and magnificence, or sweetness, simplicity, and repose, await the pleasure of the purchaser'.[387] Shopping had evolved, as part of Rocke's 'revolution', from a dull chore performed by an underclass of servants to a seductive middle-class leisure activity which, to this day, it remains.

Rocke's 'adjustment' of English ways was to edit them. Just as he selectively sifted through the great and the good of England's literary canons to support the interior ideals in his book, he sifted out the readers who could not afford to participate in his 'revolution'. His commentary on the decoration of houses abandoned the mass of Australia's working and lower middle-class and focused his attentions on the wealthy. Through the purchasing power of this social minority he could fashion a perfect replica of sophisticated English belonging.

Towards the end of the century Harriet Wicken and Wilhelmina Rawson would join the ranks of the army of (mostly English) women advice writers. But they would add to this already substantial library with their own, Australian-specific content. Both found it necessary to correct the imbalance of injudicious over-expenditure, and the alienation of those of lesser means able only to live 'nice' rather than 'excessive' lives. The financial crises of the 1880s and '90s that shattered the economies of many cities including Melbourne would spur a rise in advice driven by 'domestic economy' rather than 'domestic decoration'. Interior commodities, however, were already tightly bound in the modern economy, so still featured heavily in the works of Wicken and Rawson.

Wicken, like Rocke, was an English migrant, and as such imposed a distinct homeland bias on her readers. Like Rocke, she does not falter

from a hardline recognition of the English as the arbiters of taste, style and behaviour. But she specifically addresses the confusion of 'class' within her new-found home. As outlined in the introduction, Australia was a site of rapid, self-propelled social mobility. Its egalitarian mythology permitted all sorts of people to align their rank to those they did not belong to. Wicken's task was to realign it, 'to know one's place'. Hers was the advice for the vast suburban majority. Through her text, she persuades middling-class women to dwell among their own; not aim higher than the status they were born to, or debase themselves by descending below it. Her advice is a filtered conglomeration of English texts. Within hers, she extracts the advice she deemed appropriate for her readers, and for the first time deposes middle-class women from their comfortable drawing rooms and directs them to the room they had, for the previous century, avoided as a site of service not authority: the kitchen. Wicken incubated a new female stereotype, which by the twentieth century would become both the most subscribed to and the one most derided: the 'housewife'.

Rawson is the only Australian-born author in this study. She possessed no true experience of English life as had the preceding two, but, like most white Australians whether migrant or locally born, she subscribed to the authority of English hegemony. Of the three, she was the one required to adapt most of all. Her geographic situation in the isolated backwaters of Queensland's southern coastal region altered her advice considerably from that delivered by the city-dwelling Rocke and Wicken. She was determined her Anglo middle-class identity, and that of the women she advised, would not be jeopardised by her removal from the common bonds of urban bourgeois behaviour. From the 'nothing' of her bush setting she fashioned a middle-class home, engaged in polite social activities and asserted a mistress's control over

her home, her family and her servants with the same acute prowess as her city sisters. Her advice, above the other two, met the needs of the isolated women of the Australian frontier. Their inability to access either the riches of Rocke or the sensible appointments of Wicken, gave Rawson an entirely independent audience: the squatters' wives; the bush bourgeoisie. Their isolation was an obstacle, but not an insurmountable barrier to middle-class homemaking. The 'sweetness and repose' so often cited as the benchmark of the middle-class dwelling were not as easily acquired in the bush, bereft of the requisite purveyors of fancy goods and furniture suites. But with ingenious adaptability Rawson advised on how to fashion a pretty, comfortable and feminine space from the detritus of bush existence: bark slabs, packing cases and barrels. That her advice is predominantly autobiographical meant her text had an unusual authority; born of truth rather than unachievable ideals. Within her four-roomed bush cottage she fashioned an English-like interior from the odds and ends of colonial expansion: a perfect simulation of English belonging sheathed in delicate layers of chintz and cretonne.

'What can frequently be found in Australia', states Tony Fry, 'is a fallout and modification of that which was originally created for other circumstances. Australia is the land of the simulacrum, a place of original copies and unplaceable familiarity.'[388] Fry's 'A Geography of Power' situates Australia historically as a powerless dependent, positioned on the periphery of Britain's social, political and economic dominance. Its southern location was debilitating – too distant to be of influence and too provincial to be of importance. Nonetheless, from this situation he argues Australia was able to successfully operate in a 'network, a system of circulation... a community that can function in concentrated or dispersed forms'.[389]

Arguably Australia's unfaltering devotion to Anglicised domestic-ity, and the rich ground of semiotics it harboured, corroborates Fry's claim. Dependency on Britain in the ways of dwelling obliterated any real invention in interior identity. It was intended to spell the death of wilderness and savagery, not establish a site of alternative allegiance. Even Rawson, with her idiosyncratic manipulation of rudimentary materials, still selected identifiable European forms to replicate: ottomans, armchairs, dressing stools, mantelpieces; 'familiar copies' of 'unplaceable familiarity'. She was also part of Fry's com-munity that was required to operate in a 'dispersed form'. Not only was she in Australia, itself considered isolated, but within it, hidden further away in the remote and shapeless landscape collectively defined as 'outback'. Her interior, and in particular her books, were part of a colonial network of knowledge engaged in the spread of shared ideals pertaining to modern, middle-class identity. Her books, and those of Rocke and Wicken, were a part of the 'system of circulation' of ideas that helped collect together the widely dispersed residents of (white) Australia within a single Anglo-identity that aligned, as much as it was possible, to a greater population of British nationals.

Different as each author was in terms of advice, audience and loc-ation, each was determined to shape a portion of the Australian bourgeois community via a clear reproduction of English dwelling in which they could realise their true space of belonging. The benefit of interiors and interior objects is that they are real; tangible and visible, and reassuring because of it. Within their class-conscious, 'English-like' rooms Australians could settle amid 'real' references to nationality, gender, taste and class. The pretense of equivalent rooms had solidified into a physical presence; no longer an imitation or diluted veneer of English civility, but judged to be the real thing.

'It is no longer a question of imitation, nor duplication, nor even parody', argues Baudrillard. 'It is a question of substituting the signs of the real for the real, that is to say of an operation of deterring every real process via its operational double, a programmatic, metastable, perfectly descriptive machine that offers all the signs of the real and short-circuits all its vicissitudes'.[390]

To return one final time to Emma Boyd's drawing room – the space that exemplifies the greater Australian devotion to interior dwelling – we see the evidence of Baudrillard's claim. It is the 'operational double' of an English drawing room, invested with both the 'real' evidence of English devotion and the 'signs' of cultural comprehension. Within this space, and the many other 'perfectly descriptive machines' that registered the operation of a modern Anglocentric world, Australians could reside with confidence. Through their layered tableau of ornaments, textiles and furnishings they could rest assured of their true belonging. Their rooms provided a comfortable haven and an armoury of evidence to prove they could be assessed as 'real' residents of the British Empire; expert in the guiding principles of comfort and judgement.

NOTES

1 Rachel Rich, "'If You Desire to Enjoy Life, Avoid Unpunctual People":
 Women, Timetabling and Domestic Advice, 1850–1910', *Cultural and Social
 History*, 12:1 (2015), 95–112.

2 Grace Lees-Maffei, *Design at Home: Domestic Advice Books in Britain and the
 USA since 1945* (New York, Routledge, 2014), 23.

3 Rachel Rich, 97.

4 Long after Beeton published her *Book of Household Management* in 1861 – and
 her untimely death in 1865 – specific Australian content was eventually added
 to her tome. Alongside her now familiar advice the 1888 edition includes two
 chapters on Australian cooking. The first entitled 'General Observations on
 Australian Cookery' contains an illustration of the Australian kitchen and
 information on colonial meat, groceries, beer, wines and spirits. A section
 on 'Wages in Australia' alerts the middle-class Australian housewife of the
 shortcomings of emigrant domestic service and that she 'ought to be prepared
 to take on the duties of any absent domestic, so that a knowledge of cooking
 and ordinary household work, are necessary qualifications for a settler's wife'.
 The second chapter includes 10 recipes for 'Australian' dishes including roast
 wallaby, fricasseed or curried kangaroo tails and parrot pie.

5 Deborah Cohen, *Household Gods: The British and Their Possessions* (New Haven,
 Yale University Press, 2006), 90.

6 Emma Ferry, "'Any Lady Can Do This Without Much Trouble… ": Class and
 Gender in the Dining Room', *Interiors*, 5:2 (2014), 141–159.

7 H. Mortimer Franklin, *A Glance at Australia in 1880: or, Food from the South*
 (Melbourne, The Victorian Review Publishing Company, 1881), 264.

8 Anon. quoted in Terence Lane, *A Souvenir of Marvellous Melbourne: W.H.
 Rocke's 1880–81 Exhibition Cabinet* (Melbourne, National Gallery of Victoria,
 2014). http://publications.ngv.vic.gov.au/artjournal/a-souvenir-of-marvellous-
 melbourne-w-h-rockes-1880-81-exhibition-cabinet/#.VFiqC5h7S--, accessed 4
 November 2014.

9 For further information on the cabinet, see Terence Lane's NGV catalogue essay 'A
 Souvenir of Marvellous Melbourne: W.H. Rocke's 1880–81 Exhibition Cabinet'.

10 See Tracey Avery, 'Furniture Design and Colonialism: Negotiating
 Relationships between Britain and Australia, 1880–1901' in *The Design History
 Reader*, eds. Grace Lees-Maffei and Rebecca Houze (London, Bloomsbury,
 2010); Andrew Montana, 'Stylists for the Nineteenth Century: The Finsbury
 Cabinet-makers Smee & Sons in Colonial Australia' in *Recollections: Journal of
 the National Museum of Australia*, vol. 7, no. 1 (2012), 1–27.

11 Enormous quantities of the Rocke text are reproduced in Suzanne Forge's *Victorian Splendour: Australian Interior Decoration, 1837–1901* (1981), but appeared as little more than quantifiable evidence of the importance of decoration to colonial settlement. Reference to the document is made in Fahy, Simpson and Simpson's exceptional catalogue of colonial furnishings, *Nineteenth Century Australian Furniture* (1985) but without specific analysis or review. Amateur historian Caressa Crouch refers briefly to *Remarks on Furniture* in *Australiana* (1999), but the principal focus of her essay is the use of Australian materials in locally manufactured furniture of the period as evidenced in the *Furniture Pattern Book, W.H. Rocke & Co., 1874–6*. Michael Cannon, in his 1975 book *Life in the Cities: Australia in the Victorian Age*, uses references from the Rocke book – among other publications – to illustrate a commonly held dislike for Victorian furnishing that 'seem hideous to the modern eye'. Rocke's suggestion for an oilcloth imitation of tessellated tiles is described by Cannon as 'tasteless imitation', but the remainder of his discussion uses Rocke's commentary simply as a catalogue of Victorian interior content without further criticism.

12 Reference to Wicken appears in Kimberley Webber's chapter 'Embracing the New' in *A History of European Housing in Australia*. It is a fascinating investigation of the history of Australia's kitchens and laundries and their reinvention according to the emergence of new technologies and 'scientific' principles founded on hygiene. Wicken's contribution to the decoration of houses, however, does not appear. Webber's chapter also makes extensive reference to Wilhelmina Rawson's publications, but it is only her forthright opinion on the function of laundries and kitchens that, like Wicken's, is used to explore the operational shifts in these spaces from the end of the nineteenth century into the twentieth.

13 The analysis of Wicken and Rawson in regard to food and dining has already been amply covered in a number of significant works, most notably *One Continuous Picnic: A Gastronomic History of Australia* by Michael Symons. Blake Singley, Barbara Santich, Jacqui Newling and Adele Wessell have also made considerable contributions to scholarship in Australia's colonial food culture.

14 Blake Singley, 'Hardly anything fit for a man to eat: food and colonialism in Australia' in *History Australia*, Volume 9, Number 3 (December, 2012), 27 – 42.

15 Emma Ferry, 15.

16 Rachel Rich, 100.

17 Sarah Leavitt, *From Catharine Beecher to Martha Stewart: A Cultural History of Domestic Advice* (Chapel Hill, North Carolina University Press, 2002), 39.

18 Rick Morton, *One Hundred Years of Dirt* (Melbourne, Melbourne University Press, 2018), 17.

19 Wicken and Rawson are undeniably the authors of their work, although, as this
 book exposes, it frequently appropriated the advice of existing English manuals.
 This does nothing to lessen their value, but rather intensifies their devotion to the
 systems of English middle-class identification. The actual authorship of *Remarks*,
 however, is not evident. There is no by-line to prove exact authorship. It is written
 as the 'voice' of the Rocke company and a collective 'we' is used throughout rather
 than 'I'. Rocke owned the store and did all the international travel to purchase its
 products and gather information regarding its fashionable styles of furnishings
 and decoration. As such, he was 'author' of the material content and decorative
 schemes discussed in the book. As a successful businessman acutely aware of the
 value of reputation in Victorian society, he would certainly have approved the
 book if indeed he did not write it. However, for the purposes of easier reading,
 William Henry Rocke is identified in this book as the 'author/owner' of *Remarks
 on Furniture and the Interior Decoration of Houses*.

20 Wilhelmina Rawson, *The Australian Enquiry Book* (Melbourne, J.W. Knapton,
 Printers and Publishers, 1898), 205.

21 Anon., *Men and How to Manage Them: A Book for Australian Wives and Mothers,
 by an Old Housekeeper* (Melbourne, A.H. Massina & Co., 1885), 74.

22 Jane Ellen Panton, *From Kitchen to Garret, Hints for Young Householders*
 (London, Ward and Downey, 1893), 102.

23 Jukka Gronow, 'Fads, Fashions and Real Innovations: Novelties and Social
 Change' in *Time, Consumption and Everyday Life. Practice Materiality and
 Culture*, eds. Elizabeth Shove, Frank Trentmann and Richard Wilk (Oxford,
 Berg, 2009), 129–142.

24 Colin Bisset, 'Is the Fish Knife Our Most Pretentious Utensil?' on *By Design*,
 ABC Radio National. http://www.abc.net.au/radionational/programs/
 bydesign/4954624, accessed 4 November 2014.

25 Ibid.

26 Anon., *Men and How to Manage Them: A Book for Australian Wives and Mothers,
 by an Old Housekeeper* (Melbourne, A.H. Massina & Co., 1885), 72–74.

27 Anon., 'Australian Artists' Association', *The Argus*, Friday 7 October 1887.

28 Ibid.

29 *Corner of a Drawing-room* and *The Window Seat* were last publicly shown as part
 of a broader exhibition of the Boyd Family, entitled 'Outer Circle' at the Ian
 Potter Centre at the National Gallery of Victoria, Melbourne, between October
 2014 and March 2015.

30 Gaston Bachelard, *The Poetics of Space* (Boston, Beacon, 1994), 17.

31 Mary Douglas, 'The Idea of a Home: A Kind of Space' in *The Domestic Space
 Reader*, eds. Chiara Briganti and Kathy Mezei (Toronto, University of Toronto
 Press, 2012), 50–54.

32 Henry Archibald Hertzberg Lawson (1867–1922) was an Australian-born writer and poet who wrote prolifically in the 1890s. His stories are predominantly located in the Australian bush.

33 Deyan Sudjic, *The Language of Things* (London, Allen Lane, 2008), 21.

34 Linda Young, *Middle-Class Culture in Nineteenth-century America, Australia and Britain* (New York, Palgrave MacMillan, 2003), 6.

35 Tracey Avery, 'Furniture Design and Colonialism: Negotiating Relationships between Britain and Australia, 1880–1901', *Home Cultures*, 4:1 (2007), 69–92.

36 Erving Goffman, *The Presentation of Self in Everyday Life* (London, Penguin Press, 1969), 19.

37 Walter Benjamin, *The Arcades Project* (Cambridge MA, Harvard University Press, 2002), 9.

38 Walter Benjamin, *Reflections: Essays, Aphorisms, Autobiographical Writings* (New York, Harcourt Brace Jovanovich, 1978), 216.

39 Tracey Avery. 'Acknowledging Regional Interior Design? Developing Design Practices for Australian Interiors (1880–1900)', *Journal of Design History, vol. 21, no. 1, Professionalizing Interior Design 1870–1970* (Oxford University Press on behalf of Design History Society, 2008), 41–58.

40 Young, 31.

41 Wilkins Micawber is a clerk in Charles Dickens's 1850 novel *David Copperfield*.

42 W.H. Rocke & Co. *Remarks on Furniture and the Interior Decoration of Houses* (Melbourne, McCarron, Bird & Company, 1874), 17.

43 Harriet Wicken, *The Australian Home, A Handbook of Domestic Economy* (Sydney, Edwards Dunlop, 1891), 117.

44 Wilhelmina Rawson, *The Australian Enquiry Book of Household and General Information. A Practical Guide for the Cottage, Villa and Bush Home* (Melbourne, J.W, Knapton & Co., 1894/1898), 206.

45 Tony Fry, 'A Geography of Power: Design History and Marginality' in *The Idea of Design*, eds. Victor Margolin and Richard Buchanan (Cambridge, MA: MIT, 1995), 204–218.

46 Bachelard, 137.

47 Anon., 'Art and Artists – Mr Fred McCubbin', *Table Talk*, Friday, 26 April 1889.

48 Frederick McCubbin, like Emma Boyd, did paint sentimental interior narratives. But McCubbin's *Home Again* (1884) and *Kitchen at the Old King Street Bakery* (1884) present interiors of a different colonial virtue to that represented by Boyd. *Home Again* is a celebration of the working poor; an itinerant worker joyfully returning home to a wife within an interior bereft of fussy decoration and only furnished with essentials. McCubbin's image of his

mother's kitchen in King Street, Melbourne, is also a heroic celebration of an Australian work ethic. This kitchen is not a place of drudgery and oppression but the heart of industry and labour upon which the nation relied. The virtues of labour and 'making a go of it' are strongly represented in both paintings; a narrative that does not appear in Boyd's interior paintings.

49 Fulton Street is located in St Kilda, a seaside suburb of Melbourne. In the nineteenth century, St Kilda was among the sweep of emerging south-eastern settlements that drew thousands of aspirational middle-class suburban dwellers.

50 Chris McAuliffe, *Art and Suburbia* (Roseville, Craftsman House, 1996), 43.

51 Anon., 'Identity: The bush' in *Collection Stories*, National Gallery of Victoria. www.ngv.vic.gov.au/collection/stories/identity/identity-and-place/the-bush, accessed 4 November 2014.

52 J. Alex Allan, *Men and Manners in Australia* (Melbourne, F.W. Cheshire, 1945), 111.

53 Eliza, Lady Darling, *Simple Rules for the Guidance of Persons in Humble Life: More Particularly for Young Girls Going Out to Service* (Sydney, James Tegg & Co., 1837), 33.

54 Young, 31.

55 Jane Clark and Bridget Whitelaw, *Golden Summers: Heidelberg and Beyond* (Melbourne, National Gallery of Victoria, 1986), 47.

56 Thorstein Veblen, *The Theory of the Leisure Class* (Pennsylvania State University Electronic Classics Series, 2003), 46.

57 Ibid.

58 Elizabeth Langland, *Nobody's Angels: Middle-class Women and Domestic Ideology in Victorian Culture* (New York, Cornell University Press, 1995), 9.

59 Penny Sparke, *As Long as it's Pink – The Sexual Politics of Taste* (London, Pandora, 1995), 1.

60 Walter Benjamin, *Illuminations* (New York, Schocken Books, 2007), 42.

61 'Parvenu' describes a person who has gained wealth or celebrity without having been born to it. The term was used extensively, and disparagingly, by Twopeny when describing Australia's colonial nouveau elite.

62 Richard Ernest Norwell Twopeny, *Town Life in Australia, 1883* (Project Gutenberg ebook, no. 16664, release date 6 September 2005), 172–173.

63 Charles Eastlake, *Hints on Household Taste in Furniture, Upholstery and Other Details* (London, Longmans, Green & Co., 1869), 7.

64 Ibid.

65 Rawson, 205.

66 Thomas Carlyle quoted in Rocke, 10.

67 Beryl, 'Art in the House, Hints on Decorating and Furnishing Australian Homes', *The Illustrated Sydney News*, Thursday 3 April 1890.

68 Trevor Keeble, 'Everything Whispers of Wealth and Luxury: Observation, Emulation and Display in the Well-to-do Victorian Home', in *Women in the Making of Built Space in England 1870–1950*, eds. Elizabeth Darling and Lesley Whitworth (Aldershot, Ashgate Publishing Limited, 2007) 68–84.

69 Fanny H. Barbour, 'Jottings 12 July 1887–20 May 1888' quoted in Brenda Niall, *The Boyds* (Melbourne, Melbourne University Press, 2007), 67.

70 Celeste Olalquiaga, *The Artificial Kingdom: A Treasury of the Kitsch Experience* (London, Bloomsbury Publishing, 1999), 285.

71 Deborah Cohen, *Household Gods: The British and Their Possessions* (New Haven, Yale University Press, 2006), xi.

72 Thorstein Veblen, 56.

73 Sabine Willis, 'Homes are Divine Workshops', in *Women, Class and History: Feminist Perspectives on Australia 1788–1978*, ed. Elizabeth Windschuttle (Melbourne, Fontana Books, 1980) 173–191.

74 Young, 15.

75 John Howard quoted in Fiona Allon, *Renovation Nation: Our Obsession with Home* (Sydney: UNSW Press, 2008), 18. The topic of 'home' has been a familiar keynote for Australian Prime Ministers. Australia's longest serving Prime Minister, Sir Robert Gordon Menzies, lauded the concept in his famous 'Forgotten People' speech in 1942: 'the home is the foundation of sanity and sobriety; it is the indispensable condition of continuity; its health determines the health of society as a whole'. The entire speech can be found at www.liberals.net/theforgottenpeople.htm, accessed 4 December 2018.

76 Richard Ernest Norwell Twopeny, *Town Life in Australia, 1883* (Project Gutenberg ebook, no.16664, release date September 2005), 13.

77 H. Mortimer Franklyn, *A Glance at Australia in 1880, or Food from the South* (Melbourne, The Victorian Review Publishing Company, 1881), 264. Franklyn's *A Glance at Australia in 1880* was written for an audience of prospective English migrants. The enthusiastic text was intent on seducing the right 'type' of migrant; those for whom the trappings of middle-class success were an aspirational goal or a reassuring continuum.

78 Walter Benjamin, *The Arcades Project* (Cambridge, MA, Harvard University Press, 2002), 7.

79 Kevin Fahy, Christina Simpson and Andrew Simpson, *Nineteenth-Century Australian Furniture* (Sydney, David Ell Press, 2008), 158.

80 H. Mortimer Franklin, 264.

81 Walter Benjamin, *Berlin Childhood around 1900* (Cambridge, MA, Harvard University Press, 2006), 87–88.

82 Franklyn, 12.

83 Twopeny, 32.

84 Andrew Montana, 'Stylists for the Nineteenth Century: The Finsbury Cabinet-makers Smee & Sons in Colonial Australia' in *Recollections: Journal of the National Museum of Australia*, vol. 7, no. 1 (2012), 1–27.

85 Thorstein Veblen, *The Theory of the Leisure Class* (Pennsylvania State University Electronic Classics Series, 2003), 47.

86 Anon., *The Australian Illustrated News* (Melbourne, Friday 1 January 1869), 24.

87 Fahy, Simpson and Simpson, 160.

88 Linda Young, *Middle-class Culture in the Nineteenth Century: America, Australia and Britain* (New York, Palgrave Macmillan, 2003), 71.

89 Rocke's reputation as a city dignitary was recognised when the newly formed Melbourne suburb of Ivanhoe, where Rocke resided at the time of his death, named 'Rocke Street' after him, and 'Salisbury Avenue' and 'Buchanan Street' after his wife, Salisbury Ann Buchanan.

90 Anon., quoted in Tracey Avery, 'Furniture Design and Colonialism: Negotiating Relationships between Britain and Australia, 1880–1901' in *Home Cultures*, 4:1 (London, Routledge, 2007), 69–92.

91 Ibid.

92 Charles Eastlake, *Hints on Household Taste in Furniture, Upholstery and Other Details* (London, Longmans, Green and Co., 1869), 6.

93 Anon., *Cassell's Household Guide: Being a Complete Encyclopedia of Domestic and Social Economy, and Forming a Guide to Every Department of Practical Life – Volume 1* (London, Cassell, Petter and Galpin, c.1870). www.victorianlondon. org/cassells/cassells-1.htm, accessed 4 November 2014.

94 Originally Eastlake's *Hints* were accessed via regular columns in the popular press (*The Queen* and *London Review*) before being edited and committed to a single volume in 1868.

95 Veblen, 12.

96 Eastlake, ix, 6.

97 Ibid., 8.

98 Lucy Orrinsmith, *The Drawing-room: Its Decorations and Furniture* (London, MacMillan, 1878), 3.

99 Eastlake, 10.

100 Orrinsmith, 7.

101 Nadine Rottau, '"Everyone to his taste" or "truth to material": The Role of Materials in Collection of Applied Art', in *Material Cultures, 1740–1920: The Meanings and Pleasures of Collecting*, eds. John Poyvin and Alla Myzelev (Farnham, Ashgate, 2009), 71–85.

102 Deborah Cohen, *Household Gods: The British and Their Possessions* (New Haven, Yale University Press, 2006), 19.

103 Anon. quoted in Andrew Montana, 'Stylists for the Nineteenth Century: The Finsbury Cabinet-makers Smee & Sons in Colonial Australia', in *Recollections: Journal of the National Museum of Australia*, vol. 7, no. 1 (2012), 1–27.

104 F.W. Gibson and Rev. Charlotte L. Brunskill, 'Eastlake, Charles Locke (1833–1906)' in *Oxford Dictionary of National Biography* (Oxford University Press, 2004, online edition, May 2014). www.oxforddnb.com/view/article/32959, accessed 4 November 2014.

105 Eastlake, 142.

106 Ibid.

107 Ibid., 35.

108 W.H. Rocke & Co. *Remarks on Furniture and the Interior Decoration of Houses* (Melbourne, McCarron, Bird & Company, 1874), 27.

109 Eastlake, 107.

110 Rocke, 7, 15.

111 Deborah Cohen, 34.

112 Rocke, 18, 9.

113 Patrick Brantlinger, *The Reading Lesson: The Threat of Mass Literacy in Nineteenth-Century British Fiction* (Bloomington, Indiana University Press, 1998), 71–72.

114 Alfred Austin quoted in Brantlinger, 23.

115 Martha Loftie, *The Dining Room* (London, Macmillan and Co., 1878), 76.

116 Kate Flint, *The Woman Reader, 1837–1914* (Oxford, Oxford University Press, 1994), 47.

117 Sarah A. Leavitt, *From Catherine Beecher to Martha Stewart: A Cultural History of Domestic Advice* (Chapel Hill, The University of North Carolina Press, 2002), 12.

118 Ibid.

119 Sara Mills, *Gender and Colonial Space* (Manchester, Manchester University Press, 2005), 46.

120 Samuel Smiles, *Self Help, With Illustrations of Character and Conduct* (Project Gutenberg ebook, no. 935, release date May 2003), 226.

121 Anon., *Men and How to Manage Them: A Book for Australian Wives and Mothers, by an Old Housekeeper* (Melbourne, A.H. Massina, 1883), 132.

122 W.H. Rocke & Co., no page number.

123 An 'Envoi' is the explanatory commentary that precedes or concludes a poem, essay or book.

124 Tracey Avery, 'Furniture Design and Colonialism: Negotiating Relationships between Britain and Australia, 1880–1901' in *Home Cultures*, 4:1 (London, Routledge, 2007), 69–92.

125 Among those in Rocke's employ was John Mather, most famous for his painted decoration in the Melbourne Exhibition Buildings. He also successfully wooed cabinetmakers from the esteemed English firm Gillow and Sons to join him at his Melbourne manufactory.

126 Michael Rock, 'The Designer as Author', in *Graphic Design Theory: Readings from the Field*, ed. Helen Armstrong (New York, Princeton University Press, 2009), 108–114.

127 Owen Jones, *The Grammar of Ornament* (London, Herbert Press, 2010), 17.

128 Walter Benjamin, *The Arcades Project* (Cambridge, MA: Harvard University Press, 2002), 88.

129 Anca I. Lasc, 'Interior Decorating in the Age of Historicism: Popular Advice Manuals and the Pattern Books of Édouard Bajot', *Journal of Design History*, vol. 26, no. 1 (Oxford University Press, 2012), 1–24.

130 Anon., 'A Splendid Mansion. Villa Alba', *Table Talk*, Melbourne, Friday 26 June 1885.

131 Ibid.

132 Ibid.

133 Ibid.

134 Ibid.

135 Ibid.

136 Thad Logan, *The Victorian Parlour* (Cambridge, Cambridge University Press, 2001), 48.

137 Leah Price, *How to Do Things with Books in Victorian Britain* (Princeton, Princeton University Press, 2012), 3.

138 Rocke, 39.

139 Ibid.

140 Ibid.

141 In 1885 Sala would arrive in Melbourne for a round of lectures and talks to prop up his ailing fortune; and of course to coin the city's famous catchphrase that, to this day, is liberally used: 'It was on the 17th of March, in the present year of Grace, 1885, that I made my first entrance, shortly before high noon, into Marvellous Melbourne'. Melbourne's city-dwelling middle-class, desperate to prove their worth and align themselves to English thinking, would willingly patronise his verbose and pompous lectures (one of which was titled 'Famous people I have seen or known') and see in person the journalist whose writings they had for years been required to admire.

142 James Button, 'He Came, He Saw, He Marvelled', *The Age*, 10 January 2004.

143 Peter Blake, 'George Augustus Sala and the English Middle Class View of America', in *19: Interdisciplinary Studies in the Long Nineteenth Century, Number 9: Transatlanticism: Identity and Exchange*, eds. Ella Dzelzainis and Ruth Livesey (London, University of London, 2009). www.19.bbk.ac.uk/index.php/19/article/view/509/503, accessed 4 November 2014.

144 Ibid.

145 Matthew Arnold quoted in Button.

146 George Sala quoted in Rocke, no page number.

147 George Sala quoted in Blake.

148 William Ramsay Smith, *The Place of the Australian Aboriginal in Recent Anthropological Research* (Adelaide, C.E. Bristow South Australian Government Printers, 1907), 20.

149 Charles Dickens, *The Noble Savage* (University of Adelaide ebook). https://ebooks.adelaide.edu.au/d/dickens/charles/d54rp/chapter12.html, accessed 4 November 2014.

150 Rocke, 2.

151 Lynn Beaton, *Part of the Furniture: Moments in the History of the Victorian Branch of the Federated Furnishing Trade Society* (Melbourne, MUP, 2007). Online extract. http://historyastimetravel.blogspot.com.au/2009/11/clash-between-european-chinese.html, accessed 4 November 2014.

152 Anon. quoted in Lynn Strahn, 'Exhibition Buildings, Melbourne', in *Australia's National Trust Historic Houses* (Canberra, Adrian Savvas Publishing, 1993), 554–563.

153 Samuel Smiles, 322.

154 William Shakespeare in Rocke, no page number.

155 William Shakespeare, *The Tragedy of King Lear*, in *William Shakespeare Complete Works*, eds. Jonathan Bate and Eric Rasmussen (London, Royal Shakespeare Company, 2007), 2040. Bold text by author.

156 Young, 89.

157 Edward Bulwar Lytton quoted in Rocke, 8.

158 Anon., 'The Parisians', Books, *The Spectator Archive*, 17 January 1874. http://archive.spectator.co.uk/article/17th-january-1874/14/books, accessed 4 November 2014.

159 Ibid.

160 Flint, 50.

161 Edward Bulwar Lytton, *The Parisians* (Project Gutenberg ebook, no. 7749, release date March 2009). www.gutenberg.org/files/7749/7749-h/7749-h.htm, accessed 4 November 2014.

162 Ibid.

163 Lytton quoted in Brantlinger, 23.

164 Edgar Allen Poe, 'The Philosophy of Furniture', in *The Domestic Space Reader*, eds. Chiara Briganti and Kathy Mezei (Toronto, University of Toronto Press, 2012), 206–209.

165 Ibid.

166 Ibid.

167 Poe quoted in Rocke, 19.

168 Poe, 206–209.

169 Rocke, 20.

170 John Ruskin quoted in Rocke, 9.

171 John Ruskin, *The Seven Lamps of Architecture* (New York, John Wiley, 1849), 17.

172 Ibid., 55.

173 Rev. John Eagles, *Essays Contributed to Blackwood's Magazine* (London, Edward Blackwood and Sons, 1857), 291.

174 Ibid.

175 Ruskin, 146.

176 Ibid. 56.

177 Owen Jones quoted in Rocke, 36.

178 Pye Henry Chavasse, *Advice to a Mother on the Management of Her Children* (Project Gutenberg ebook, no. 6595, release date September 2004). www.gutenberg.org/cache/epub/6595/pg6595.html, accessed 4 November 2014.

179 Chavasse quoted in Rocke, 35.

180 Rocke, 35.

181 Ibid.

182 Pye Henry Chavasse, *Advice to a Wife on the Management of Her Own Health and on the Treatment of Some of the Complaints Incidental to Pregnancy, Labour, and Suckling*, 7th Edition (London, John Churchill and Sons, 1866), 4.

183 Ibid., 10.

184 Ibid., 56.

185 Ibid., 22.

186 Ibid., 25.

187 E.M. Forster, *A Room with a View* (Rockville, Serenity Publishing, 2008), 115.

188 Thad Logan, 33.

189 Rocke, 5.

190 Anon., *Men and How to Manage Them: A Book for Australian Wives and Mothers, by an Old Housekeeper* (Melbourne, A.H. Massina & Co., 1885), 80.

191 Anne Anderson, 'Drawing Rooms: A backward Glance – Fashioning an Individual Drawing Room', in *Domestic Interiors: Representing Homes from the Victorians to the Moderns*, ed. Georgina Downey (London, Bloomsbury, 2013), 39–60.

192 Rocke, 29.

193 Ibid., 30.

194 Ibid., 32.

195 Ibid., 33.

196 Veblen, 46.

197 Anderson, 40.

198 Rocke, 17.

199 Ibid., 23.

200 Ibid., 26.

201 A *prie-dieu* is a 'devotional chair' designed for kneeling in private prayer.

202 Deborah Cohen, *Household Gods: The British and Their Possessions* (Yale University Press, 2009), x.

203 Ibid., 17.

204 Ibid., 25.

205 Ibid., 37–38.

206 Ibid., 53.

207 Mary Anne, Lady Barker, *The Bedroom and Boudoir* (Project Gutenberg ebook, no. 41922, release date January 2013), 86.

208 William Makepeace Thackeray quoted in Rocke, 12.

209 *The History of Pendennis: His Fortunes and Misfortunes, His Friends and His Greatest Enemy* (1850) is a novel by the English author William Makepeace Thackeray.

210 Rocke, 13. Rocke included a chapter titled 'Our Share in the Revolution'. In it he applauds the role of furnishers in the transformation of Melbourne from a rough colonial outpost to an opulent modern metropolis that can take its place alongside the great cities of Europe. His revolution is an overthrow of poor quality furniture, not any administration. His use of 'revolution' is explored in greater detail in the concluding chapter.

211 Isabella Beeton, *Beeton's Book of Household Management* (London, Chancellor Press, 1861/1994), 3.

212 W.H. Rocke & Co., *Remarks on Furniture and the Interior Decoration of Houses* (Melbourne, McCarron, Bird & Company, 1874), 10.

213 Adele Wessell, 'There's No Taste like Home: The Food of Empire', in *Exploring the British World: Identity, Cultural Production, Institutions*, eds. Kate Darian-Smith,

Patricia Grimshaw, Kiera Lindsey and Stuart Mcintyre (Melbourne, RMIT Publishing, 2004), 811–821.

214 Sara Mills, *Gender and Colonial Space* (Manchester, Manchester University Press, 2005), 122.

215 Anne Summers, *Damned Whores and God's Police* (Ringwood, Penguin, 1975/1994), 342.

216 Ibid.

217 Harriet Wicken, *The Australian Home: A Handbook of Domestic Economy* (Sydney, Edwards Dunlop, 1891), 3.

218 Blake Singley, 'More Than Just Recipes: Reading Colonial Life in the Works of Wilhelmina Rawson', in *TEXT Special Issue 24: Cookbooks: Writing, Reading and Publishing Culinary Literature in Australasia*, eds. Donna Lee Brien and Adele Wessell (October, 2013). www.textjournal.com.au/speciss/issue24/content.htm, accessed 4 November 2014.

219 Wilhelmina Rawson adopted the pseudonym 'Mother' for some of the columns she wrote for *The Queenslander* in the 1890s.

220 John Fewing quoted in Helen Gregory, 'Lifestyle', in *The Queensland House – A Roof over Our Heads*, eds. Rod Fisher and Brian Crozier (Brisbane, Queensland Museum, 1995), 1–12.

221 Beverley Kingston, 'Wicken, Harriett Frances (1847–1937)', in *Australian Dictionary of Biography* (MUP). http://adb.anu.edu.au/biography/wicken-harriett-frances-13247, accessed 4 November 2014.

222 Anon., 'Occupations Accessible to Women', in *Cassells Household Guide*, New and Revised Edition (4 Vols.) c.1880s. www.victorianlondon.org/cassells/cassells-19.htm#National%20Training%20School%20for%20Cookery, accessed 4 November 2014.

223 Ibid.

224 Ibid.

225 Charles Dickens Jr, *Dickens's Dictionary of London*, 4th Edition (London, Macmillan & Co., 1882), 90.

226 Pye Henry Chavasse, *Advice to a Wife on the Management of Her Own Health and on the Treatment of Some of the Complaints Incidental to Pregnancy, Labour, and Suckling*, 7th Edition (London, John Churchill and Sons, 1866), 30.

227 Ibid., 31

228 Beeton, 1.

229 Ibid., 9.

230 Wicken, 125, 2.

231 Chavasse, 97.

232 Wicken, no page number.

233 Louisa MacDonald in 'The Women's College', *The Sydney Morning Herald*, Monday, 7 May 1894, 6.

234 Grace Lees-Maffei, *Design at Home: Domestic Advice Books in Britain and the USA since 1945* (New York, Routledge, 2014), 43.

235 Mrs Edgeworth David in Wicken, vii.

236 Wicken, 1.

237 Wicken, no page number.

238 Ibid., iv.

239 Ibid., vi.

240 Raymond Evans and Kay Saunders, 'No Place Like Home', in *Gender Relations in Australia –Domination and Negotiation*, eds. Raymond Evans and Kay Saunders (Sydney, Harcourt Brace Jovanovich, 1992), 175–196.

241 Richard Ernest Norwell Twopeny, *Town Life in Australia, 1883* (Project Gutenberg ebook, no. 16664, release date 6 September 2005), 96.

242 Ibid., 103.

243 Margaret Anderson, 'Good Strong Girls – Colonial Women and Work', in *Gender Relations in Australia – Domination and Negotiation*, eds. Raymond Evans and Kay Saunders (Sydney, Harcourt Brace Jovanovich, 1992), 225–236.

244 Summers, 341.

245 Twopeny, 113.

246 Wicken, 109.

247 Moira Donald, 'Tranquil Havens? Critiquing the Idea of Home as the Middle-class Sanctuary', in *Domestic Space – Reading the Nineteenth-century Interior*, eds. Inga Bryden and Janet Floyd (Manchester, Manchester University Press, 1999), 103–120.

248 Wicken, 3.

249 Henry Parkes quoted in Summers, 337.

250 David in Wicken, vii–viii.

251 Wicken, 13.

252 Linda Young, *Middle-class Culture in the Nineteenth Century: America, Australia and Britain* (New York, Palgrave Macmillan, 2003), 179.

253 Wicken, 117.

254 Chavasse, 33–34.

255 Wicken, 77.

256 Ibid.

257 Ibid., 8.

258 Sarah Leavitt, in *From Catherine Beecher to Martha Stewart*, observed that Christian doctrine informed most advice manuals. Standards of morality were

informed by prevailing Christian belief systems, so it stands to reason that domestic behaviour should follow suit.

259 Ibid., 7.

260 Witold Rybczynski, 'Intimacy and Privacy', in *The Domestic Space Reader*, eds. Chiara Briganti and Kathy Mezei (Toronto, University of Toronto Press, 2012), 88–90.

261 Young, 93.

262 Wicken, 111.

263 Ibid., 112.

264 Ibid., 108.

265 Saunders and Evans, 175–196.

266 John Gloag, *Victorian Comfort: A Social History of Design, 1830–1900* (Newton Abbot; David and Charles 1961/1973), 40–41.

267 Wicken, 125.

268 John Ruskin, *Sesame and Lilies* (London, Smith, Elder and Co., 1865), 147.

269 Wicken, 243–244.

270 Twopeny, 172–173.

271 Gaston Bachelard, *The Poetics of Space* (Boston, Beacon, 1994), xxxviii.

272 Wicken, 117–118.

273 Rocke, 35.

274 Wicken, 111.

275 Ibid., 114.

276 Ibid., 116.

277 Ibid., 117.

278 Ibid., 116.

279 Tony Fry, 'A Geography of Power: Design History and Marginality', in *The Idea of Design*, eds. Victor Margolin and Richard Buchanan (Cambridge, MA: MIT Press, 1995), 204–218.

280 Lucy Orrinsmith, *The Drawing-room – Its Decorations and Furniture* (London, MacMillan, 1878), 1.

281 Charles Eastlake, *Hints on Household Taste in Furniture, Upholstery and Other Details* (London, Longmans, Green and Co., 1869), 171.

282 James Anthony Froud quoted in David Cannadine, *Ornamentalism: How the British Saw Their Empire* (Oxford, Oxford University Press, 2001), 34.

283 George Orwell, *Keep the Aspidistra Flying* (Adelaide, University of Adelaide Library ebooks). https://ebooks.adelaide.edu.au/o/orwell/george/o79k/complete.html#, accessed 4 November 2014.

284 Wilhelmina Rawson, *Mrs Lance Rawson's Cookery Book and Household Hints* (Rockhampton, William Hopkins, 1878/1890), v.

285 The book is also known as *The Queensland Cookery and Poultry Book* when republished in 1890. Rawson was a prolific author and penned cookbooks, fairytales, short stories and newspaper columns as well as her very bush-specific advice manual, *The Australian Enquiry Book. Her Practice as an Author Made a Vital Contribution to the Income of Her Family.*

286 Anon., 'Identity: The bush', in *Collection Stories*, National Gallery of Victoria. www.ngv.vic.gov.au/collection/stories/identity/identity-and-place/the-bush, accessed 4 November 2014.

287 Blake Singley, 'More Than Just Recipes: Reading Colonial Life in the Works of Wilhelmina Rawson', in *TEXT Special Issue 24: Cookbooks: Writing, Reading and Publishing Culinary Literature in Australasia*, eds. Donna Lee Brien and Adele Wessell (October, 2013). www.textjournal.com.au/speciss/issue24/content.htm, accessed 4 November 2014.

288 Mrs Lance Rawson, 'Making the Best of it', *The Queenslander*, Saturday, 10 April 1920.

289 Richard N.S. Robinson and Charles Arcodia, 'Reading Australian Colonial Hospitality: A Simple Recipe', *International Journal of Culture, Tourism and Hospitality Research*, vol. 2, issue 4 (2008), 374–388. http://dx.doi.org/10.1108/1750618 0810908998, accessed 4 November 2014.

290 Raymond Evans and Kay Saunders, 'No Place Like Home', in *Gender Relations in Australia – Domination and Negotiation*, eds. Raymond Evans and Kay Saunders (Sydney, Harcourt Brace Jovanovich, 1992), 175–196.

291 Rawson (1890), 33.

292 Anthony Trollope, *New South Wales and Queensland* (London, Chapman and Hill, 1875), 12.www.archive.org/stream/australiaandnew03trolgoog#page/n12/mode/2up, accessed 4 November 2014.

293 Robert O'Hara Burke (1821–1861) and William John Wills (1834–1861) were commissioned by the Victorian Government to survey the Australian interior and its top end to locate a possible route for an international telegraph system. The expedition would claim both their lives and those of another five men. Only one survivor, John King, returned to Melbourne.

294 Kay Schaffer, *Women and the Bush* (Cambridge, Cambridge University Press, 1988), 62.

295 *No Place for a Woman* (1900) is a Lawson short story in which a traveller is met by Ratty Howlett, a bushman driven mad by the death of his wife in childbirth. His grief is suppressed by imagining her still alive and enacts her domestic duties as if she had done them herself. Any sense of hope or happiness in the isolation of the bush is embodied in the tidiness of their rudimentary bush

dwelling. While the denial of his wife's death is presented as proof of madness, retaining her well-kept house is also arguably what prevents his absolute descent into complete and brutal insanity.

296 Henry Lawson, 'The Drover's Wife', in *The Penguin Henry Lawson* (Camberwell, Penguin Group Australia, 1986), 24.

297 Ibid., 25.

298 Ibid., 19.

299 Wilhelmina Rawson, *Australian Enquiry Book of Household and General Information. A Practical Guide for the Cottage, Villa and Bush Home* (Melbourne, J.W, Knapton & Co., 1894/1898), 192–205, 270.

300 Whilhelmina Rawson, *The Antipodean Cookery Book and Kitchen Companion* (Kenthurst, Kangaroo Press, 1895/1992), 33.

301 Dagmara Zabiello, 'The Role of Architectural Pattern Books in the British Empire in the Nineteenth Century', in *Exploring the British World: Identity, Cultural Production, Institutions*, eds. Kate Darian Smith, Patricia Grimwade, Kiera Lindsay and Stuart Mcintyre (Melbourne, RMIT Publishing), 854–868.

302 Lawson, 24.

303 Caroline Chisholm quoted in Anne Summers, *Damned Whores and God's Police* (Ringwood, Penguin, 1975/1994), 337.

304 Rawson (1890), 17, 20, 33, 36–37.

305 Ibid., 32.

306 Blake Singley, 'Hardly Anything Fit For a Man to Eat – Food and Colonialism in Australia', *History Australia*, vol. 9, no. 3 (December, 2012), 27–42.

307 Blake Singley, 'More Than Just Recipes: Reading Colonial Life in the Works of Wilhelmina Rawson', in *TEXT Special Issue 24: Cookbooks: Writing, Reading and Publishing Culinary Literature in Australasia*, eds. Donna Lee Brien and Adele Wessell (October 2013) 1–7.

308 Ibid.

309 Rawson (1992), 55.

310 Ibid., 54.

311 Rawson (1890), 35.

312 Mary Anne Jebb and Anne Halbich, 'Across the Great Divide, Gender Relations in Australian Frontiers', in *Gender Relations in Australia: Domination and Negotiation*, eds. Raymond Evans and Kay Saunders (Sydney, Harcourt Brace Jovanovich, 1992), 26–54.

313 Rawson (1890), 35.

314 Mrs Lance Rawson, 'Making the Best of it', *The Queenslander*, Saturday, 6 March 1920.

315 Anon., 'Mrs Lance Rawson', *The Brisbane Courier*, Friday, 11 August 1933.

316 Mrs Lance Rawson, 'Making the Best of it', *The Queenslander*, Saturday, 6 March 1920.

317 Rawson (1890), 1.

318 Richard Ernest Norwell Twopeny, *Town Life in Australia, 1883* (Project Gutenberg ebook, no. 16664, release date 6 September 2005), 92.

319 Isabella Beeton, *Beeton's Book of Household Management* (London, Chancellor Press, 1861/1994), 961.

320 Rawson (1890), 4.

321 Ibid., 5.

322 Rawson (1898), 148.

323 Rawson (1890), 3.

324 Ibid., 2

325 Rawson (1898), 205–206.

326 Ibid., 132.

327 Ibid., 32.

328 Anon in John Gloag, *Victorian Comfort: A Social History of Design, 1830–1900* (Newton Abbot, David and Charles, 1961/1973), 41.

329 Lawson, 24.

330 Philip Drew, *The Coast Dwellers* (Ringwood, Penguin Books, 1994), 51.

331 Rawson (1898), 208.

332 Ibid., 208.

333 Ibid., 210.

334 Ibid.

335 Ibid.

336 Robin Boyd, *Australia's Home* (Ringwood, Penguin, 1952/1968), 15–16.

337 Rawson (1898), 210.

338 Walter Benjamin, *The Arcades Project* (Cambridge MA, Harvard University Press, 2002), 9.

339 Rick Morton, *One Hundred Years of Dirt* (Melbourne, Melbourne University Press, 2018), 20.

340 Harriet Wicken, *The Australian Home: A Handbook of Domestic Economy* (Sydney, Edwards Dunlop, 1891), 120.

341 Ibid., 116.

342 Rawson (1898), 207.

343 The 'Wardian' case was invented by Dr Nathaniel Ward. It is the forerunner of the 'terrarium' and the inspiration for the 'aquarium'. It was a small glass case

used to transport plant specimens from country to country and prevented them dying from exposure or disease.

344 Rawson (1898), 207.

345 Anon., *Cassell's Household Guide, Volume 1* (London, Cassell, Petter and Galpin, c.1880), 361.

346 Rawson (1898), 207.

347 Taxidermy was a familiar interior ornament among Australia's middle-class. In *A Bunyip Close behind Me: Recollections of the Nineties* by Eugenie McNeil, McNeil recounts her mother finding a dead owl, having it halved and stuffed by a taxidermist and used it to ornament each end of her drawing room mantelpiece.

348 Most English fireplaces were coal fuelled. With no risk of sparking embers, firescreens could be made from any number of flammable materials including feathers, papier-mâché and embroidery.

349 *Cassell's Household Guide*, 289.

350 Thad Logan, *The Victorian Parlour* (Cambridge, Cambridge University Press, 2001), 147.

351 Rosamund Marriott Watson, *The Art of the House* (London, George Bell and Sons, 1897), 12.

352 Martha Loftie, *The Dining Room* (London, Macmillan and Co., 1878), 3.

353 Lucy Orrinsmith, *The Drawing-room: Its Decorations and Furniture* (London, MacMillan, 1878), 5.

354 Penny Sparke, *As Long as it's Pink – The Sexual Politics of Taste* (London, Pandora, 1995), 45.

355 Clive Edwards, 'Women's Home-Crafted Objects as Collections of Culture and Comfort, 1750–1900', in *Material Cultures, 1740–1920: The Meanings and Pleasures of Collecting*, eds. John Potvin and Alla Myzelev (Farnham, Ashgate, 2009), 37–52.

356 Rawson (1898), 211.

357 Anon., 'Sudan (New South Wales Contingent) March–June 1885', in *War History, Australian War Memorial*. www.awm.gov.au/articles/atwar/sudan, accessed 4 November 2014.

358 Rawson (1894), 211.

359 Drew, 9.

360 Jean Baudrillard, *The System of Objects* (London, Verso, 1968/1996), 27.

361 Drew, 6.

362 Rawson (1898), 127.

363 Anon., *Cassell's Household Guide, Volume 3* (London, Cassell, Petter and Galpin, c.1880), 280.

364 Ibid.

365 Jean Baudrillard, 'Simulacra and Simulation', in *Jean Baudrillard – Selected Writings*, 2nd Edition, ed. Mark Poster (Stanford, Stanford University Press, 2001), 169–187.

366 Ibid.

367 Jean Baudrillard, 'The System of Collecting', in *The Cultures of Collecting*, eds. John Elsner and Roger Cardinal (Cambridge MA, Harvard University Press, 1994), 1–24.

368 Walter Benjamin, *The Arcades Project* (Cambridge, MA: Harvard University Press, 2002), 220.

369 Penny Sparke, *As Long as it's Pink: The Sexual Politics of Taste* (London, Pandora, 1995), 27.

370 Linda Young, *Middle-class Culture in the Nineteenth Century: America, Australia and Britain* (New York, Palgrave Macmillan, 2003), 16.

371 Kay Schaffer, *Women and the Bush: Forces of Desire in the Australian Colonial Tradition* (Cambridge, Cambridge University Press, 1988), 52.

372 Beverley Skeggs, *Formations of Class and Gender: Becoming Respectable* (London, Sage, 1997), 10.

373 Daniel Miller, 'Possesions', in *Home Possessions: Material Culture behind Closed Doors*, ed. Daniel Miller (Oxford, Berg, 2001), 107–121.

374 Penny Sparke, *The Modern Interior* (London, Reaktion Books, 2008), 25.

375 Anon. quoted in Sara Mills, *Gender and Colonial Space* (Manchester, Manchester University Press, 2005), 32.

376 Anne Summers, *Damned Whores and God's Police* (Ringwood, Penguin, 1994), 342.

377 Ibid., 357.

378 Caroline Chisholm quoted in Anne Summers, 337.

379 Dagmara Zabiello, 'The Role of Architectural Pattern Books in the British Empire in the Nineteenth Century', in *Exploring the British World: Identity, Cultural Production, Institutions*, eds. Kate Darian Smith, Patricia Grimwade, Kiera Lindsay and Stuart Mcintyre (Melbourne, RMIT Publishing), 854–868.

380 Anthony Trollope, *New South Wales and Queensland* (London, Chapman and Hill, 1875), 19. www.archive.org/stream/australiaandnew03trolgoog#page/n12/mode/2up, accessed 4 November 2014.

381 Clifford Geertz, *The Interpretation of Cultures: Selected Essays* (New York, Basic Books, 1973), 68.

382 Phillip Drew, *The Coast Dwellers: A Radical Reappraisal of Australian Identity* (Ringwood, Penguin Books, 1994), 59.

383 Jane Robinson, *Angels of Albion: Women of the Indian Mutiny* (London, Viking, 1996), 13.

384 Walter Benjamin, 218.

385 W.H. Rocke & Co., *Remarks on Furniture and the Interior Decoration of Houses* (Melbourne, McCarron, Bird & Co., 1874), 13.

386 Ibid., 13, 14

387 Ibid.

388 Tony Fry, 'A Geography of Power: Design History and Marginality', in *The Idea of Design*, eds. Victor Margolin and Richard Buchanan (Cambridge, MA: MIT, 1995), 204–218.

389 Ibid.

390 Jean Baudrillard, 'Simulation and Simulacra', in *Jean Baudrillard: Selected Writings*, 2nd Edition, Revised and Expanded, ed. Mark Poster (Stanford, Stanford University Press, 2001), 169–187.

INDEX